Camera Atomica

edited by
John O'Brian

AGO
Art Gallery of Ontario

black dog
publishing
london uk

Contents

Foreword
Matthew Teitelbaum
Michael and Sonja Koerner Director,
and CEO, Art Gallery of Ontario

Camera Atomica begins with questions: what role have photographs played in creating a public image of the bomb and nuclear energy? Is this image myth or reality? Has the circulation of nuclear images heightened or lessened anxieties about the times in which we live? Might these images' ubiquity on the front pages of newspapers do both, at the same time? Can photographs and reproduced images trigger memories of the past while encouraging an activism for the future? How should the different visual protocols of photography—scientific, journalistic, documentary, touristic and post-documentary—be understood as having reach, affect and influential meaning?

Camera Atomica is the first substantial exhibition of nuclear photography to encompass the entire post-war period from the bombing of Hiroshima and Nagasaki in 1945 to the triple meltdown at Fukushima Daiichi in 2011 and ongoing developments in North Korea and Iran. It brings together in one place vintage and contemporary photographs, press and fine art photographs, scientific and touristic images, and advertisements and propaganda from a diffuse range of places.

In the 1980s artists such as Bruce Conner, Barbara Kruger and Nancy Burson as well as photographers such as Robert Adams, Carole Gallagher, Richard Misrach and Kenji Higuchi responded in large numbers to a new nuclear arms race and the intensification of the Cold War. They also reacted to a heightened cultural debate about the meaning and efficacy of the photograph to "tell the truth" or "open a window on the world". *Camera Atomica* explores the work produced before and after 1980. Do the latter images imply that nuclear representation can only be directional, suggestive and incomplete? Do the scientific and documentary photographs that dominated nuclear representation before 1980 hold an aura of truth—are they somehow more "real"? These are some of the questions that *Camera Atomica* seeks to pose for the twenty-first-century viewer.

Camera Atomica addresses four of the most pressing social issues of the post-war era—nuclear weapons proliferation, toxic waste disposal, climate change and geo-political power relations—in subtle yet provocative ways. This vision is the result of the searching, inquisitive and truly creative thinking of the exhibition's guest curator, University of British

Columbia professor and cultural historian John
O'Brian. He explores the contemporary relevance
of historical images in incisive ways, demonstrating
that all acts of looking are of the moment and
informed by personal experience.

John was wonderfully supported by the AGO's
Associate Curator of Photography, Sophie Hackett,
who acted as the Gallery's in-house curator, and
Sarah Yaffe, Project Manager for the exhibition. Jim
Shedden and the AGO Publishing team contributed
constructive ideas and insight at every turn and
carried out key research, image selection, narrative
sequencing and book production tasks with energy
and finesse.

I deeply appreciate the esteemed authors and
scholars who contributed essays to this volume: Iain
Boal, Julia Bryan-Wilson, Douglas Coupland, Blake
Fitzpatrick, Gene Ray, Susan Schuppli and Hitomitsu
Toyosaki. Their diverse, perceptive observations on
nuclear imagery are truly engrossing, and enrich
our understanding of the photographic past and
present. I also extend my thanks to Black Dog
Publishing, our co-publisher, for partnering with
us on this project; Duncan McCorquodale and
his colleagues at Black Dog have been generous
collaborators on this book, and on all the books we
have produced with them in recent years.

This publication and the exhibition that
accompanies it would not be possible without the
vital involvement of our lenders and supporters. I
thank the many individuals, galleries and institutions
that have provided works for inclusion in *Camera
Atomica*, and the numerous organisations that
support the AGO's programming year-round.

Camera Atomica is offered as a deep meditation
on two pivotal technologies of our recent history—
nuclear energy and photography—and the complex
relationship between them. The book and exhibition
raise a number of fascinating, at times troubling
questions about the role of representation in the
atomic age. *Camera Atomica* does not aim to settle
these penetrating questions, however; it provokes
us to think deeply about how nuclear imagery has
affected our past, and how it will continue to shape
our future.

Acknowledgements
John O'Brian

A group exhibition accompanied by a publication is a cooperative venture and *Camera Atomica* is no exception. My investigations into nuclear photography have depended on the collaboration of many individuals. The artist Jeremy Borsos has been involved in the project from the start, as has Trevor Smith, Curator of the Present Tense at the Peabody Essex Museum, and Serge Guilbaut, my colleague at the University of British Columbia, whose work on visual representation during the Cold War era preceded my own. Carole Gallagher and Robert Del Tredici, co-founders of the Atomic Photographers Guild, helped to point the way with advice and groundbreaking books, *American Ground Zero: The Secret Nuclear War* and *At Work in the Fields of the Bomb*, respectively. Akira Mizuta Lippit's book *Atomic Light (Shadow Optics)* also pointed the way.

In the course of my research, I have benefited from conversations and exchanges with a long list of photographers, artists and writers. My thanks to Robert Bean, Eric Bednarski, Michael Broderick, Cameron Campbell, Tama Copithorne, Douglas Coupland, Gordon Edwards, Olivia Fermi, Blake Fitzpatrick, Daniel Grausam, Jamie Hilder, Kristan Horton, Robert A Jacobs, Genevieve Fuji Johnson, Mary Kavanagh, Robert Kleyn, Kiyoski Kusumi, Martha Langford, Tim Lee, Ishiuchi Miyako, Joseph N Newland, David Pantalony, Giuseppe Penone, Andrea Pinheiro, Kristina Lee Podesva, Richard Prince, Helena Reckitt, Mark Ruwedel, Julie Salverson, Eric Sandeen, Geoffrey Sea, the late Allan Sekula, Mark Selden, Dan Starling, Sally Stein, John Timberlake, Momoko Usami, Peter C van Wyck, and Ken and Julia Yonetani. I am also grateful to friends, colleagues and family who have shaped my thinking: Heribert Adam, Claudia Beck, Laura Brandon, Richard Cavell, Ramsay Derry, David Donaldson, Thierry Gervais, Robin Glass, David Gooderham, Colin Griffiths, Andrew Gruft, Caroline Hirasawa, Gareth James, David Knaus, Christina Laffin, Elizabeth MacKenzie, Harry and Ann Malcolmson, Shane McCord, Kogila Moodley, Laura Moss, Ira Nadel, Melanie O'Brian, Peter O'Brian, Helga Pakasaar, David Pantalony, Carol Payne, Shelly Rosenblum, Joan Schwartz, Matthew Speier, Sarah Stacy, Fred Stockholder, Peter White, Ross Winter and Jerry Zaslove.

Matthew Teitelbaum, Director of the Art Gallery of Ontario, initiated the idea for an exhibition and has been supportive throughout. The collective expertise

of the gallery has been crucial in realising the project. I particularly wish to mention Sophie Hackett, Associate Curator of Photography, Jim Shedden, Manager of Publishing, and Sol Legault, coordinator of rights and reproductions, for their contributions. I am also grateful to other staff members, some no longer with the gallery, for their support: Bruce Ferguson, Dennis Reid, Elizabeth Smith, Maia-Mari Sutnik, David Wistow, Sarah Yaffe and Catherine de Zegher.

Museum curators, registrars, librarians and archivists have gone out of their way to show me their collections and assist with research. I am indebted to Barbara Adams and Timothy Prus, Archive of Modern Conflict, London; Martha Hannah, Andrea Kunnard and Sue Lagosi, Canadian Museum of Contemporary Photography, Ottawa; Sarah Newby, Center for Creative Photography, Tucson; the Clara Thomas Archives and Special Collections, York University, Toronto; Doug Beeton, Diefenbunker Museum, Ottawa; Hiroshima Peace Memorial Museum; Christopher Phillips and Claartje van Dijk, International Center of Photography, New York; Jill Delaney, Library and Archives Canada, Ottawa; Marina Chao, Museum of Modern Art, New York; Ann Thomas, National Gallery of Canada, Ottawa; the San Francisco Museum of Modern Art; Emmy Lee Wall, Vancouver Art Gallery; Thierry Gervais, Charlene Heath and Chantal Wilson, Ryerson Image Centre, Toronto; Vanessa Kam, University of British Columbia Library; David Pantalony, Canada Science and Technology Museum, Ottawa; and Joshua Chuang, Yale University Art Gallery, New Haven.

Invitations to give lectures and talks provided me with opportunities to test ideas in public and receive comments in return. I am grateful to the following individuals as well as the institutions with which they were associated at the time I spoke: Jan Allen and Janet M Brooke, Agnes Etherington Art Centre, Queen's University, Kingston, Ontario; Victoria Baster and Leslie Dawn, University of Lethbridge, Alberta; Iain Boal, Institute for International Studies, University of California, Berkeley; Carolyn Butler-Palmer, Erin Campbell and Catherine Harding, University of Victoria, British Columbia; Mark Cheetham and Elizabeth Legge, University of Toronto; James B Cuno and Marjorie B Cohn, Harvard University Art Museums, Cambridge, Massachusetts; Karen Duffek, Museum of Anthropology, University of British Columbia, Vancouver; Patricia Failing and Cynthea Bogel, University of Washington, Seattle; Ma Gang and Hsingyuan Tsao, Central Academy of Fine Arts, Beijing; Serge Guilbaut, Fondation Hartung Bergman, Antibes; David Howard, NSCAD University, Halifax; Robert A Jacobs and Hiroko Takahashi, Hiroshima Peace Institute; Helga Pakasaar and Reid Shier, Presentation House Gallery, North Vancouver; Suzanne Paquet, Université de Montréal; Sarah Parsons, Interdisciplinary Photography Discussion Group, Toronto; Eric Rosenberg, Tufts University, Medford, Massachusetts; Catherine M Soussloff, University of California, Santa Cruz; Taira Uchida, Tokyo Economic University; Jerry Zaslove, Simon Fraser University, Burnaby, British Columbia; Scott C Zeman, Albuquerque; and Luo Zhongli and Gu Xiong, Sichuan Fine Arts Academy, Chongqing.

Students and research assistants at the University of British Columbia have been among my most demanding interlocutors. I owe special thanks to Hannah Acton, Kate Allen, Lisa Andersen, Ashley Belanger, Jesse Birch, Darlene Calyniuk, Blaine Campbell, Alice Choi, Karl Fousek, Juan A Gaitán, Britt Gallpen, Ryan Gauvin, Carmella Gray-Cosgrove, Kyoung Yong (Anton) Lee, Rebecca Lesser, Klara Manhal, Leanna Orr, Yasmin Nurming-Por, Daniel Ralston, Erin Ramlo, Michaela Rife, Robin Simpson, Devon Smither, Kate Steinmann, Aletheia Wittman and Sophia Zwiefel. Jeff O'Brien deserves special mention for his many contributions to the project.

My investigations have benefited from a visiting professorship at Ritsumeikan University, Kyoto, the Brenda and David McLean Chair in Canadian Studies at the University of British Columbia, and the Orion lectureship at the University of Victoria, British Columbia. The Ritsumeikan professorship gave me an opportunity to teach and conduct research in Japan, the McLean Chair time to travel and write, and the Orion lectureship a venue to present work in progress. I have received generous funding from the Social Sciences and Humanities Research Council of Canada.

Finally, I would like to thank Iain Boal, Julia Bryan-Wilson, Douglas Coupland, Blake Fitzpatrick, Gene Ray, Susan Schuppli and Hiromitsu Toyosaki for their insightful texts. Critically engaged photography requires critically engaged writers.

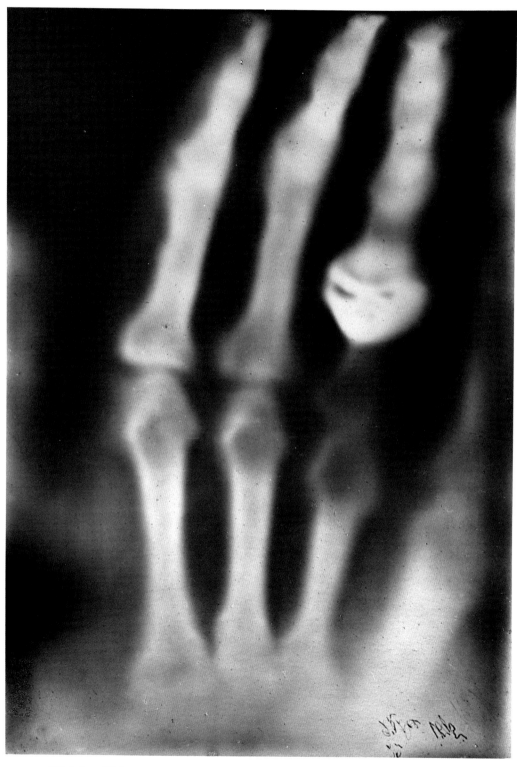

Wilhelm Conrad Röntgen
Bertha Röntgen's X-rayed Hand, 1895

Introduction: Through a Radioactive Lens
John O'Brian

Wherever nuclear events occur, photographers are present. They are there not only to record what happens, but also to assist in the production of what happens. From the outset, photographic images have been instrumental in shaping nuclear research and how it is used. The camera's prosthetic eye possesses the power of deferred sight, the uncanny ability to make visible after an event what could not be seen at the time.[1] Few aspects of the nuclear environment have escaped the camera's gaze.

This book and the exhibition to which it relates explore the relationship of photography to nuclear technologies as well as to issues of visibility and invisibility, which are central to the relationship.[2] The nuclear physicist Ernest Rutherford used a strip of film in his radiation experiments at McGill University to visually differentiate between alpha and beta particles.[3] Nuclear events from the early twentieth century up to our own time, which is to say, from Rutherford's and Marie Curie's research on radioactivity to the 2011 triple meltdown at Fukushima Daiichi and ongoing developments in North Korea and Iran, were preceded in 1895 by the discovery of the X-ray. The German physicist Wilhelm Röntgen chanced upon this form of electromagnetic radiation during an experiment with fluorescent light, and designated it an "X" ray to signify its enigmatic properties. Soon after, he exposed his wife's hand to the so-called X-ray as it lay across a photographic plate. On being shown the resulting ghostly image, in which her fingers, one adorned with a wedding ring, look spectral, Bertha Röntgen declared: "I have seen my own death."[4] By means of spontaneous radioactivity, the invisible had been made visible; photo-imaging technology had penetrated solid matter for the first time. The invention of the X-ray and Bertha Röntgen's exclamation upon being shown the photograph of her hand, I want to argue, foreshadow the disordered histories of the atomic age that have followed.

In 1945, half a century after Röntgen's discovery, the human species developed the capacity to destroy itself. The creation of a nuclear "gadget", as the atomic bomb was initially called, occurred under the auspices of the Manhattan Project, a secret wartime consortium led by the United States with the support of Britain and Canada.[5] The Manhattan Project announced new orders of destructive capability, and in the process introduced the unruly ingredients for potential catastrophe. But splitting the atom also held out the prospect of a brave new world in which nuclear energy would be capable of fuelling machines at a fraction of the cost of fossil fuels. Walt Disney's book *Our Friend the Atom*, a nuclear fantasia published in 1956, imagined that atomic energy would open the way to enhanced lives and "the blessings of peace".[6] Disneyland introduced visitors to a ride on a nuclear submarine, taking them on a journey to the North Pole, at the same time that American schools were drilling children in Duck and Cover exercises against Soviet attack.[7] While living on the outskirts of New York City in the early 1950s, I participated in "Duck and Cover" exercises myself and found them to be exercises *in* terror more than *against* terror.[8] Disney also

LEFT
U.S. Department of Defense
Nuclear Device Detonated at the Trinity Test Site, Alamorgordo, New Mexico,
16 July 1945

RIGHT
Max Scheler
Alarm at Culver City High School: Duck and Cover Drill, c 1950

produced films that featured Wernher von Braun, the rehabilitated Nazi rocket scientist who had been responsible for developing the V-2 during the Second World War.[9] Von Braun was Disney's consultant on space travel.[10]

Our Friend the Atom is more dialectically minded than its title would suggest. Although the book promotes the peaceful side of the atom, sometimes called the sunny side of the atom, it also recognises that nuclear energy possesses deadly attributes. This is more than can be said of another popular book of the time, *Atoms for Peace: U.S.A. 1958*, which was published by the United States Atomic Energy Commission.[11] "The atomic genie", declares *Our Friend the Atom*, substituting a supernatural being for the military-industrial complex, "holds in his hands the powers of both creation and destruction."[12] 30 years later the philosopher Jacques Derrida did not disagree with the proposition but introduced an important qualification. In a reading of Plato's *Phaedrus*, and in a subsequent article called "No Apocalypse, Not Now" that draws on the *Phaedrus*, he argued that the benefits and harm of nuclear energy cannot be prised apart.[13] They are fused together. The positive and the negative, Derrida said, participate in an unstable and sometimes violent relationship that can be explained by reference to Plato's concept of the "*pharmakon*".

The *pharmakon* is a remedy that also has the ability to injure. The machine represented in the photograph *Detecting Disease with Atoms*, like a modern-day Medusa sprouting wires instead of snakes from its head, looks designed to injure rather than heal a patient. Or take technetium-99m, a short-lived radioisotope used in nuclear medicine to generate highly coloured data images of the human body or animals.[14] When injected into the body, the radioisotope gravitates towards certain organs and tumours to reveal with rainbow intensity what is happening beneath the skin, and in this way allows for a more precise diagnosis than would otherwise be possible. Too much technetium-99m would prove fatal and too little would yield unsatisfactory results. As both poison and cure, Derrida concludes, nuclear energy is the "absolute *pharmakon*".[15]

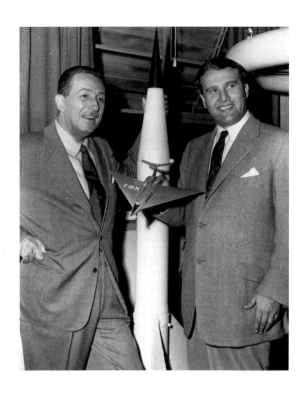

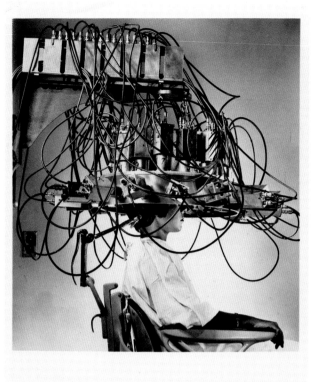

National Aeronautics and Space Administration (NASA)
Walt Disney and Wernher von Braun at the Redstone Arsenal, Huntsville, Alabama, 1954

United States Information Service
Detecting Disease with Atoms: A patient sits underneath a complicated contrivance with dangling wires called a multidetector, which can pinpoint a brain tumor, c 1950s

TRIUMF, University of British Columbia
PET Scan Group, "Skeleton and Head of a Mouse", 2013

With the exception of Röntgen's X-ray image, the works in the exhibition date from 1945 to the present. The primary function of the X-ray photograph is scientific, regardless of how compelling it is to look at, but nuclear photography has also been engaged in activities and investigations that extend beyond the scientific and diagnostic. It has generated images for a wide range of purposes.[16] Nuclear photography has been used as an instrument of photojournalism and the mass media; an agent of advertising and commerce; a means of documentation; a contrivance for surveillance; a tourist

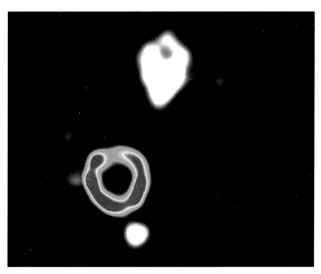

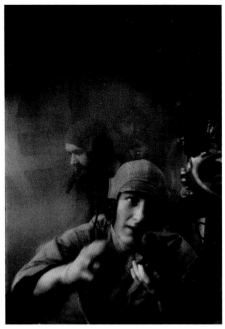

LEFT
Edward Burtynsky
*Uranium Tailings #12, Elliot Lake,
Ontario,* 1995

RIGHT
Margaret Bourke-White
*B-36 Bomber Crewmen Grabbing for Oxygen
Control, Strategic Air Command, Carswell Air
Force Base, Texas,* 1951

souvenir; a memory device; an apparatus of propaganda; and a medium for the production of art. This list is not exhaustive, any more than the individual categories cited are discrete. New uses for nuclear photography are constantly being found, and there is as much slippage between the categories as there is slippage between the competing meanings they produce.

A single nuclear image can serve multiple purposes at once. Edward Burtynsky's large colour photograph *Uranium Tailings #12, Elliot Lake, Ontario* is not only a visual document (the matter-of-factness in the information supplied by its title underscores a documentary intention) and a work of art (it has been displayed in galleries and written about in art journals), but also a protest against unsafe mining practices (tailings left over from uranium extraction are six times more radioactive than uranium itself). Margaret Bourke-White's *Bomber Crewmen, Strategic Air Command, Carswell Air Force Base, Texas* was taken for a photo essay in *Life* magazine in 1951, but has since assumed an entirely different existence, detached from the mass-circulation magazine to which it contributed, as a photograph sought after by museums and collectors.[17] Mike Mandel and Larry Sultan's project *Evidence*, initially produced as a book in 1977, was later transformed into an exhibition. Armed with a government grant and an official letter of recommendation, the artists ordered archival photographs from corporations and government agencies, including images with nuclear content, and stripped them of their original purposes and meanings. By discarding their titles and captions, Mandel and Sultan deprived the images of their institutional contexts and repositioned them as art. Many of the photographs were strange to begin with and the artists made them stranger still.

Evidence separates corporate and government photographs from their subjects. A related if less radical process of displacement

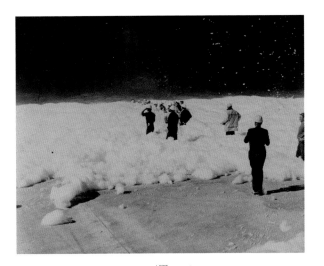

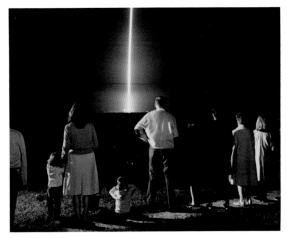

occurs when photographs are disseminated in mass-circulation magazines and newspapers, particularly when they are called upon to play a significant role in shaping public memory. It is through photography and camera-based imagery in general that collective memories of major events such as the Hiroshima and Nagasaki bombings and the Chernobyl meltdown are constructed, as seen in Robert Del Tredici's photograph of contaminated reindeer destroyed in the wake of the Chernobyl disaster.[18] "Photography works hand in glove with image and memory", writes Georges Didi-Huberman in reference to the Nazi death camps, and cannot be disassociated from Auschwitz any more than it can be disassociated from "the memory of the bodies of the prisoners".[19] For Didi-Huberman, photography possesses "epidemic power". Nuclear events, like the events at Auschwitz, have been assimilated into public memory by means of the *epidemic* force of photography, and then shaped and reshaped by changing social circumstances. This has been especially the case when photographs have become icons, like *Mushroom Cloud, Test Baker*, taken by the US Army Photographic Signal Corps on 26 July 1946, during the first atomic tests conducted at Bikini Atoll in the Pacific, or *Raising the Flag on Iwo Jima*, taken by Joe Rosenthal on 23 February 1945, or even *Radioactive Cats*, produced by Sandy Skoglund at a time when public anxiety about President Ronald Reagan's escalation of the nuclear arms race was on the rise. By coincidence, all three of these photographs were staged. Rosenthal shot 18 images of the event on Iwo Jima, and the US Army Photographic Signal Corps produced tens of thousands of photographs of the Bikini test.

This book and exhibition address some persistent questions. What has been the role of nuclear photography in constructing public memory, that is, in underwriting a public image of the bomb and nuclear energy? To what degree has photography contributed to an understanding of the reciprocal relationship in nuclear energy between harm and benefit? How should the different visual regimes of nuclear

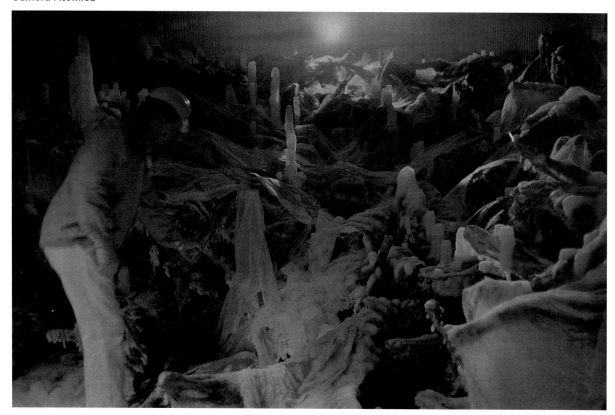

Robert Del Tredici
The Becquerel Reindeer, Harads Same-produktor,
Harads, Lapland, Sweden, 3 December 1986

photography—scientific, surveillant, journalistic, documentary, fine art, propagandistic, touristic—be comprehended? What can photography tell us, or not tell us, about pressing social issues such as nuclear weapons proliferation, geo-political relations, climate change and radioactive waste disposal?

The essays in this publication offer insights into these questions, often from a previously unexplored vantage point. In the first essay, I consider how nuclear imagery has shaped public memory in an age of risk through representations of the mushroom cloud, the most extravagant figurehead of the atomic age. Julia Bryan-Wilson looks at photographs of atomic tests in which cameras also appear, drawing attention in her essay to a genre of imagery engaged in a self-referential exchange between photography and nuclear events. Many of the photographs she discusses are in the exhibition. Photojournalist Hiromitsu Toyosaki writes about victims of radiation damaged by the attacks on Hiroshima and Nagasaki, nuclear testing, uranium mining and accidents in nuclear plants. He interviewed and photographed radiation victims from around the world and identifies them as *hibakusha*, a term initially applied only to survivors of the Japanese bombings.[20] Blake Fitzpatrick concentrates on the Atomic Photographers Guild, founded by Robert Del Tredici and Carole Gallagher in 1987, and on the challenge presented in mounting exhibitions of nuclear photography. Fitzpatrick is himself a member of the Guild and, like its founders, writes on nuclear photography as well as making and exhibiting it.

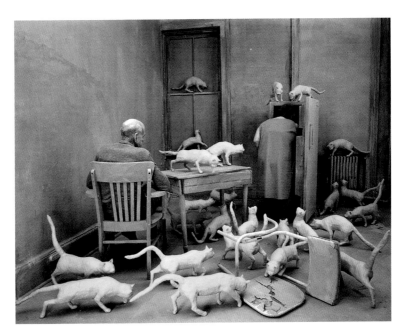

The allegorical arrangement of quotations and images brought
together by Iain Boal and Gene Ray—a constellation of "technocratic
utterances and instruments", as the authors put it—focuses on
social relations between modern science, capitalism, commodity
production, nuclear threat and war. The final essay, by Susan
Schuppli, investigates contact prints made from radiological objects.
Schuppli argues that a piece of 35 mm film shot by the Ukranian
filmmaker Vladimir Shevchenko while flying over Nuclear Reactor
Unit 4 at Chernobyl in 1986 may be the most radical contact print
of all. The emulsion of the film was pockmarked by the radioactivity
emitted from the reactor.

NOTES

1 Akira Mizuta Lippit addresses the nuclear optics of the visible and the invisible, and of visuality and "avisuality", by which he means the "profoundly unseen", in *Atomic Light (Shadow Optics)*, Minneapolis: University of Minnesota Press, 2005. See also Derrida, Jacques, "No Apocalypse, Not Now (Full Speed Ahead, Seven Missiles, Seven Missives)", *Diacritics* 14, no 2, summer 1984, pp 20–31; Derrida, Jacques, *The Gift of Death*, David Wills, trans, Chicago: University of Chicago Press, 1995; Virilio, Paul, *War and Cinema: The Logistics of Perception*, Patrick Camiller, trans, London: Verso, 1989; and Deutsche, Rosalyn, *Hiroshima After Iraq: Three Studies in Art and War*, New York: Columbia University Press, 2010. In Alain Resnais' film *Hiroshima mon amour*, 1959, a French women says to her Japanese lover, "I saw everything. Everything", to which he replies, "You saw nothing. Nothing." The notion of "deferred sight" in photography is discussed by Jayne Wilkinson in "Art Documents: The Politics of the Visible in the Work of Taryn Simon and Trevor Paglen", unpublished MA thesis, University of British Columbia, Vancouver, 2014.

2 Apart from ongoing displays at peace museums in Japan and shows organised by the Atomic Photographers Guild, exhibitions of nuclear photography have been rare. Two exhibitions accompanied by catalogues are: *Nuclear Half-Century—Witnesses Testify*, Hiroshima: Hiroshima Peace Memorial Museum, 1994; and *The Atomic Photographers Guild: Visibility and Invisibility in the Nuclear Era*, Toronto: Gallery TPW, 2001, organised by Blake Fitzpatrick and Robert Del Tredici. *In-Security: Le Dilemme Nucléaire*, organised in 2008 by the Musée International de la Croix-Rouge et du Croissant-Rouge in Geneva, had a significant online component.

3 One of the strips of film used by Rutherford in his radiation experiments is on display at the Rutherford Museum, McGill University, Montreal. *The Rutherford Museum of McGill University* guide, Montreal: McGill University, 1996, fig 8 and pp 8–9, presents a diagram of an apparatus with a photographic plate and explains how it worked. See also Heilbrun, JL, *Ernest Rutherford and the Explosion of Atoms*, New York: Oxford University Press, 2003. Some of photography's contributions to nuclear science are discussed in Peter Kuran, *How to Photograph an Atomic Bomb*, Santa Clarita, California: VCE, 2006, pp 11–19, and in Ferenc Morton Szasz, "The History of Atomic Photography", *Larger than Life: New Mexico in the Twentieth Century*, Albuquerque: University of New Mexico, 2006, pp 175–178.

4 Quoted in Landwehr, Gottried, "Wilhelm Röntgen and the Beginning of Modern Physics", *Röntgen Centennial: X-rays in Natural and Life Sciences*, Singapore: World Scientific, 1997, pp 7–8. In his last book, written while mourning the death of his mother, Roland Barthes insisted that *all* photographs traffic in the "what-has-been", and therefore in death. "Death is the *eidos* of [the] photograph", he wrote in *Camera Lucida: Reflections on Photography*, New York: Farrar, Straus and Giroux, 1981, p 15.

5 The most complete account of the bomb's development is by Richard Rhodes, *The Making of the Atomic Bomb*, New York: Simon and Schuster, 1986. See also Jungk, Robert, *Brighter Than a Thousand Suns: The Moral and Political History of the Atomic Scientists*, London: Victor Gollancz and Rupert Hart-Davis, 1958; and Fermi, Rachel, and Esther Samra, *Picturing the Bomb: Photographs from the Secret World of the Manhattan Project*, New York: Harry N Abrams, 1995.

6 Haber, Heinz, *The Walt Disney Story of Our Friend the Atom*, New York: Simon and Schuster, 1956, dust jacket. The book accompanied a film of the same name. Haber was a German nuclear scientist working for Disney.

7 Langer, Mark, "Why the Atom is Our Friend: Disney, General Dynamics, and the USS Nautilus", *Art History* 18, issue 1, March 1995, pp 63–96; and Rose, Kenneth D, *One Nation Underground: The Fallout Shelter in American Culture*, New York: New York University Press, 2001, pp 128–131.

8 A related yearly exercise, conducted by the US Federal Civil Defense Administration in the mid-1950s, was Operation Alert. It simulated nuclear attacks on cities throughout the country in the name of civil defence preparedness and informing the public about the risks of fallout. Newspapers produced special editions announcing the number of dead from the attacks in large print, with disclaimers in smaller print stating: "This Didn't Happen... But It Could!" Rose, *One Nation Underground*, pp 62–64.

9 The "V" stood for *Veltungwaffen*, or vengeance weapons. Von Braun could work for Disney, but Soviet President Nikita Khrushchev could not visit Disneyland. On a trip to Los Angeles in 1960, Khrushchev was denied entry on security grounds. The president was furious and asked if the United States was keeping "rocket-launching pads there".

Farish, Matthew, *The Contours of America's Cold War*, Minneapolis: University of Minnesota Press, 2010, p xi.

10 President Dwight D Eisenhower, unlike Walt Disney, mistrusted the creator of modern rocketry in the same way that he mistrusted Edward Teller, the Hungarian-born creator of the hydrogen bomb. "Beware Wernher von Braun and Edward Teller", he told his aides. Mckie, Robin, "Megaton Megalomaniac", review of *Edward Teller: The Real Dr Strangelove*, by Peter Goodchild, *Guardian Weekly*, 13–19 May 2004. See also Jacobsen, Annie, *Operation Paperclip: The Secret Intelligence Program that Brought Nazi Scientists to America*, Boston: Little Brown, 2013.

11 Hogerton, John F, ed, *Atoms for Peace: U.S.A. 1958*, New York: United States Atomic Energy Commission, 1958. The AEC commissioned the consulting firm Arthur D Little, Inc, to write the book.

12 Haber, *Our Friend the Atom*, p 160. The term "military industrial complex" was not coined until five years after the book was published, by President Eisenhower in his "Farewell Address to the Nation", 17 January 1961. See Griffin, Charles, "New Light on Eisenhower's Farewell Address", *President Studies Quarterly* 22, summer 1992: pp 469–479.

13 Derrida, Jacques, "Plato's Pharmacy", *Dissemination*, Barbara Johnson, trans, London: Athlone Press, 1981, pp 61–172, and "No Apocalypse, Not Now".

14 Lougheed, Tim, "Putting a New Spin on Some Old Physics", *TREK*, December 2013, pp 27–29.

15 Derrida, "No Apocalypse, Not Now", p 24.

16 The atomic bomb and the Cold War era have generated a large literature, but the discussion of nuclear imagery has been relatively modest. Some recent books and articles on nuclear-era imagery not mentioned above are: Jacobs, Robert A, *The Dragon's Tail: Americans Face the Atomic Age*, Amherst: University of Massachusetts Press, 2010; O'Brian, John, "On Photographing a Dirty Bomb", in *The Cultural Work of Photography in Canada*, Carol Payne and Andrea Kunnard, eds, Montreal: McGill-Queen's University Press, 2011, pp 182–194; o'Hara slavick, elin, *Bomb After Bomb: A Violent Cartography*, Milan: Edizioni Charta, 2007; and van Wyck, Peter C, *The Highway of the Atom*, Montreal: McGill-Queen's University Press, 2010.

17 Bourke-White's photo essay is titled "SAC: The Strategic Air Command Has Its Big Planes Ready for Intercontinental War", *Life* magazine, 27 August 1951. The B-36 bomber preceded the B-52 as the United States' principal carrier of strategic nuclear weapons.

18 Robin Kelsey spoke on "Making Photography into Public Memory" at a symposium on "The 'Public Life' of Photographs", organised by Thierry Gervais at Ryerson University, Toronto, 9–11 May, 2013. I am indebted to the symposium and to Kelsey's presentation.

19 Didi-Huberman, Georges, *Images in Spite of All: Four Photographs of Auschwitz*, Shane B Lillis, trans, Chicago: University of Chicago Press, 2008, p 23.

20 The Japanese word *hibakusha* translates as "bomb-affected people".

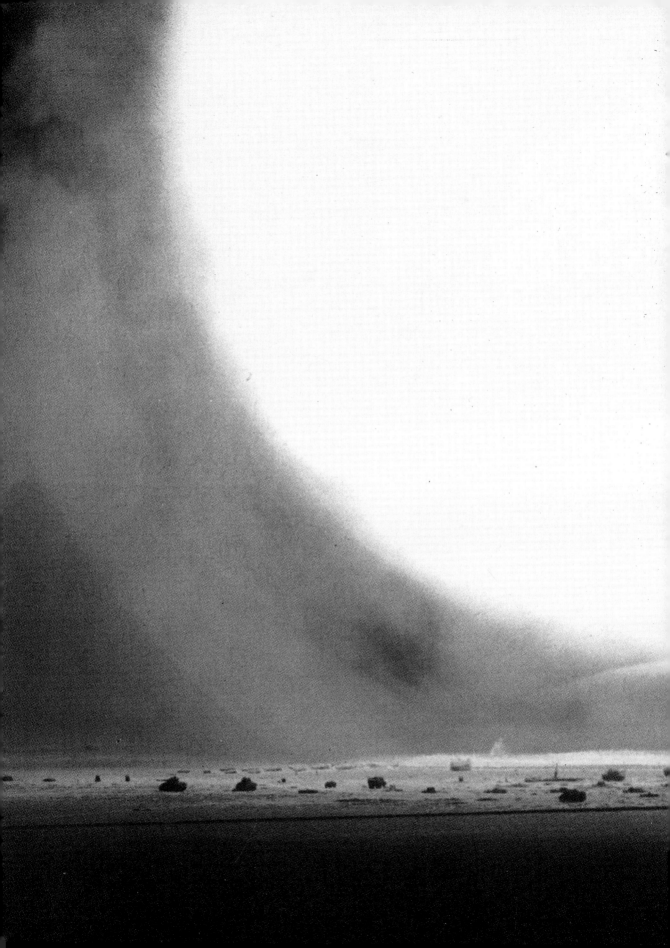

U.S. Military
White Atomic Fireball, Nevada Test Site, c 1950s

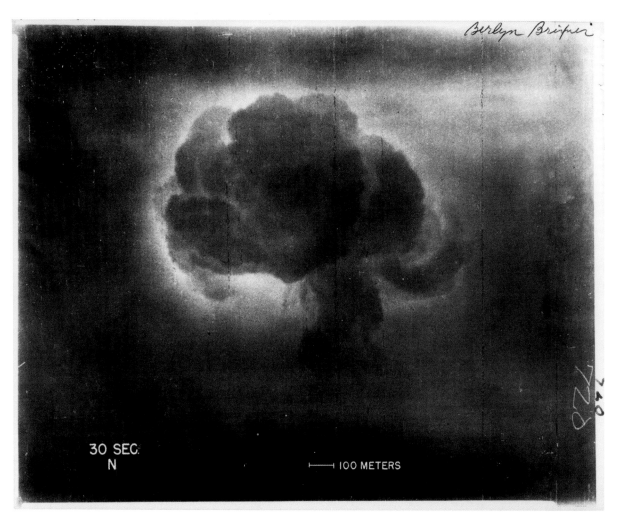

30 SEC
N

100 METERS

Berlyn Brixner
Trinity Test Explosion, 30 Seconds,
16 July 1945

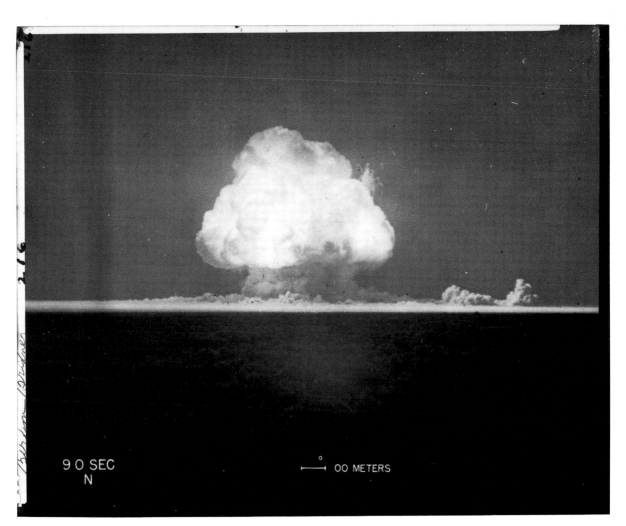

9 0 SEC
N

⊢———⊣ OO METERS

Berlyn Brixner
Trinity Test Explosion, 90 Seconds,
16 July 1945

Emmet Gowin
Minuteman III ICBM Silo Near Conrad,
Montana, 1989/91

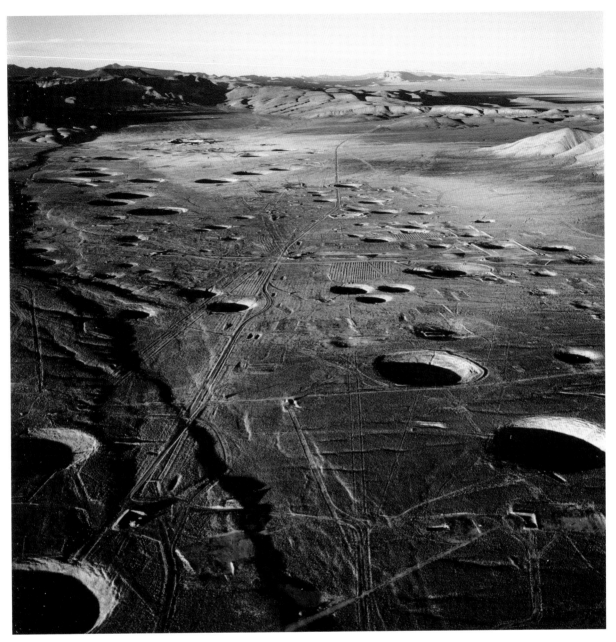

Emmet Gowin
Subsidence Craters, Northern End of Yucca Flat,
Nevada Test Site, 1996

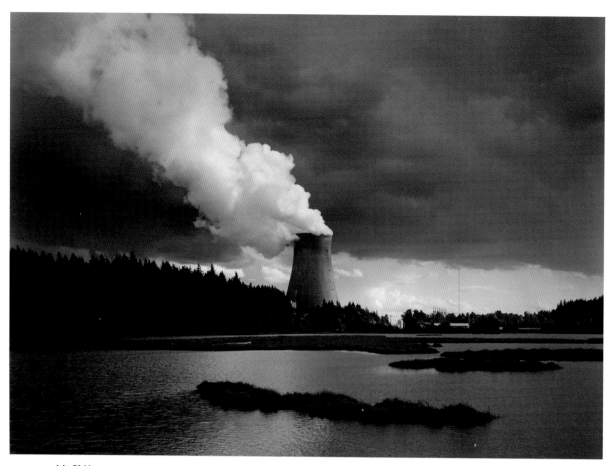

John Pfahl
Trojan Nuclear Power Plant,
Columbia River, Oregon, 1982

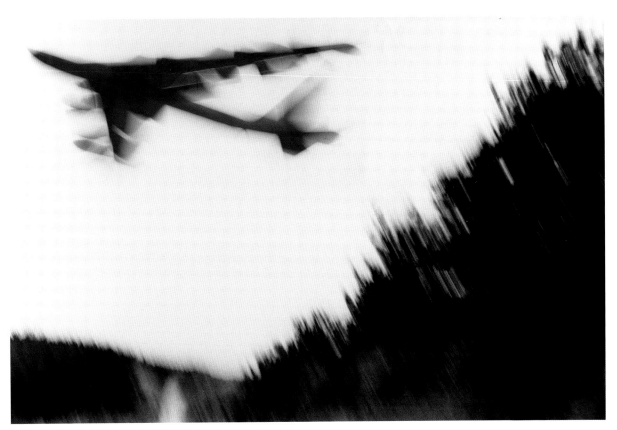

Shomei Tomatsu
*B-52 Taking Off from Kadew
Air Base*, 1960

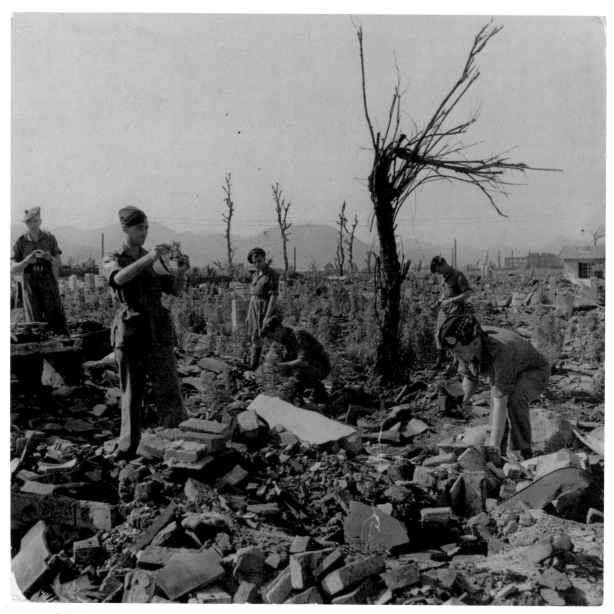

Unknown
Hiroshima, Japan, 1946

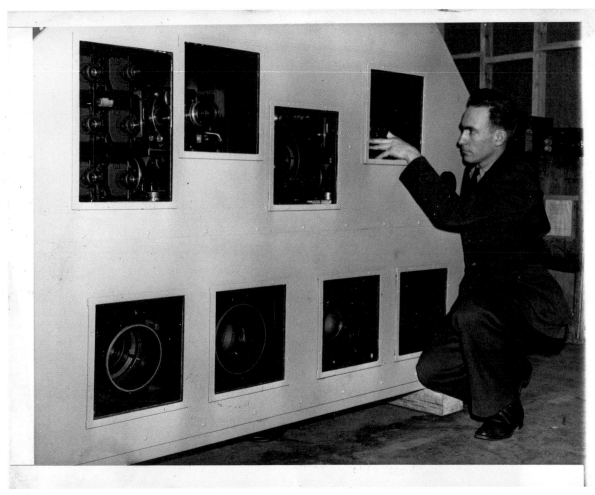

Associated Press
Chief Photographer John E. Richter
Preparing Radio-Controlled
Cameras to Be Used in Bikini
Atomic Bomb Tests, 1946

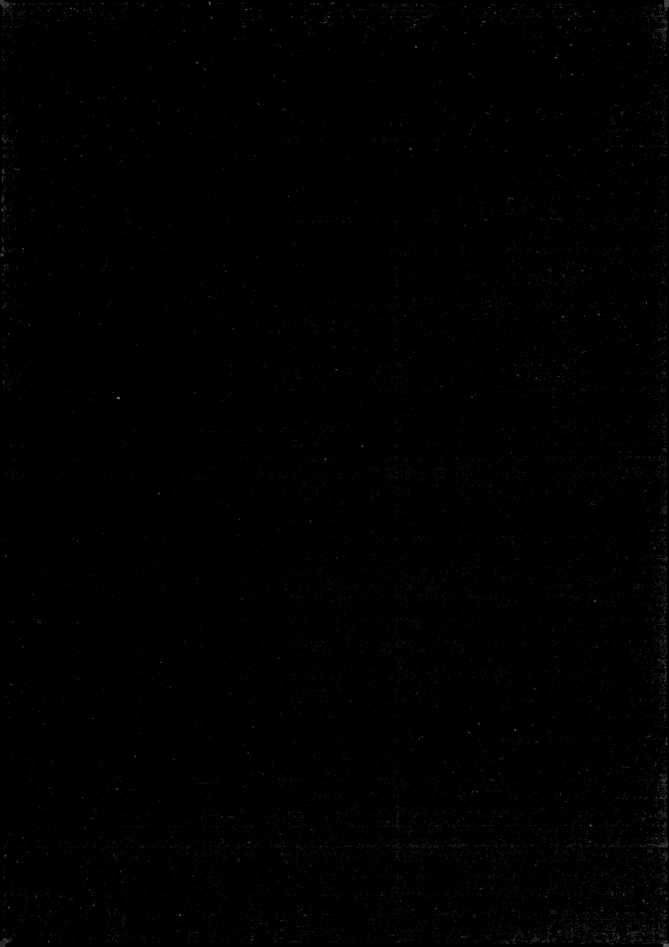

Test
and
Protest

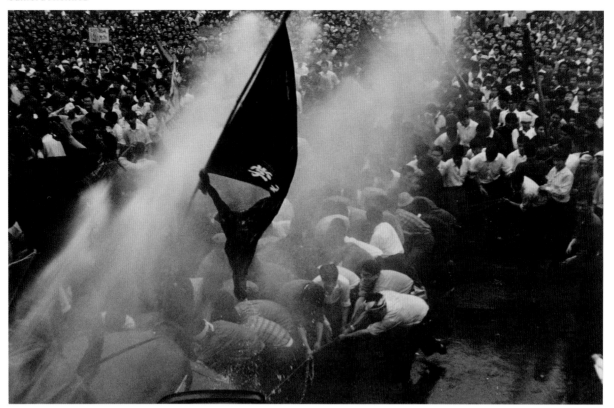

Hiroshi Hamaya
*The United States-Japan Security
Treaty Protest, Tokyo [Protestors
being attacked with water hoses.]*
Alternate Title: *Chronicle of Grief
and Anger*, 15 June 1960

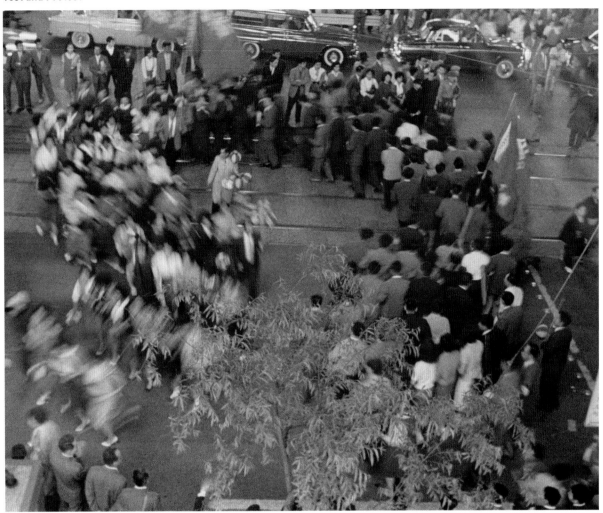

Hiroshi Hamaya
*The United States-Japan Security
Treaty Protest, Tokyo [Aerial view
of Japanese people marching
in a semi-circle in front of a row
of observers.] Alternate Title:
Chronicle of Grief and Anger,*
15 June 1960

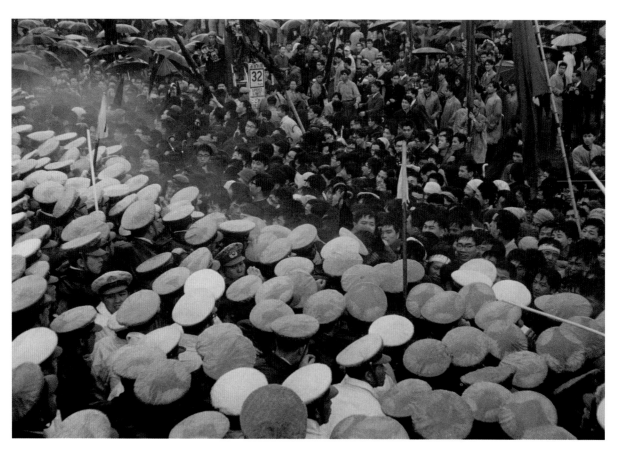

OPPOSITE TOP
Hiroshi Hamaya
*The United States-Japan Security
Treaty Protest, Tokyo [A crowd of
protestors being sprayed by a water
hose.]* Alternate Title: *Chronicle of
Grief and Anger*, 15 June 1960

OPPOSITE BOTTOM
Hiroshi Hamaya
*The United States-Japan Security
Treaty Protest, Tokyo [Police in
rain gear facing off with crowds
of protestors, some of whom
are drenched while others have
umbrellas.]* Alternate Title:
Chronicle of Grief and Anger,
20 May 1960

TOP
Hiroshi Hamaya
*The United States-Japan Security
Treaty Protest, Tokyo [Night time
view of flags being waved in front
of spot lights.]* Alternate Title:
Chronicle of Grief and Anger,
19 June 1960

Margaret Bourke-White
B-36 Bomber Flight Engineer,
Strategic Air Command, Carswell Air
Force Base, Texas, 1951

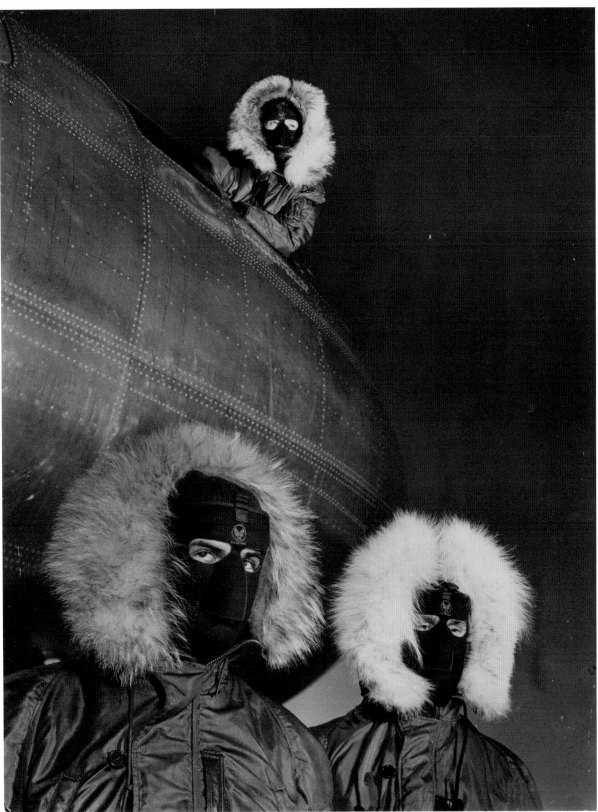

Margaret Bourke-White
Crewmen of B-36 Bomber Posing in
Artic Equipment [Greenland], 1951

Robert Del Tredici
First Foreign Journalists on
Novaya Zemlya, South Island,
15 October 1992

Robert Del Tredici
The Last Underground Explosion,
Semipalatinsk Test-Site,
Kazakhstan, **16 October 1991**

TOP
Robert Del Tredici
*H-Bomb Lake, Semipalatinsk Test
Site, Kazakhstan,* 16 October 1991

BOTTOM
Robert Del Tredici
*Maids of Muslyumovo, Chelyabinsk
Region, Russia,* 23 May 1991

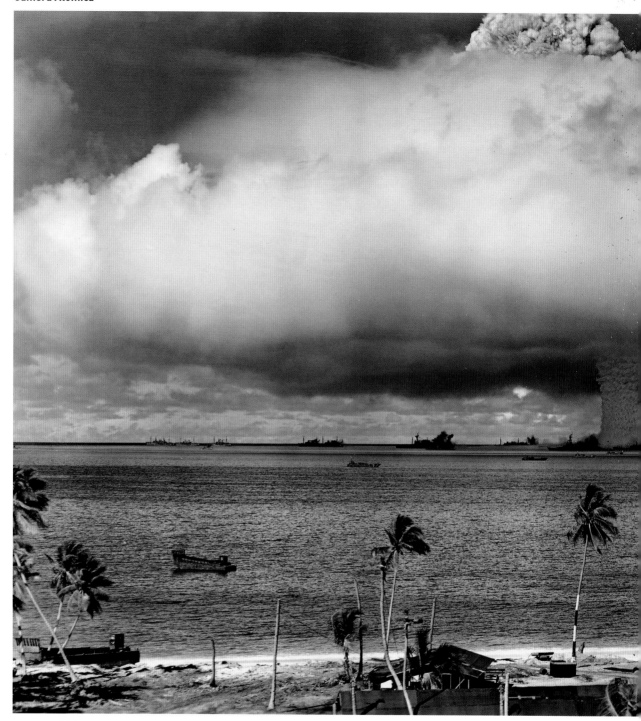

U.S. Army Photographic Signal Corps
Test Baker, Operation Crossroads,
Bikini Atoll, 1946

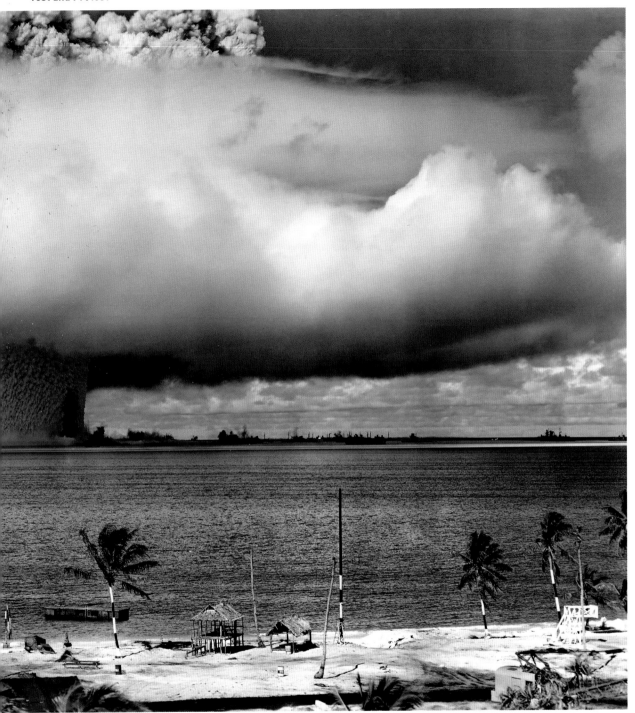

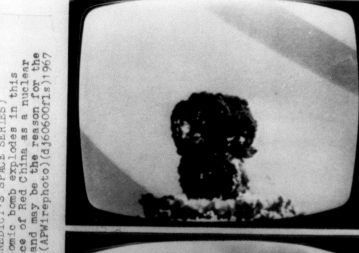

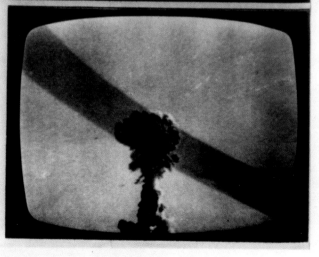

(FOR USE IN WEDNESDAY PMS, JULY 12, WITH PART THREE OF HOWARD BENEDICT'S SPACE SERIES) (NY2-July 7)CHINA EXPLODES ITS ATOMIC BOMB--Communist China's atomic bomb explodes in this sequence of pictures taken from Japanese television. The emergence of Red China as a nuclear power is forcing the United States to re-evaluate its position, and may be the reason for the development of at least a limited antiballistic missile system. (APWirephoto)(dj60600fls)1967

AP Wirephoto
Chinese Atomic Test, 1967

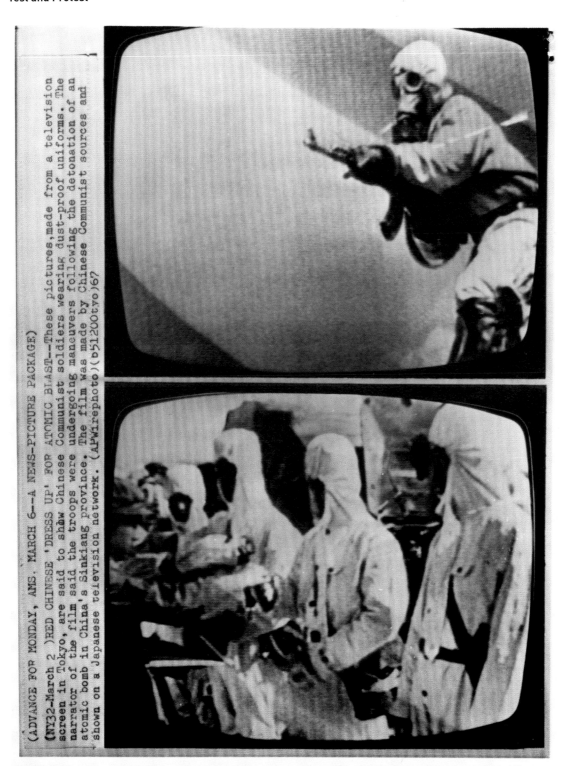

(ADVANCE FOR MONDAY, AMS. MARCH 6--A NEWS-PICTURE PACKAGE)

(NY32-March 2)RED CHINESE 'DRESS UP' FOR ATOMIC BLAST--These pictures,made from a television screen in Tokyo, are said to show Chinese Communist soldiers wearing dust-proof uniforms. The narrator of the film said the troops were undergoing maneuvers following the detonation of an atomic bomb in China's Sinkiang province. The film was made by Chinese Communist sources and shown on a Japanese television network. (APWirephoto)(b5l200tyo)67

AP Wirephoto
*Chinese Soldiers Wearing Anti-
Radiation Gear*, 1967

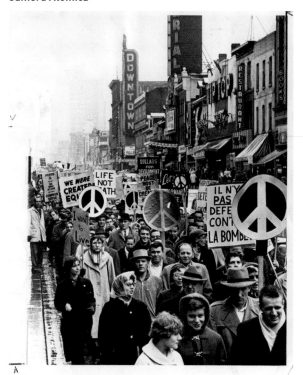

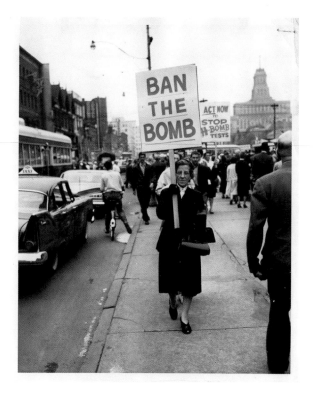

TOP LEFT
Frank Grant
Ban the Bomb Protest, Toronto,
4 November 1961

TOP RIGHT
Proulx
Woman with Ban the Bomb Sign,
2 July 1959

BOTTOM
Pete Ward
Ban the Bomb Protest Signs, Toronto,
11 April 1961

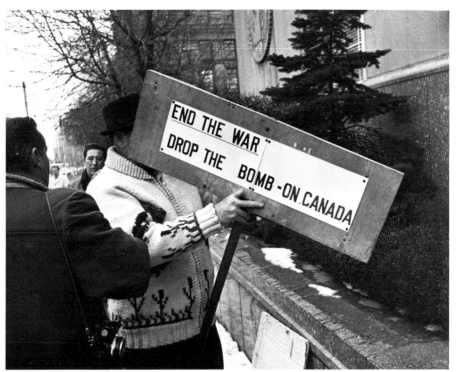

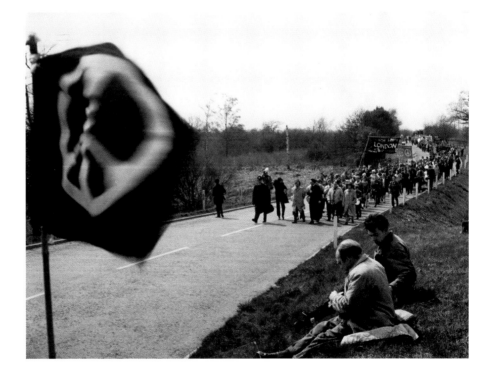

TOP
Pete Ward
*Demonstration Outside U.S.
Consulate, Toronto,*
16 January 1967

BOTTOM
London Express News
*Aldermaston March with Peace
Flag in Foreground,* 14 May 1962

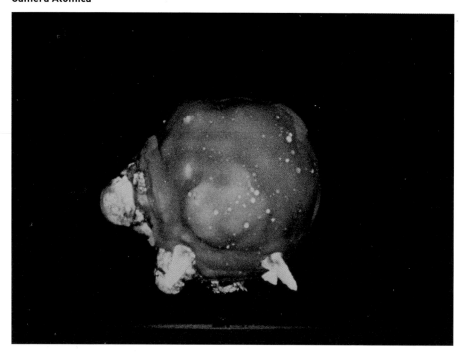

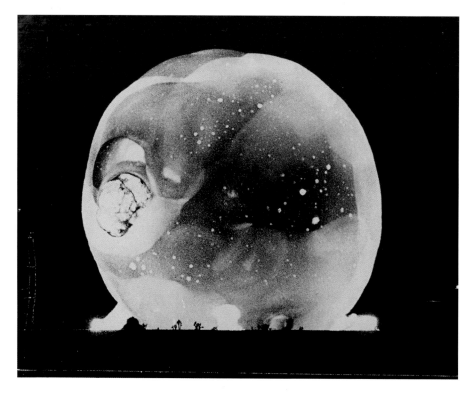

TOP
Harold Edgerton
Rapatronic Photograph of Atomic Test, c 1950s

BOTTOM
Harold Edgerton
Rapatronic Photograph of Atomic Test, c 1950s

OPPOSITE
Harold Edgerton
Rapatronic Photograph of Atomic Test, c 1950s

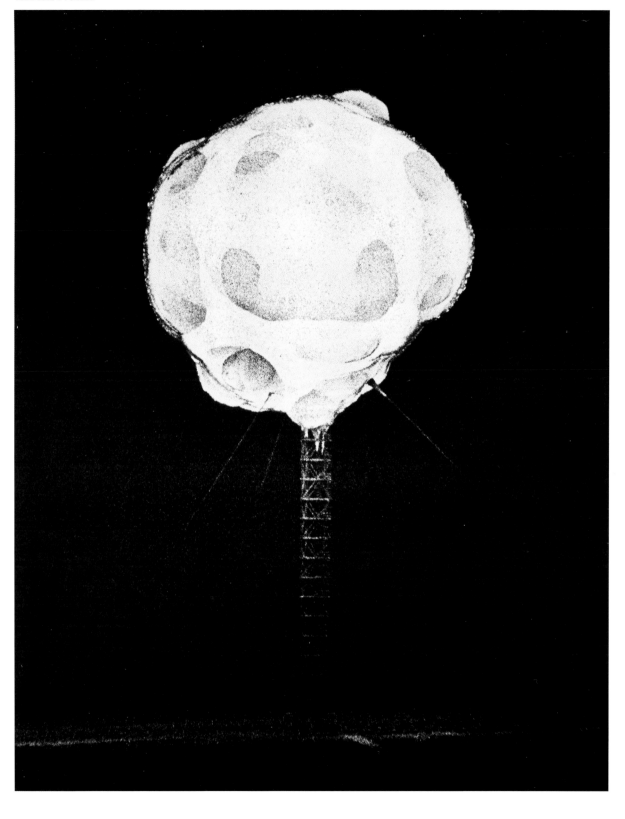

OPPOSITE
Jin Hai
Shi jie zhi shi chu ban she
[The Making of the Atomic Bomb], 2005

金孝 著

原子弹演义

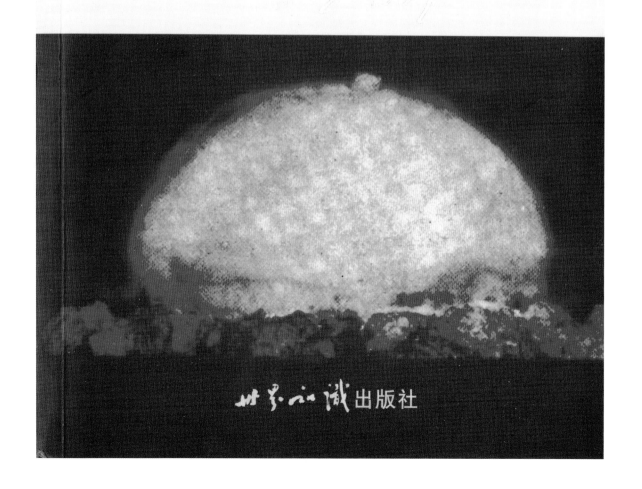

世界知识出版社

Richard Misrach
Princesses Against Plutonium,
Nuclear Test Site, Nevada, 1988

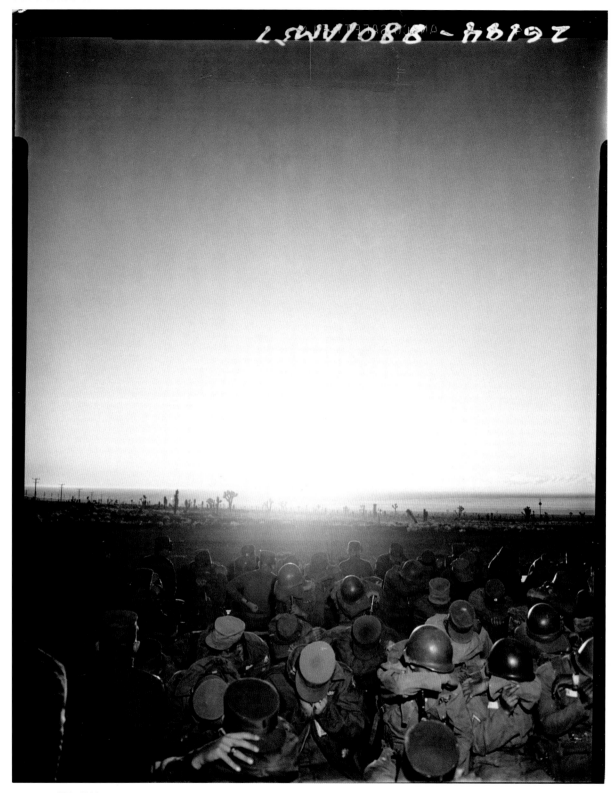

Michael Light
100 SUNS: 008 STOKES/19 Kilotons/
Nevada/1957, 2003

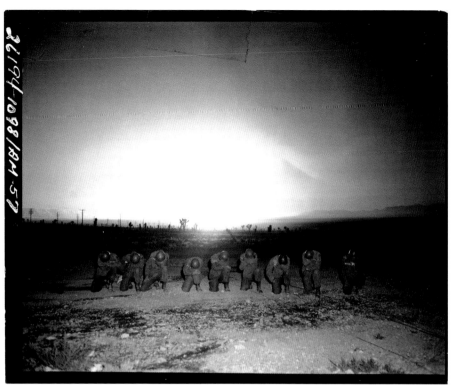

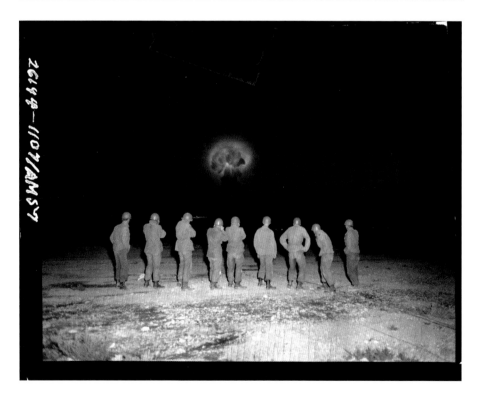

Michael Light
100 SUNS: 023, 024 SMOKY/
44 Kilotons/Nevada/1957, 2003

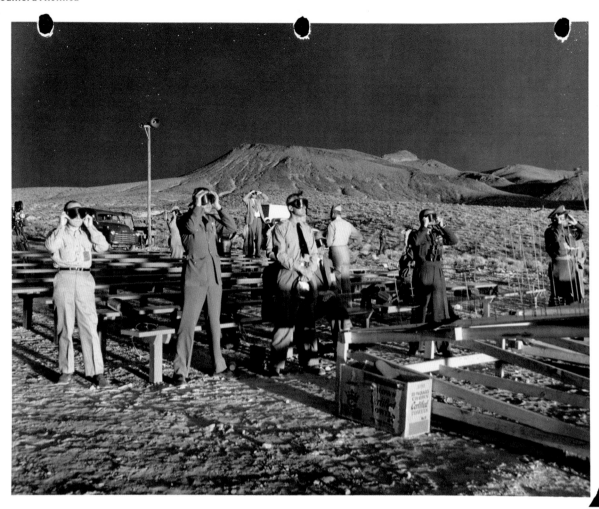

Michael Light
100 SUNS: 037 ZUCCHINI/28 Kilotons/
Nevada/1955, 2003

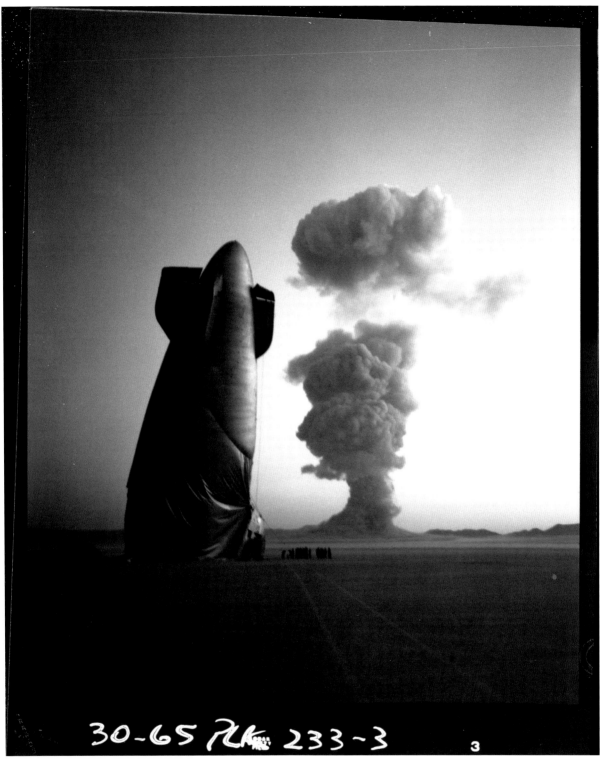

30-65 RK 233~3 3

Michael Light
100 SUNS: 045 STOKES/19 Kilotons/
Nevada/1957, 2003

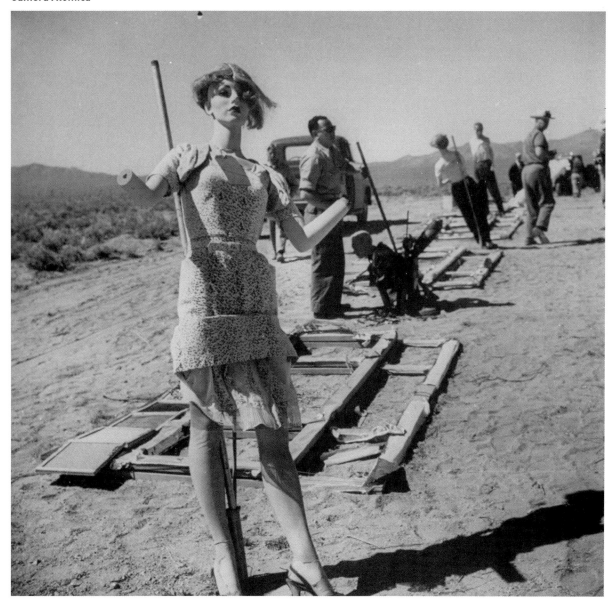

Loomis Dean
*Unburned female mannequin with
wig askew is wearing light-colored
dress that absorbs less heat from
atomic bomb blast, Yucca Flat,
Nevada,* 1 May 1955

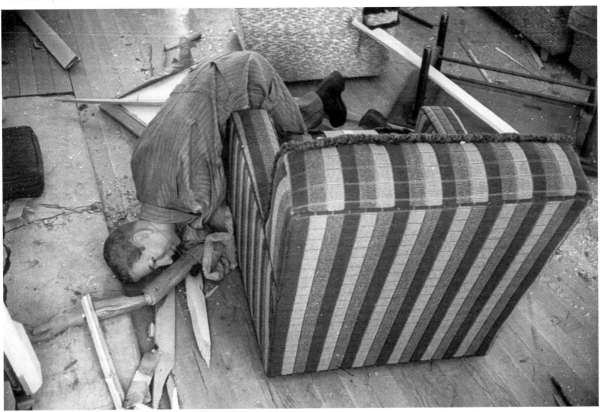

Loomis Dean
*Fallen mannequin in house 5,500 feet
from bomb is presumed dead, Yucca
Flat, Nevada,* 1 May 1955

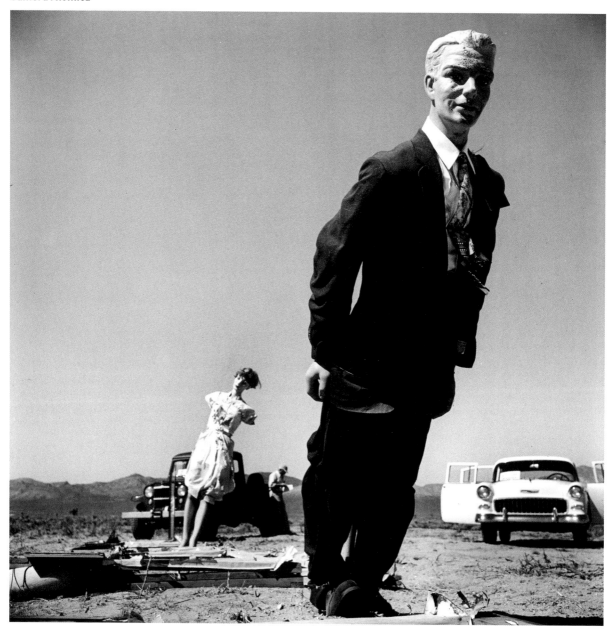

Loomis Dean
Scorched male mannequin wearing
dark suit indicates a human would
be burned by atomic bomb blast but
alive, Yucca Flat, Nevada, 1 May 1955

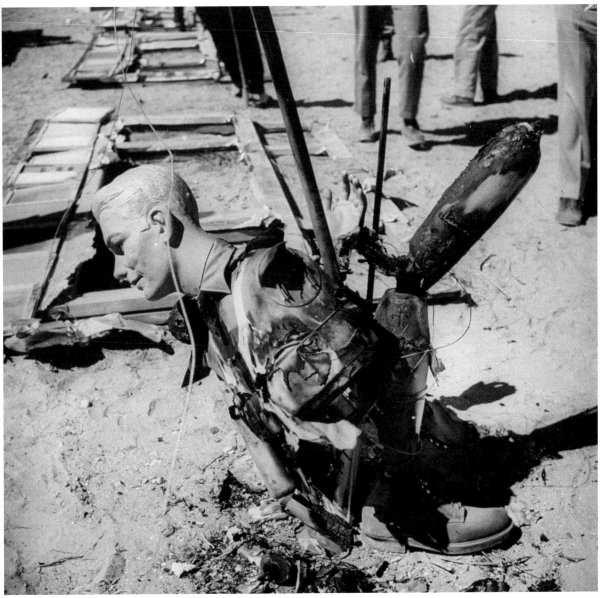

Loomis Dean
*Burned up except for face, this
mannequin was 7,000 feet from
atomic bomb blast, Yucca Flat,
Nevada, 1 May 1955*

Philippe Chancel
*Arirang Series, DPRK (Democratic
People's Republic of Korea)*, 2006

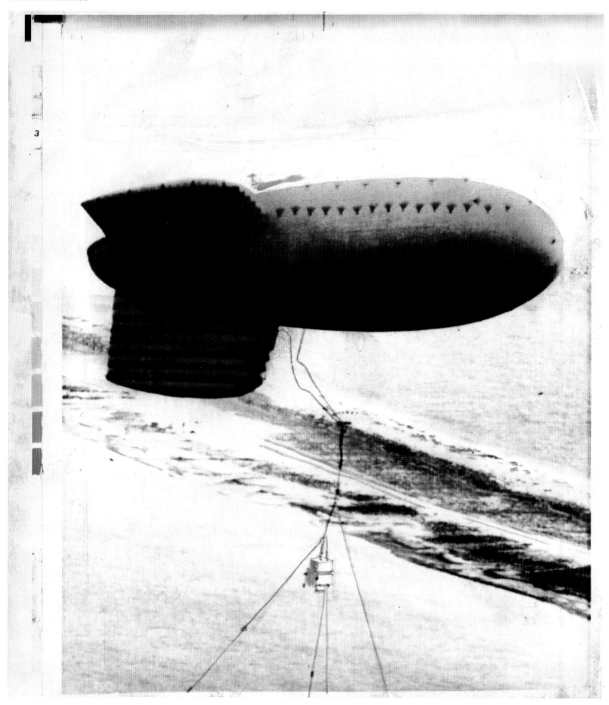

Associated Press
*French Atomic Bomb Suspended
from an Airship, Mururna, South
Pacific*, July 1971

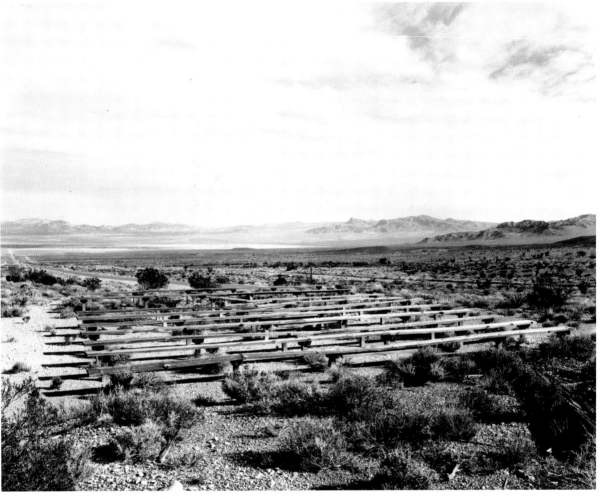

Mark Ruwedel
The Witnesses (1), Nevada Test Site:
Viewing Area for 14 Atmospheric Tests,
at Frenchman Flat, 1951–1962, 1995

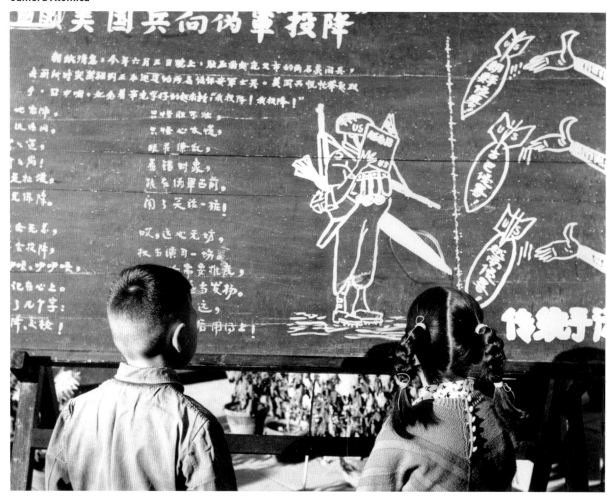

TOP
Richard Harrington
*Beijing, China (Children Reading Anti-
American Sign)*, 1966

OPPOSITE
Richard Harrington
*Beijing, China (Movie Billboard with
Mushroom Cloud and Soldier Wearing
Anti-Radiation Gear)*, 1966

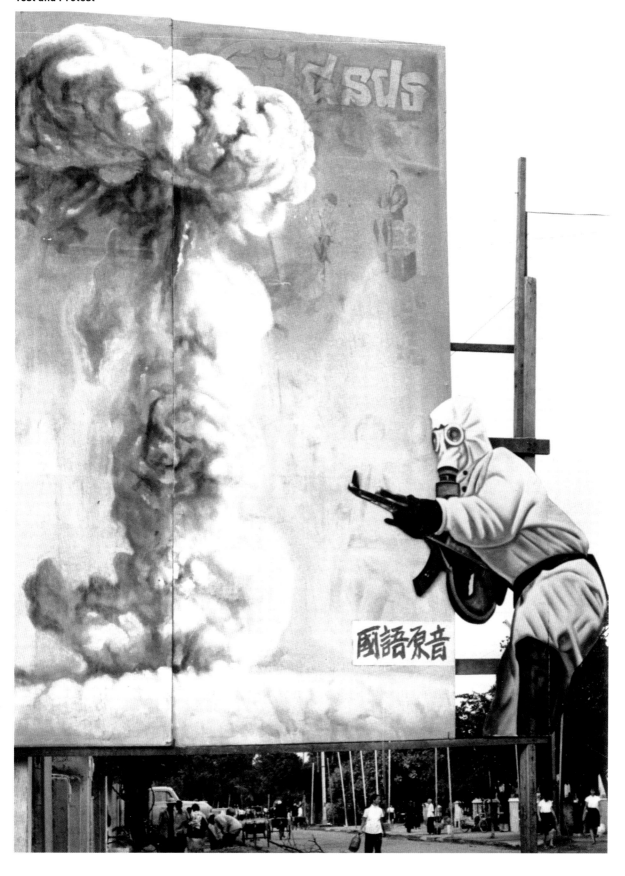

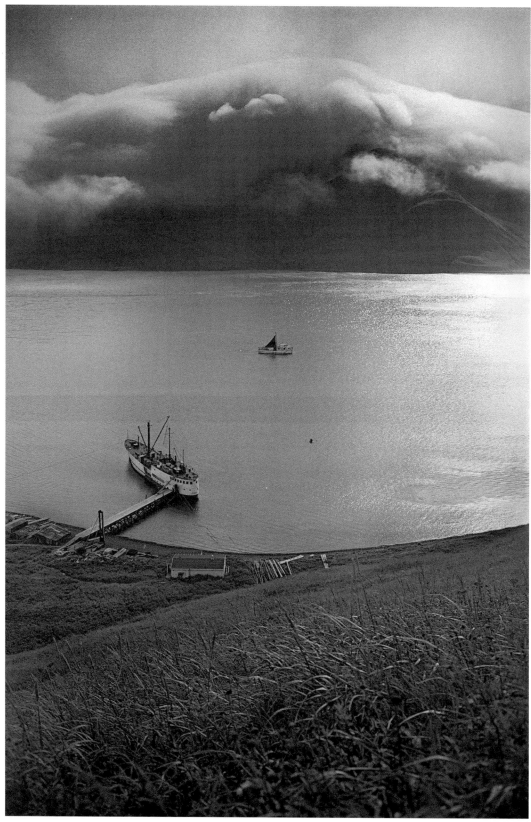

Robert Keziere
The Greenpeace Anchored in Akutan Bay,
Alaska, 1971

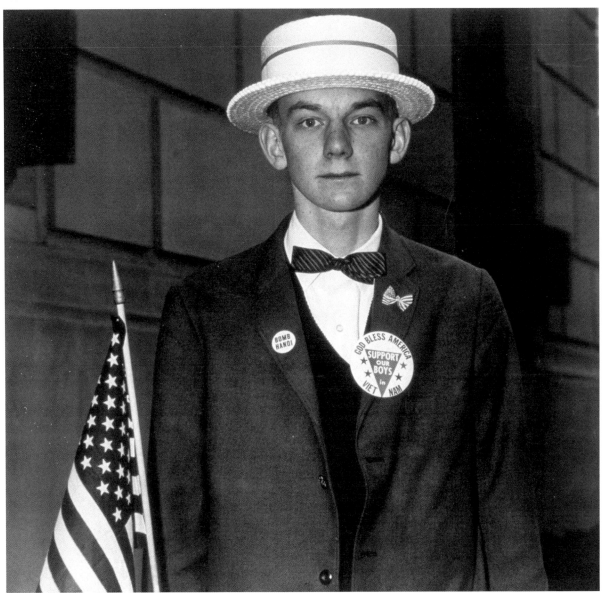

Diane Arbus
A Boy with Straw Hat and Flag
About to March in a Pro-War
Parade, New York, 1967

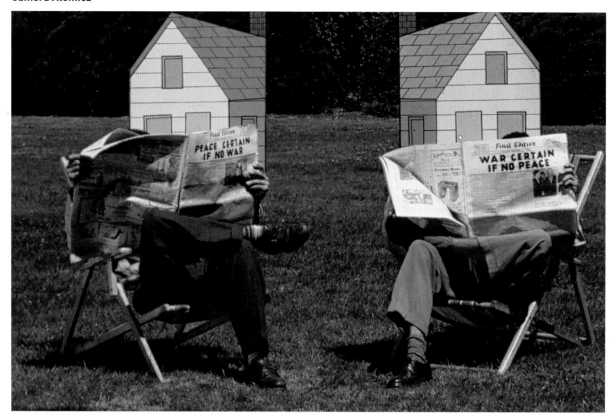

Norman McLaren
Still image from *Neighbours/
Voisins*, 1952

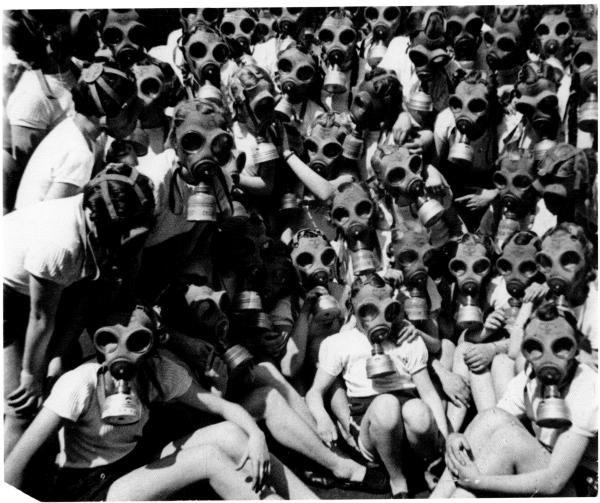

Neustadt
*German children during a gas
mask drill*, after 1945

Robert Frank
Hoover Dam, Nevada, 1955

Los Alamos National Laboratory
*Fireball, Test Mohawk, Operation
Redwing*, 1956

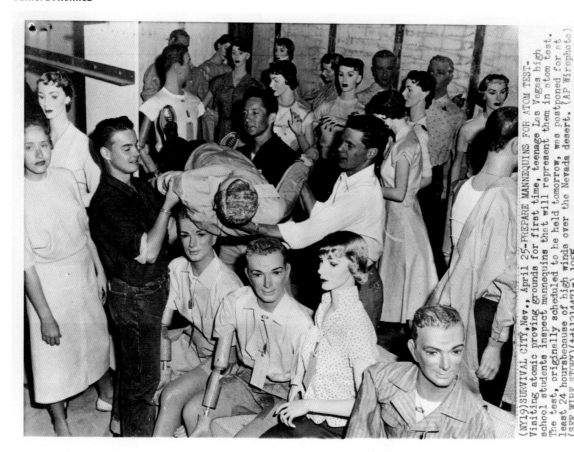

(NY19)SURVIVAL CITY,Nev., April 25.-PREPARE MANNEQUINS FOR ATOM TEST-Visiting atomic proving grounds for first time, teenage Las Vegas high school students inspect mannequins that will represent them in atom test. The test, originally scheduled to be held tomorrow, was postponed for at least 24 hoursbecause of high winds over the Nevada desert. (AP Wirephoto) (SEE WIRE STORY)(tdil214471v) 1955

AP Wirephoto
*Las Vegas High School Students
Prepare Mannequins that Will
Represent Them during a
Nuclear Test,* 25 April 1955

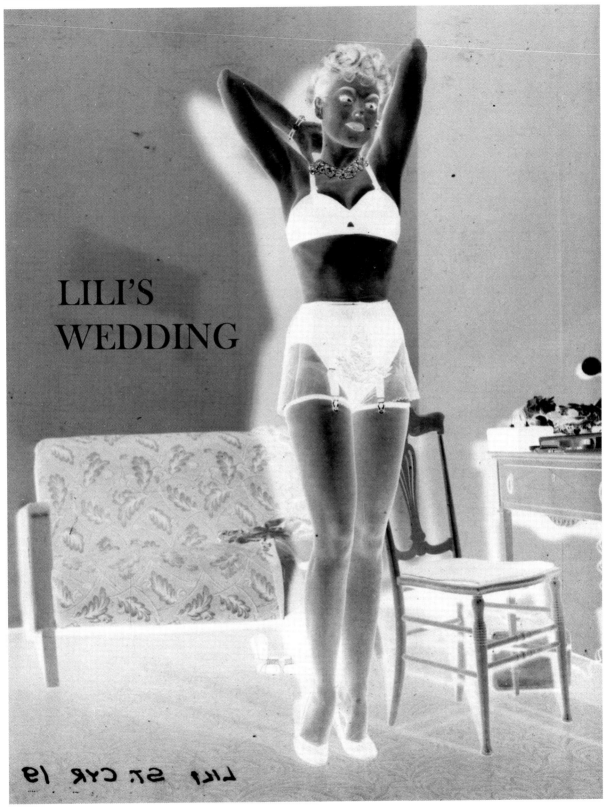

Mark Ruwedel
Lili's Wedding (back cover), 2007

Nuclear Flowers of Hell

John O'Brian

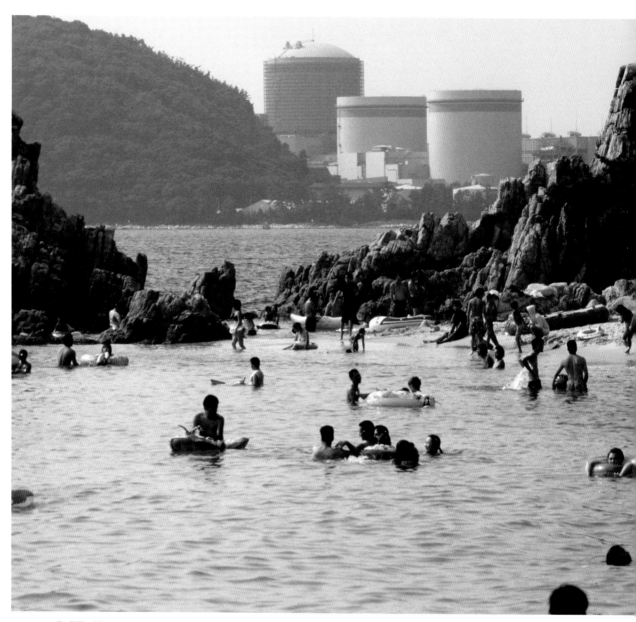

Kenji Higuchi
A Beautiful Day at Crystal Beach,
Mihama Bay, August 2004

"Nuclear explosions are beautiful", she said. "At a distance."
Elizabeth Hay, *Garbo Laughs*

Threats caused by advanced technology on the scale of nuclear devastation, climate change and species extinction have exposed a fault line between past industrial society and present techno-scientific society.[1] The fault line has sometimes been made visible through photography, as in Kenji Higuchi's *A Beautiful Day at Crystal Beach, Mihama Bay*, where swimmers are seen bathing in the shadow of a nuclear power plant. In industrial society, it was possible to evaluate the positives and negatives of technological advancement more or less accurately, but in techno-scientific society it is not. The Mihama Nuclear Reactor Plant, when operating, releases radioactive water into the sea, a low-level discharge the nuclear industry claims is harmless.[2] Although radiation cannot be tasted, touched, smelled or seen, even at low levels it is potentially destructive. Since the Second World War, science has been unable to predict or control its effects. Beginning with the Manhattan Project, the existential hazards associated with atomic weapons and nuclear energy have been consistently minimised by "techno-scientifico-militaro-diplomatic" authorities, as Jacques Derrida calls them, and hidden from public scrutiny.[3] An official at the Pantex nuclear weapons assembly plant in Amarillo, Texas, stated in the early 1980s, when the Cold War was intensifying during Ronald Reagan's presidency, that handling warheads was "Just like pickin' up a box of Silly Putty in a dime store."[4] He did not say what might happen if one of the warheads had a defective part.

Other threats to species extinction and the impact of climate change have been similarly minimised. In her 1962 book *Silent Spring*, Rachel Carson warned of the indiscriminate use of toxic chemicals. Arguing that there were limits to technological progress, she called for a ban on the production of DDT, a pesticide that was destroying the natural world, she said, as surely as nuclear weapons had destroyed Hiroshima and Nagasaki. "Chemicals are the sinister and little-recognized partners of radiation", she declared.[5] In techno-scientific circles, Carson's message was met with hostility and denial—an excess of hostility and denial, given the force of her research.[6]

Nuclear photography, like the nuclear era itself, is haunted by questions of excess. To understand how atomic representation has shaped public attitudes and memory, I want to consider the surplus production of mushroom cloud imagery since the end of the Second World War through two early images, one from the Nagasaki bombing in 1945 and the other from Test Baker at Bikini Atoll, then a Trust Territory of the United States, in 1946.[7] The flash-and-bang imagery of mushroom clouds and fireballs, I will argue, has separated the spectacle from the socially produced environment in which it has occurred. The imagery has generated more noise than signal.[8] "Our mental picture of the Bomb", writes Robert Del Tredici in *At Work in the Fields of the Bomb*, "includes

the distant mushroom cloud, a city turned to ash, rockets in the atmosphere, the tapered cone—icons worn smooth by time and use."[9] Del Tredici's photographs offer an alternative to the spectacle and its normalisation. In addition to photographs of atomic workers

U.S.M. Corp. Atomic Power Dept.
DEFECTIVE PART

Part Name_____Quantity_____
Part Number_____
Defect:_____

Date_____ _____ Insp.
USE OTHER SIDE FOR REWORK INSTRUCTIONS.

APD.-QC 9

U.S.M. Corporation Atomic Power Deptartment
Label for a Defective Part, c 1960

and their workplaces—uranium mines, ore processing plants, research laboratories, factories, nuclear power stations—it contains published interviews with workers involved in activities that range from mining to manufacturing to nuclear physics.[10] *At Work in the Fields of the Bomb* focuses on the "Yellowcake Road", which is named for the colour of the concentrate obtained by processing uranium ore after it has been mined but before enrichment. The Yellowcake Road that leads from the uranium mine to the mushroom cloud is far less vivid in the public imagination than the Yellow Brick Road that leads from Kansas to the Emerald City. Neither road is paved with real gold, but Dorothy and her companions made theirs glitter.

After the bombing of Hiroshima and Nagasaki in 1945, the mushroom cloud became the dominant icon of the atomic age, its most extravagant figurehead. Every part of the globe was stamped with its image through photographs and imprinted with a spectacle of mass destruction.[11] Photographs taken during the attacks of 6 and 9 August made the mushroom cloud instantly recognisable, and the atomic tests conducted by the United States at Bikini Atoll and in Nevada following the end of the Second World War made it a staple of the mass media and popular culture.[12]

The first mushroom cloud produced by an atomic bomb, which did not acquire its "mushroom cloud" moniker immediately, rose from the desert floor at the Trinity test site in Alamogordo, New Mexico, in the early hours of the morning on 16 July 1945. Upon witnessing the explosion, the theoretical physicist J Robert Oppenheimer, sometimes called the father of the atomic bomb for his role in its development, famously (and pompously) declared, "I am become Death, the destroyer of worlds", while speaking in front of a motion-picture camera recording the event.[13] A photograph of a statue of Oppenheimer, taken by Barbara Norfleet at the Bradbury

Robert Del Tredici
*Cooling the Derby and Sampling
the Derby,* from the book *At Work
in the Fields of the Bomb,* 1987

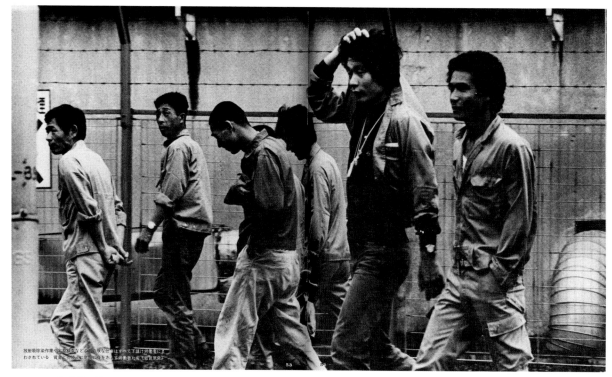

Kenji Higuchi
Subcontract workers, Tsuruga nuclear power plant,
Fukui Prefecture, July 1977, from the book Photo
Document: Japan's Nuclear Power Plants, 1979

Science Museum in Los Alamos, transmutes the scientist into a metaphorical pillar of salt capped by his signature porkpie hat.[14] Norfleet's camera freezes Oppenheimer against a black background, making it look as if he has just gazed upon the forbidden and paid a biblical price for his transgression.

The iconography of nuclear explosions began with the Trinity explosion, where photographers took at least 100,000 photographic exposures of the test.[15] At laboratories in Los Alamos, Julian E Mack and Berlyn Brixner designed specialised cameras for recording the detonation and scientifically measuring the blast yield of the weapon. Some of the photographs record the exact moment of their execution down to a fraction of a split second, which is recorded on the prints. Nuclear testing and the development of increasingly sophisticated camera and film equipment to document what otherwise could not be recorded went hand in hand.[16] A photograph taken during preparations for the first Bikini test, for example, shows the mounting of dual movie cameras in the nose of an observation aircraft. "The technologies of cinema and warfare have developed a fatal interdependence", observes Paul Virilio, the French theorist of speed, technology and warfare.[17] An extreme version of this

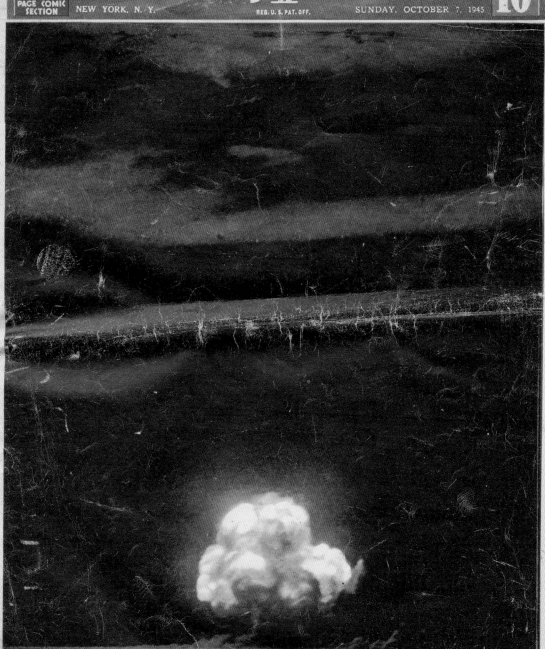

Jack Aeby (U.S. Army)
Atomic Bomb Burst That Changed the World:
First Color Photo, 16 July, 1945, 7 October 1945

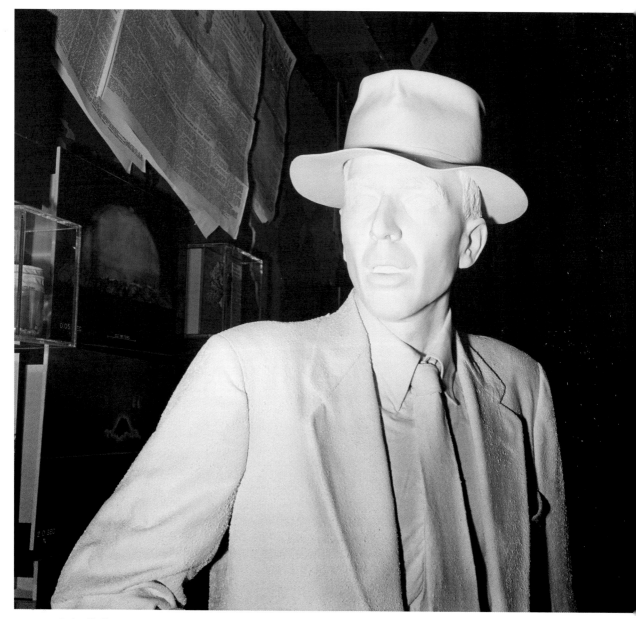

Barbara Norfleet
*Dr. J. Robert Oppenheimer, Bradbury Science
Museum, Los Alamos*, 1988

interdependence was produced by the atomic "flash" at Hiroshima, where the violent excess of light and heat from the explosion caused images of bodies to be imprinted on the steps and walls of the city. In her essay "Radical Contact Prints", Susan Schuppli writes that these radiographic prints—literally atomic shadows—"document life at the very moment of death".[18] A survivor described the Hiroshima sky after the explosion as being "filled by a garish light which resembles the magnesium light used in photography".[19]

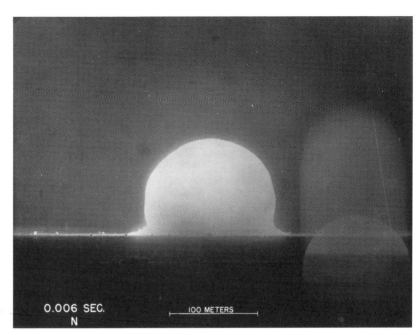

Berlyn Brixner
Trinity Test Explosion, 0.006 Seconds, 16 July 1945

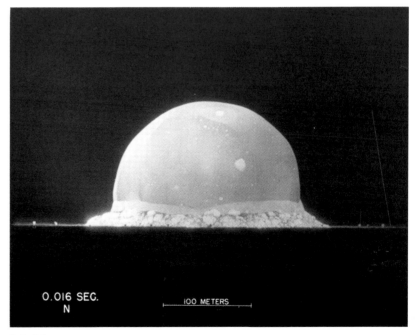

Berlyn Brixner
Trinity Test Explosion, 0.016 Seconds, 16 July 1945

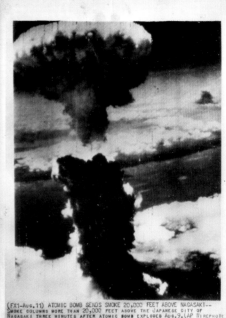

(FX1-Aug.11) ATOMIC BOMB SENDS SMOKE 20,000 FEET ABOVE NAGASAKI--
SMOKE COLUMNS MORE THAN 20,000 FEET ABOVE THE JAPANESE CITY OF
NAGASAKI THREE MINUTES AFTER ATOMIC BOMB EXPLODED Aug.9.(AP WIREPHOTO
FROM STRATEGIC AIR FORCES VIA NAVY RADIOPHOTO, GUAM)(NRW/1000AAF/PL)
1945

LEFT
Associated Press
*Lieutenant T.H. Martin Mounting
Dual Movie Camera in the Nose of a
B-29 Bomber, Bikini Atomic Bomb
Tests,* 1946

RIGHT
AP Wirephoto
*Atomic Bomb Sends Smoke 20,000
Feet Above Nagasaki,* 9 August 1945

The most immediately recognisable of all mushroom cloud photographs came from the "Fat Man" plutonium bomb dropped on Nagasaki. It exists in multiple versions and constitutes the first of my primary examples.[20] The version released to the press was a two-tone, two-tier image taken from the air minutes after the detonation, as the caption states, and then rapidly circulated around the globe as a wirephoto. The upper part of the cloud contrasts sharply with the dark column of smoke and debris that forms the lower part, and is separated from it by a slender gap The gap is highly charged, like the gap in Michelangelo's ceiling fresco in the Sistine Chapel between God's forefinger and the hand of Adam, but whereas Michelangelo's fresco represents the creation of life the Nagasaki photograph represents the destruction of it. The relationship between generative and destructive power is also the subject of a poem by William Carlos Williams.[21] In "Asphodel, That Greeny Flower", Williams reflects on the correlation between the mushroom cloud as a blooming flower and the mushroom cloud as a bloom of death.[22] "The bomb/also/is a flower", he writes, aware that in classical times asphodels were associated with mourning and death. Asphodels were flowers of hell.

The gap separating the light and dark components of the Nagasaki image, referred to as a signature feature by those who make a specialty of studying mushroom cloud iconography, makes it unlike any other atomic image. But this has not prevented the photograph from being identified with the explosion that took place three days earlier at Hiroshima.[23] Because Hiroshima and

Awatani (Kyoto)
The Atomic Cloud, c 1945–1946

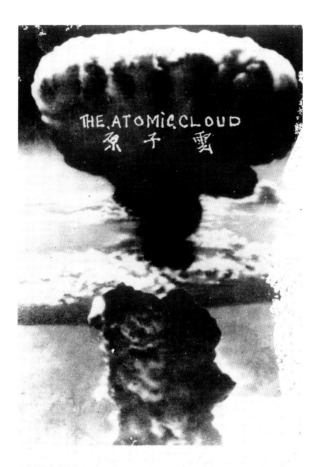

Nagasaki are often spoken of as a single event, and because the attack on Hiroshima preceded that on Nagasaki, the sibling cities are frequently conflated into one word. "Hiroshima" has become a sign for both. Soon after the war, the Kyoto publisher Awatani printed a postcard of the Nagasaki cloud with an inscription, "The Atomic Cloud", written across it in English and Japanese.[24] The postcard alludes to both Hiroshima and Nagasaki without naming either. It also miniaturises what is pictured. By encouraging audiences to view the explosion as a hold-in-the-hand spectacle, the postcard domesticates the bomb. *The Atomic Cloud*, like other postcard images of disastrous events, tames the catastrophe.[25]

In addition to being sold for touristic purposes, a version of the Nagasaki mushroom cloud was used by the US Army Air Force to commemorate the event. A deluxe presentation album containing 23 tipped-in photographs—one shy of the number found in a standard roll of film—includes the Nagasaki image. The image is horizontal in format and shows a section of the wing of the observation plane from which it was taken. Written across the top of the wing, which is represented in the lower right-hand corner, is the photograph's identification number, "AEC-51-40128 58381 A.C.". The

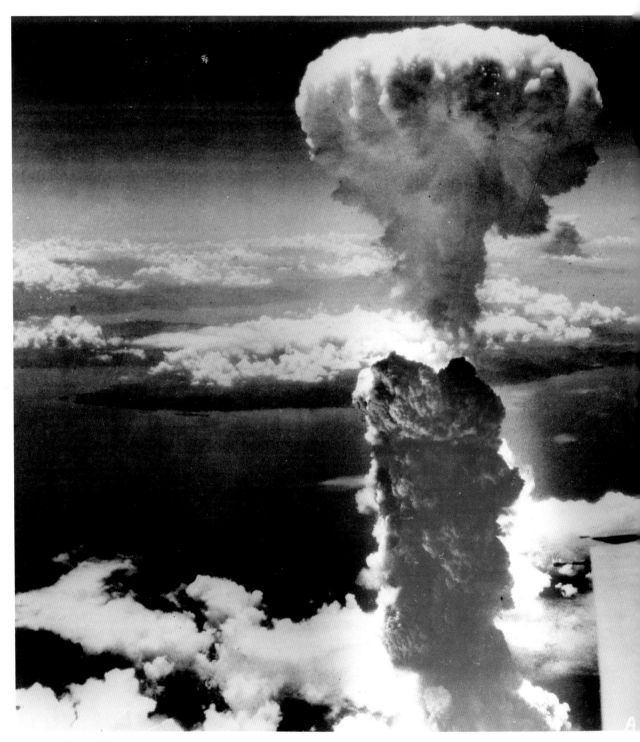

U.S. Army Air Force
*Presentation Album of Original Photographs of
the Bombing Missions on Hiroshima and Nagasaki
[Nagasaki Mushroom Cloud]*, 9 August 1945

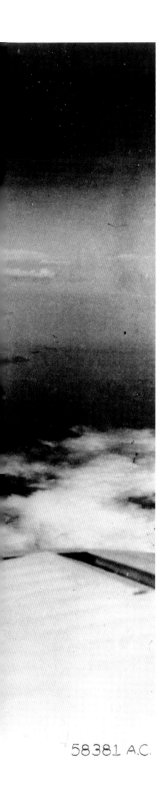

58381 A.C.

overlapping of text and wing is no doubt coincidental but serves to emphasise, as other photographs of the Nagasaki mushroom cloud do not, the connection between the interior of aircraft, where an anonymous photographer was aiming his camera out the window, and the exterior of the aircraft, where a megaton explosion had destroyed a city. Here the act of photographing the mushroom cloud and the act of detonating the bomb align.[26] A military aircraft delivered the nuclear weapon, another military aircraft delivered the photograph.

Four other varieties of subject matter appear in the album. In addition to mushroom clouds, the photographs depict the target areas viewed from the air (ten images); the B-29 bombers used to reach the targets from their base on Tinian Island, 2,500 kilometres to the south of Hiroshima and Nagasaki (two); flight and ground crews posed in groups, like sports teams (four); and ground shots taken before and after the bombings (two).[27] The before-and-after ground shots function as the album's bookends. The "before" photograph, on the opening page, represents Paul Tibbets waving through the night darkness from the cockpit of the Enola Gay prior to take-off for Hiroshima, with the name of his plane visible in large capital letters on the fuselage below him.[28] Tibbets is smiling for the camera. The photograph became a flashpoint in 1995 during a controversy that erupted over an exhibition on the Enola Gay at the Smithsonian National Air and Space Museum, Washington, DC, and has since become as much a part of collective memory as the Nagasaki mushroom cloud image itself, at least in the United States. The exhibition intended to mark the fiftieth anniversary of the end of the Second World War without taking sides on whether or not the United States should have deployed nuclear weapons against Japan, but instead polarised debate around the issue.[29] Many veterans, including Tibbets, argued that nuclear weapons were necessary to end the war. Tibbets became a champion for the pro-nuclear side and his comments on the issue often accompanied the cockpit photograph of him in the Enola Gay. The plane was named for his mother, thus turning the aircraft into a generative as well as destructive force. The Enola Gay was also a flower of hell.

The "after" photograph on the final page of the album represents a flattened section of Hiroshima or Nagasaki—it is difficult to tell which of the two cities is pictured—with scattered survivors making their way along a road through the ruins. The survivors are seen from a distance, but in a celebrated photograph taken by Yosuke Yamahata the day after the Nagasaki bombing two survivors are shown much closer up, standing on a ruined suburban railway platform. The mother and child, cut by flying glass, are holding rice balls. A related Yamahata image, depicting the child alone, was included in *The Family of Man* exhibition organised by Edward Steichen for the Museum of Modern Art, New York, in 1955.[30] In the catalogue of the exhibition, the image of the child is placed directly opposite a quotation from the philosopher and anti-nuclear activist

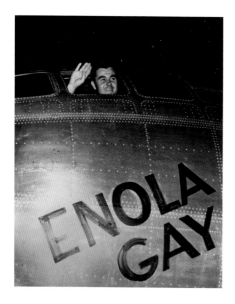

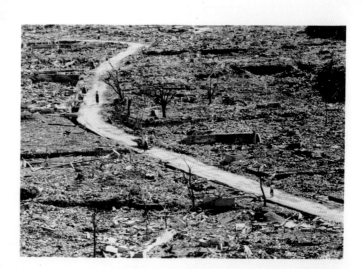

Bertrand Russell: "The best authorities are unanimous in saying that a war with hydrogen bombs is quite likely to put an end to the human race."[31]

The Nagasaki mushroom cloud image has been deployed as a matrix for the production of contemporary art. Using textiles as a medium, Douglas Coupland and Kyungah Ham have both repurposed the image. As a child, Coupland was living on the air force base at Baden-Söllingen in Germany at the time of the Cuban Missile Crisis in 1962, and his writing and art have turned repeatedly to the subject of nuclear catastrophe.[32] A section of his novel *Life After God*, titled "The Wrong Sun", is republished in this volume, and his best-known book, *Generation X: Tales for an Accelerated Culture*, also reflects on nuclear threat.[33] On the side of a large blanket, Coupland has printed an image of the Nagasaki mushroom cloud. It is not bedding for the faint of heart.

The Korean artist Kyungah Ham has also reproduced the Nagasaki cloud as a textile, pairing it with an image of the Hiroshima mushroom cloud. The large-scale diptych of hand-embroidered silk was clandestinely commissioned through intermediaries from skilled North Korean workers. Using a full-scale digital print cut into sections, the embroidery was produced piecemeal by female artisans using traditional techniques and then returned section by section to South Korea for assembly. The reason for dividing the image into parts was to lessen the risk of detection and confiscation, as the border between North Korea and South Korea is closed and unsanctioned exchanges are forbidden.[34] Ham's *Nagasaki and Hiroshima Mushroom Clouds* is an illicitly produced work that speaks not only to the Cold War and the partitioning of Korea, but also to the present sociopolitical situation in which North Korea's nuclear capabilities threaten the region.

LEFT
U.S. Army Air Force
Presentation Album of Original Photographs of the Bombing Missions on Hiroshima and Nagasaki [Paul Tibbets Waving from the Cockpit of the Enola Gay], 6 August 1945

RIGHT
U.S. Army Air Force
Presentation Album of Original Photographs of the Bombing Missions on Hiroshima and Nagasaki [Survivors Making Their Way through the Ruins of Hiroshima or Nagasaki], August 1945

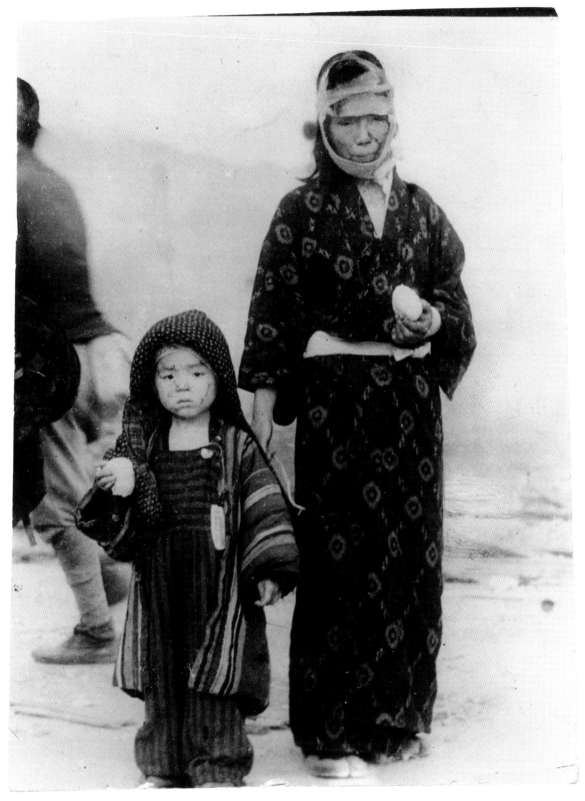

Yosuke Yamahata
Mother and son holding rationed rice balls, near
Ibinokuchimachi (present day Takaramachi), about
1.5 km south of epicenter, 10 August 1945, morning

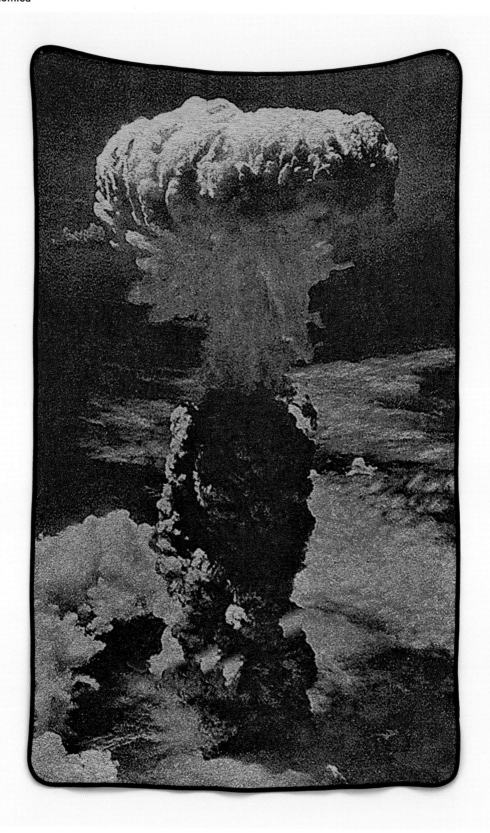

Douglas Coupland
Nagasaki Blanket, 2011

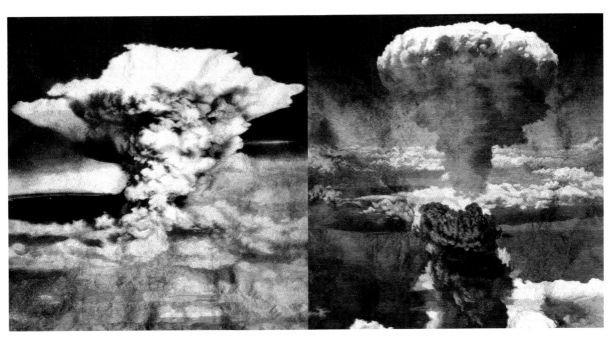

Kyungah Ham
Nagasaki and Hiroshima
Mushrooms Clouds 02, 2010

Ham's work makes visible what otherwise would have remained hidden in the closed environment of North Korea. As Trevor Smith has observed: "Time spent reproducing these forbidden images [was] time spent contemplating and thinking about them."[35]

The first two atomic tests at Bikini Atoll, code-named Operation Crossroads, were conducted in July 1946. Test Baker, which followed soon after Test Able, provides my second example of a mushroom cloud photograph that has been persistently reproduced and circulated. Test Able and Test Baker were the fourth and fifth nuclear detonations ever to take place. In part, they were scientifically managed nuclear experiments designed to assess the impact of aerial (Able) and underwater (Baker) detonations on target ships and biological specimens; and, in part, they were political theatre, carefully staged media events with the world press in attendance, mounted to assert American nuclear superiority and dispel reports about the dangers of radiation.[36] Photographers from Associated Press, International News Service, Acme and *Life* magazine were invited to attend on the condition they pooled their images for distribution under the supervision of the United States military.[37] 750 cameras were employed by the news photographers and military cameraman to record the blasts, using up half the world's supply of motion picture film in the process. Among them were the largest still camera then in existence, with a 48-inch focal length telephoto lens, and an ultra high-speed motion camera capable of shooting 10,000 frames per second. "The multiplicity of cameras was necessary to insure full records of results", a pictorial book on the operation stated, "particularly damage results."[38]

The "damage results" from Bikini that entered into public memory were provided by photographs from Test Baker, detonated 15 metres below the surface of the water. The images exist in at least as many variations as there were cameras trained on the event, and represent a column of water rising from the blast to form a cloud of

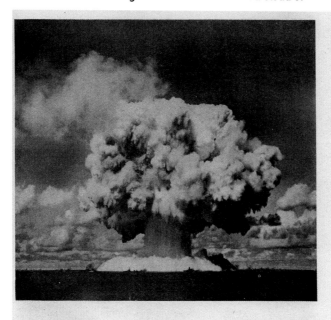

Joint Task Force One
A Tree Grows in Bikini, from the book *Operation Crossroads: The Official Pictorial Record*, 1946

A TREE GROWS IN BIKINI. Somewhere beneath this tree-shaped watery pile lies the battleship "Arkansas," which was the nearest to the center of impact when the Baker bomb was detonated. "Arkansas" and three other smaller ships sank almost at once. The aircraft carrier "Saratoga," also close to the bomb, sank seven and one-half hours later. The big battleship "Nagato" emerged from the Baker Test with a five degree list, remained in that condition for four days, sank in the middle of the night. Comparing the two tests, the Evaluation Board observed that ships remaining afloat within the damage area appeared to have been much more seriously damaged by the aerial explosion than by the underwater explosion. Damage to ships in the first test might have been far greater had the bomb exploded directly over the target ship "Nevada." No ship within a mile of either burst could have escaped without some damage to itself and serious injury to a large number of its crew. OPPOSITE. Vertical view of Baker burst.

condensation that looks more like a cauliflower than a mushroom. (Some early reports of the explosion did, in fact, describe the cloud as having a cauliflower form.[39]) The most widely known of the images goes by several titles, of which the most straightforward is *Mushroom Cloud, Test Baker*. A written description of a version of the image appearing in *Operation Crossroads: The Official Pictorial Record*, published a few months after the tests by the trade publisher Wm H Wise in conjunction with the military, concentrates less on the shape of the cloud than on the damage effects of the explosion. The description comments on what is invisible to the camera as well as on what can be seen: "The wall of spray and steam at the base of the column rushes precipitantly out from the center, drenching the target ships with its thick poisonous wetness.... Small wonder that 90 per cent of the target vessel array was affected by the deadly

page 72

page 73

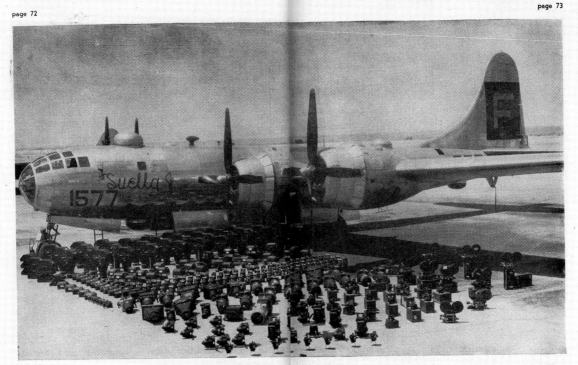

LOOK PLEASANT PLEASE. This mass grouping of cameras used by the Army Air Forces to photograph the atomic bomb explosions gives some idea of the extent of the aerial photographic coverage of these tests. Not shown here is navy camera equipment used in planes and on ships, or in fixed shore installations used by various technical groups. The AAF camera roster totalled 328, including aerial motion and still cameras, and among them the world's largest still camera, a giant instrument with a 48-inch focal length telephoto lens. Other unusual cameras included gunsight cameras and ultra high-speed cameras capable of taking 10,000 frames per second under ideal conditions. The multiplicity of cameras was necessary to insure a wide variety of filter combinations, lenses, and exposures, and in general to insure obtaining full records of results, particularly damage results.

Joint Task Force One
Mass Grouping of Cameras Used to Photograph First Bikini Tests, from the book *Operation Crossroads: The Official Pictorial Record*, 1946

radioactivity. Although the amount of damage done to the hulls was not very different from predicted damage, the extent of radiological hazards went beyond what had been expected."[40] This passage does not mince words. Ships were drenched in "thick poisonous wetness" and affected by "deadly radioactivity", while the "radiological hazards went beyond what had been expected". The phrases address the dangers of radiation with a clarity and openness that would not last in press communiqués issued by military authorities. After 1946, words such as "poisonous" and "deadly" were excised from the official nuclear lexicon and replaced with the anodyne language of bureaucratic obfuscation.[41]

Among the biological specimens placed on the target ships and assessed for radiological and other kinds of harm were pigs, goats, rats, mice and guinea pigs. Pigs were used because of the compatibility of their skin and hair to that of humans, and goats because their weight and bodily fluids were similarly compatible.[42] In *Operation Crossroads: The Official Pictorial Record*, there is a photograph of a goat laid out diagonally on an operating table, its hind feet bound with a cord of rope, surrounded by four doctors administering a blood transfusion for radiation sickness.[43] The goat has wisps of hair encircling its face, making it look uncannily human, as if it were more conscious of its situation than the masked doctors around it. The caption beneath the photograph reports that 35 per cent of the animals used in the tests died: 10 per cent from the blasts;

page 220

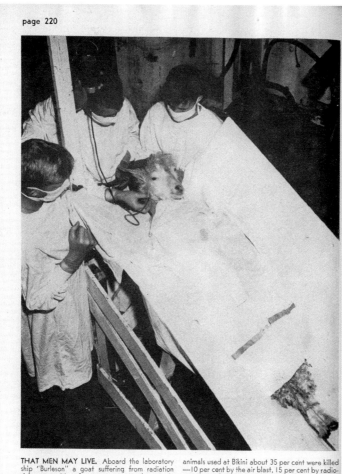

Joint Task Force One
That Men May Live, from the book
*Operation Crossroads: The Official
Pictorial Record*, 1946

THAT MEN MAY LIVE. Aboard the laboratory ship "Burleson" a goat suffering from radiation sickness resulting from exposure to the atomic bomb receives a transfusion of whole blood. Plasma used is from a goat blood bank contributed to by certain goats reserved for this purpose. Of the animals used at Bikini about 35 per cent were killed —10 per cent by the air blast, 15 per cent by radio-activity, and 10 per cent by research workers after the tests, for study. No exact parallel can be drawn between these figures and estimates of the possible effect of the bomb upon human life.

15 per cent from radiation; and another 10 per cent from medical experimentation.[44] The circulation of photographs of irradiated goats and pigs after Operations Crossroads, like the circulation of words and sentences describing radiological threat, was subsequently curtailed by military censors. In *Operation Sandstone: The Story of Joint Task Force Seven*, a book of photographs of tests conducted at Enewetak Atoll in 1948, there are no images of animals or masked doctors.[45] The photographs selected for general release by authorities were less about radiation experiments and the effects on animals and people than about the technological sublime, the flash-and-bang spectacle of fireballs and mushrooms clouds.

Two dozen photographs in *Operation Crossroads: The Official Pictorial Record* are of the Test Baker mushroom cloud, not to mention the gold embossed image of *Mushroom Cloud, Test Baker* on the front cover of the book or the photograph of an atomic cake baked in the shape of the cloud being cut by Vice Admiral "Spike" Blandy and his wife to celebrate the completion of the tests. Some of the photographs were taken by drones flying

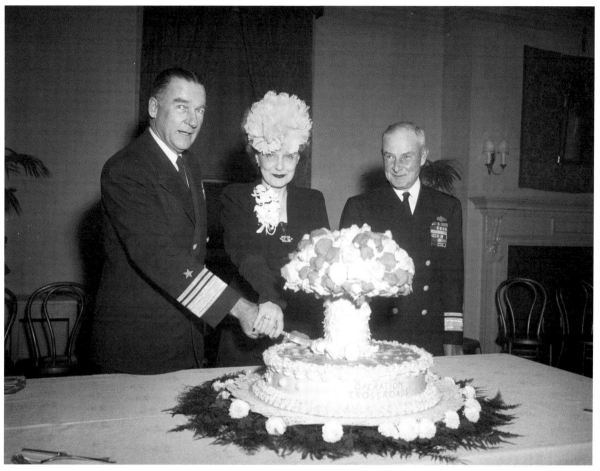

Press Agency Photo
Vice Admiral W.H.P ("Spike")
Blandy and his Wife Cutting an
Atomic Cake, 1946

overhead, some by photographers in observation planes, some
from a specially built tower, some from the surface of the water,
and some from the atoll itself. Over time, *Mushroom Cloud, Test
Baker* has supplanted most other images in constructing a public
memory of the event. In addition, the photograph has served as
the matrix for a new body of imagery ranging from advertisements
to protest art.[46]

The International Nickel Company (Inco) published a full-page
advertisement in *Time* magazine in 1954, in which *Mushroom
Cloud, Test Baker* was transformed from a black-and-white
photograph into a grisaille watercolour.[47] The illustration in the
advertisement, which reverses the photograph, remains faithful
to most of its characteristics, emphasising the extremes of dark
and light in the cloud as well as in the surrounding sky and water,
but makes two notable alterations. It eliminates the target ships
that were placed at ground zero by the military to test the force of
the bomb, and it inserts a prominent group of thatched huts and
palm trees into the lower right foreground. The changes soften
the image, transforming a representation of the atomic sublime

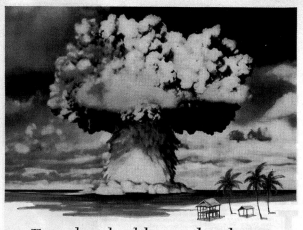

into what might be called the atomic picturesque. Whereas the force of the atomic sublime can seem disturbingly seductive, the orderliness of the atomic picturesque is merely pleasurable. Like postcards of nuclear explosions, the advertisement domesticates the deadly event. It strikes me that the bathing suit named by Louis Réard after the 1946 Bikini tests is a more compelling representation of the event than the advertisement; at least the two-piece "Bikini" acknowledges the sexual character of a nuclear discharge.

The reason for Inco's pictorial ledgermain is announced in the advertisement's message: "Even *this* cloud has a silver lining", the caption reads, invoking the beneficial side of the nuclear *pharmakon*.[48] Nickel alloys are needed in reactors to produce radioisotopes for medical purposes, Inco states, because the alloys are non-corrosive, heat-resistant and strong. The company is ideally situated to help in the production of radioisotopes for peaceful purposes. The message of the advertisement is consistent with those of other Inco advertisements in American magazines in 1954. An ad placed in *Collier's* explains to readers "How Inco Nickel Is Helping to Produce Power from the Peace Atom".[49] President Eisenhower's recently coined slogan "Atoms for Peace" was clearly finding an audience among military suppliers, just as the Atomic Energy Commission's promotion of nuclear power for civilian purposes was attracting

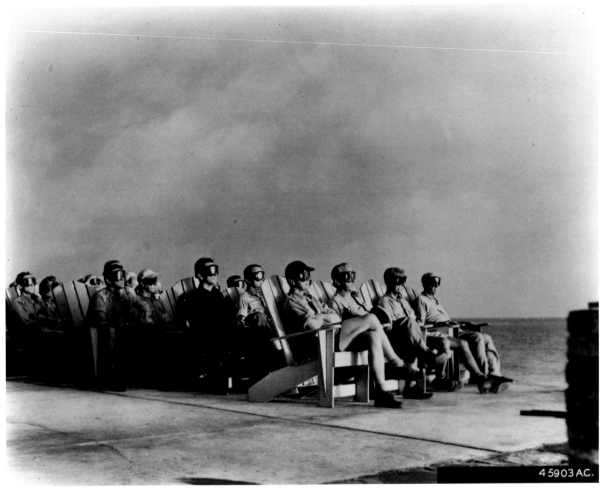

4 5903 AC.

Dennis Brack
Sitting on the Patio of the Officer's
Beach Club, Illuminated by an
Atomic Explosion at Enewetak
Atoll, 8 April 1951

commercial interest. "While the AEC's weaponeers are at work in the Pacific", an article in *Time* observed, "the AEC is also going after peaceful nuclear power in a big way".[50] In other words, the United States was turning swords into ploughshares while looking for ways to build even bigger bombs. The first thermonuclear test, Castle Bravo, took place at Bikini on 1 March 1954, just weeks before the Inco advertisement appeared. It was the most powerful nuclear device ever exploded by the United States and, after Hiroshima and Nagasaki, one of the most lethal.[51] The contradictions in the "Atoms for Peace" movement are made explicit in Dennis Brack's photograph of military officers watching a test explosion from deck chairs on the patio of their beach club while getting a sun tan.[52]

From the tone and content of Inco's advertisement, readers might be persuaded that a significant part of the company's future lay in the medical uses of nickel. They would be wrong. In an era of near-permanent war—an era that still shows no sign of abating half a century later—it follows that all corporate and government activities must be performed in the name of peace.[53] By 1950, and the outbreak of the Korean War, Inco had established a near monopoly in the production and distribution of nickel in North America—it was supplying close to 80 per cent of the United States' requirements—

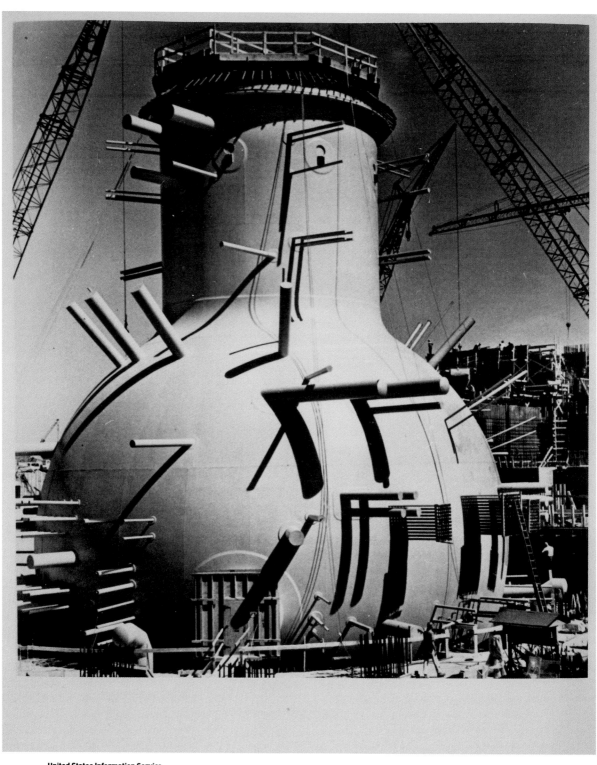

United States Information Service
Reactor Container 36 meters high being
constructed for the Niagara Mohawk Power
Corporation, Lake Ontario near Oswego,
New York, c 1950s

and Congress launched an investigation into the company's market dominance and pricing practices. Nickel was a "true war material", the United States Department of Defense declared, and it wanted the Canadian company to provide the metal to the United States at a competitive cost.[54] The construction of nuclear reactors, whether for military or peaceful purposes, required a lot of aluminum, and the United States wanted to be sure of having secure supplies.

The Congressional investigation bruised Inco's image. To repair the damage, the company increased production to bring down prices and initiated an aggressive advertising campaign to refashion itself as a concerned corporate citizen. Inco even managed to find a "silver lining" in the Baker mushroom cloud, or so its advertisement claimed, by converting a destructive force into a positive benefit to medicine. By 1954, the company was operating at full capacity and selling all the nickel it could mine. Only a very small part of its production, however, went for reactors that were making radioisotopes for medical purposes. Much more of its output went to feed the United States' war machine. A month after the advertisement in *Time* appeared, the *Inco Triangle*, an in-house company publication, reported: "War or the preparation for war creates an immediate demand for all metals and destroys the usual balance between demand and supply.... We are now in such a period."[55] The nickel supplied to the United States by Inco, like the uranium supplied to the United States Department of Defense by another Canadian company, Eldorado Mining and Refining, was directed more towards making mushroom clouds than producing isotopes for medicine.[56]

In 1981, Barbara Kruger used a photograph of the Test Baker explosion to deliver a message about nuclear weapons that drew on the techniques of billboard advertising.[57] She cropped the photograph tight at the edges to bring it closer to the viewer. "Your Manias Become Science", the work declares, if one reads the words sequentially, or "Manias Become Your Science", if one reads the middle two words first. The message was directed at those nations in possession of nuclear weapons, members of the so-called Nuclear Club. When Kruger exhibited the work in Sydney and Mexico City, she altered the title to *Their Manias Become Science* in order to distinguish Australia and Mexico from countries that were engaged in the nuclear arms race. Kruger's appropriation of an iconic Bikini image, and her reanimation of it with an aggressive political slogan, is presented without irony. The kind of dark humour found in Stanley Kubrick's film, *Dr. Strangelove or: How I Learned to Stop Worrying and Love the Bomb*, where Slim Pickens rides an atomic bomb to doomsday, is alien to Kruger's project.

In *Your Manias Become Science*, the spectacle of the mushroom cloud ceases to read as a cliché. Instead, it reads as threatening. It also reads as threatening in the work of Bruce Conner, who used images of the Test Baker explosion in three different works: A 36-minute

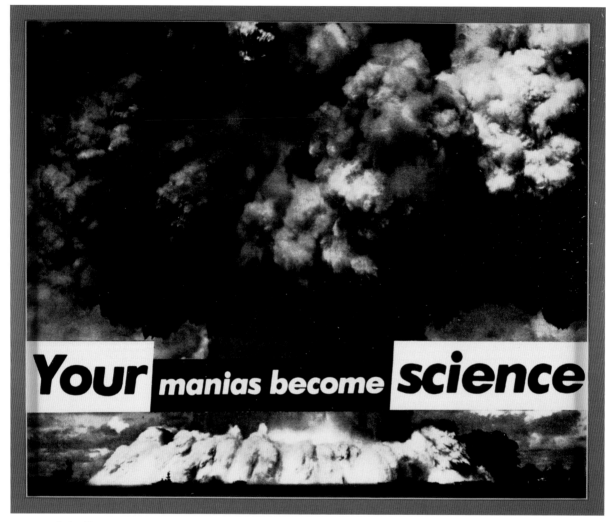

Barbara Kruger
Untitled (Your manias become science), 1981

film, *Operations Crossroads*, 1976, which was made from declassified footage of the Bikini explosion; a photomontage called *BOMBHEAD*, 1989, which was assembled from cut up photocopies and newspaper images; and a large-scale print, also called *BOMBHEAD*, 2002, that was based on the photomontage.[58] The cranium-shaped mushroom cloud in *BOMBHEAD* is attached to a male figure's uniformed body by a columnar neck of water produced by the detonation, and refers back to Conner's early work as a Beat artist in the late 1950s and early 1960s, a time of intensifying fear in the United States about the risks of nuclear catastrophe.[59] In Conner's 1959 sculpture, *Child*, a deformed body seated in a wooden highchair resembles a charred corpse. *BOMBHEAD*, like *Child*, functions within an ongoing economy of fear precipitated by the Cold War.

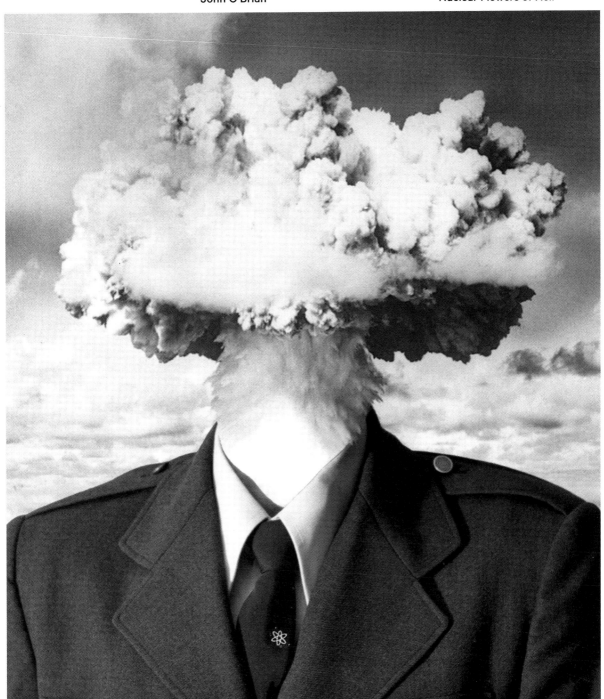

Bruce Conner
BOMBHEAD, 2002/1989

NOTES

1 The term techno-scientific is taken from Ulrich Beck, *Risk Society: Towards a New Modernity*, London: Sage, 1992. A techno-scientific society is one in which the risks of technological innovation and scientific development cannot be managed.

2 Lies, Elaine, "Four Killed in Nuclear Power Plant Accident", *The Age*, 10 August 2004. http://www.theage.com.au/articles/2004/08/09/1092022406554.html (accessed 15 March 2014).

3 Derrida, Jacques, "No Apocalypse, Not Now (Full Speed Ahead, Seven Missiles, Seven Missives)", *Diacritics* 14, no 2, summer 1984, p 23.

4 Del Tredici, Robert, "Interview with Paul Wagner, Public Relations Manager for the Department of Energy at Pantex, 10 August 1982", in *At Work in the Fields of the Bomb*, Vancouver: Douglas and McIntyre, 1987. In his introduction to the book, Jonathan Schell also quotes Wagner, p xi.

5 Carson, Rachel, *Silent Spring*, 1962, Boston: Houghton Mifflin, 2002, p 6. "In this now universal contamination of the environment", Carson writes at the beginning of the book, "chemicals are the sinister and little-recognized partners of radiation in changing the very nature of the world—the very nature of its life. Strontium 90, released through nuclear explosions into the air, comes to earth in rain or drifts down as fallout." In the same year that *Silent Spring* appeared, Norman Cousins published a new and revised edition of *In Place of Folly*, New York: Washington Square Press, 1962, which called for greater controls on nuclear energy in the United States and internationally.

6 In non-techno-scientific circles, Carson and her message in *Silent Spring* were met more favourably. On 4 June 1963, Carson was called to testify before a Senate subcommittee on pesticides.

7 My thinking has benefited from Georges Didi-Huberman, *Images in Spite of All: Four Photographs of Auschwitz*, Shane B Lillis, trans, Chicago: University of Chicago Press, 2008, and Robin Kelsey, "Making Photography into Public Memory", a paper delivered at a symposium on "The 'Public Life' of Photographs" organised by Thierry Gervais, Ryerson University, Toronto, 9–11 May 2013.

8 Guy Debord argued that "the spectacle" is a social relation mediated by images in *The Society of the Spectacle*, New York: Zone Books, 1994. See, also, Kirsch, Scott, "Watching the Bombs Go Off: Photography, Nuclear Landscapes, and Spectator Democracy", *Antipode* 29, no 3, 1997.

9 Del Tredici, Robert, "Preface", *At Work in the Fields of the Bomb*, p ix. Weart, Spencer R, *Nuclear Fear: A History of Images*, Cambridge, MA: Harvard University Press, 1988, addresses "the inarticulate pictures and emotional patterns" that were constantly changing during the bomb's reception in North America in the twentieth century.

10 See also van Wyck, Peter C, *The Highway of the Atom*, Montreal: McGill-Queen's University Press, 2010.

11 "Within weeks of the United States dropping an atomic bomb", Tom Engelhardt observes, "Americans were already immersed in new scenarios of nuclear destruction. As the late Paul Boyer so vividly described in his classic book *By the Bomb's Early Light: American Thought and Culture at the Dawn of the Atomic Age*, New York: Pantheon, 1985, it took no time at all—at a moment when no other nation had such potentially Earth-destroying weaponry—for an America triumphant to begin to imagine itself in ruins, and for its newspapers and magazines to start drawing concentric circles of death and destruction around American cities while consigning their future country to the stewardship of the roaches." http://www.tomdispatch.com/post/175821/best_of_tomdispatch%3A_noam_chomsky%2C_%22the_most_dangerous_moment%22 (accessed 22 March 2014).

12 As a doctor measuring radioactive contamination, David Bradley was present at Bikini for the first tests in 1946. His influential book, *No Place to Hide*, Boston: Little, Brown, 1948, concludes that nuclear energy has "made us less free, more interdependent, and has threatened to enslave us all in a frantic and foredoomed race for military power". Dustjacket.

13 Oppenheimer was quoting from the *Bhagavad Gita*. The film is *The Town That Never Was*, a 16-minute documentary film on Los Alamos and the Manhattan Project. The film is regularly screened at the Bradford Science Museum, Los Alamos. See Peggy Rosenthal, "The Nuclear Mushroom Cloud as Cultural Image", *American Literary History* 3, no 1, spring 1991, p 73.

14 Photographs, statues and busts of Oppenheimer are standard issue in atomic museums like the Bradbury, despite the scientist's later fall from grace for speaking out on the dangers of nuclear weapons.

15 Broad, William, "The Bomb Chroniclers", *New York Times*, 13 September 2010.

16 See Kuran, Peter, *How to Photograph an Atomic Bomb*, Santa Clarita, California: VCE, Inc, 2006.

17 Virilio, Paul, *War and Cinema: The Logistics of Perception*, Patrick Camiller, trans, London: Verso, 1989, back cover.

18 Lippit, Akira Mizuta, *Atomic Light (Shadow Optics)*, Minneapolis: University of Minnesota Press, 2005, also writes about radiographic surfaces and visibility and invisibility at Hiroshima and Nagasaki.

19 Father Siemes quoted in Delgado, James P, *Nuclear Dawn: The Atomic Bomb from the Manhattan Project to the Cold War*, Botley, Oxford: Osprey Publishing, 2009, p 92.

20 The Nagasaki explosion was also recorded on film, with colour footage shot from the window of an observation plane accompanying Bockscar, the B-29 bomber carrying the weapon. The recently discovered film is unedited, and begins with the preparation and loading of the bomb on Tinian Island. "Haunting Unedited Footage of the Bombing of Nagasaki (1945)", *Open Culture*, http://www.openculture.com/2014/02/haunting-unedited-footage-of-the-bombing-of-nagasaki-1945.html (accessed 12 February 2014).

21 Williams, William Carlos, "Asphodel, That Greeny Flower", *Journey to Love*, New York: Random House, 1955. For a commentary on the poem, see J Hillis Miller, *Poets of Reality: Six Twentieth-Century Writers*, Cambridge, MA: Harvard University Press, 1965.

22 The poet Michael Lista has published a volume called *Bloom*, Toronto: Anansi, 2010, which centres on the Canadian physicist Louis Slotkin, who died after a botched experiment with a plutonium core at Los Alamos in 1946. When plutonium goes critical, it releases what scientists call a "bloom".

23 See, for example, https://www.google.ca/#q=hiroshima+bombing, a website of Hiroshima images that includes several versions of the Nagasaki mushroom cloud image (accessed 5 February 2014).

24 The image is reproduced, along with atomic postcards from a dozen countries, in John O'Brian and Jeremy Borsos, *Atomic Postcards: Radioactive Messages from the Cold War*, Bristol: Intellect Books, 2011, p 13.

25 For a discussion on miniaturisation, see Susan Stewart, *On Longing: Narratives of the Miniature, the Gigantic, the Souvenir, the Collection*, Durham, North Carolina: Duke University Press, 1993. I have written on American atomic postcards in "Postcard to Moscow", *Postcards: Ephemeral Histories of Modernity*, David Prochaska and Jordana Mendelson, eds, University Park: Pennsylvania State University Press, 2010, pp 182–193, 222–224.

26 Ariella Azoulay has argued that photography is an *event* of a special kind that takes place through the mediation of a camera, and that it must be understood as indivisible from historical events. *The Civil Contract of Photography*, New York: Zone Books, 2008.

27 US Army Air Force, *Untitled* (Presentation Album of Original Photographs of the Bombing Missions on Hiroshima and Nagasaki), 1945, collection of the author. The bottom right-hand corner of the front cover bears the prop-and-wings insignia of the US Army Air Force. The album has no name, date or inscription.

28 Shortly before take off, the crew were filmed and photographed for 20 minutes until Tibbets brought an end to the session. See Tibbets Jr, Paul W, *Mission: Hiroshima*, New York: Stein and Day, 1985.

29 There is a large literature on the exhibition. See Linenthal, Edward T and Tom Engelhardt, eds, *History Wars: The* Enola Gay *and Other Battles for the American Past*, New York: Henry Holt, 1996; Dubin, Steven C, "Battle Royal: The Final Mission of the *Enola Gay*", in *Displays of Power: Memory and Amnesia in the American Museum*, New York: New York University Press, 1999; and MacDonald, Heather, "Revisionist Lust: The Smithsonian Today", *New Criterion* 15, issue 9, May 1997.

30 The overriding proposition of *The Family of Man* was that people are the same the world over, regardless of differences in geography and culture. Embedded within this humanist theme of putative commonality was an anti-nuclear subtheme. For an analysis of the sub-theme in *The Family of Man*, see my essay, "The Nuclear Family of Man", *Japan Focus: Asia Pacific Journal*, July 2008. http://www.japanfocus.org/-John-O_Brian/2816.

31 Russell, Bertrand, quoted in Edward Steichen, *The Family of Man*, New York: Museum of Modern Art, 1955, p 179.

32 Baden-Söllingen was on the flight path between the Soviet Bloc and Western Europe. Germany and Canada were the two countries over which World War Three was most likely to begin.

33 Coupland, Douglas, "The Wrong Sun", in *Life After God*, New York: Simon and Schuster, 1994, pp 95–111, and *Generation X: Tales for an Accelerated Culture*, New York: St Martin's Press, 1991.

34 Kang, Sumi, "The Hypertext of Some Art", *Monthly Art* 2, 2008, pp 136–141.

35 Smith, Trevor, "Kyungah Ham", *Singapore Biennale 2011*, Singapore: Singapore Art Museum, 2011,

p 232. I am grateful to Trevor Smith, one of the Biennale's curators, for bringing Ham's work to my attention. I would also like to thank Kyoung Yong (Anton) Lee and Alice Choi for their insights on Ham.

36 Light, Michael, *100 Suns: 1945–1962*, New York: Alfred A Knopf, 2003, np.

37 Office of the Historian, Joint Task Force One, *Operation Crossroads: The Official Pictorial Record*, New York: Wm H Wise and Co, 1946, p 41.

38 "Look Pleasant Please", *Operation Crossroads: The Official Pictorial Record*, pp 72–73.

39 Other reports describe it as looking like a tree or a cabbage or, more abstractly, like a colossus.

40 "Base Surge, Lagoon Level", *Operation Crossroads: The Official Pictorial Record*, p 202. The book contains 228 images, many "reclassified from secret files", which bear lengthy captions.

41 The most complete glossary on nuclear terms, such as "kill radius" and "radioactive decay", is Semler, Eric, James Benjamin and Adam Gross, *The Language of Nuclear War: The Intelligent Citizen's Dictionary*, New York: Harper and Row, 1987.

42 "Rats, Radiation, and History", *Operation Crossroads: The Official Pictorial Record*, p 67.

43 "That Men May Live", *Operation Crossroads: The Official Pictorial Record*, p 220.

44 The United States also conducted extensive radiation experiments on American citizens. Eileen Welsome revealed the scope of these experiments in *The Plutonium Files: America's Secret Medical Experiments in the Cold War*, New York: Dial Press, 1999, an exposé of the secret studies. Pregnant women and children were given radioactive iron (children got it in lemonade); prison inmates were targeted with X-rays to see what doses they could take before becoming sterile; and "radiation bombs" were tossed from military aircraft into civilian areas to measure the distances that radiation could travel. See also Caulfield, Catherine, *Multiple Exposures: Chronicles of the Radiation Age*, London: Secker and Warburg, 1989; Hilts, Philip J, "Fallout Risk Near Atom Tests Was Known, Documents Show", *New York Times*, 15 March 1995; and LaForge, John, "Contaminated Nation: Inhuman Radiation Experiments", *Counterpunch*, 12–14 April 2013.

45 White, Clarence H, ed, *Operation Sandstone: The Story of Joint Task Force Seven*, Washington, DC: Infantry Journal Press, 1949.

46 According to the website Image Atlas, created by Taryn Simon and Aaron Schwartz, *Mushroom Cloud, Test Baker* has itself been supplanted in the collective memory. Image Atlas allows users to compare top image results in different countries according to subject matter. If one enters "mushroom cloud" into the search engine, *Mushroom Cloud, Test Baker* does not appear. Most of the images are of hydrogen bomb explosions reproduced in colour. *The Atomic Cloud* is an exception. http://imageatlas.org (accessed 11 February 2014).

47 International Nickel Company, Inc, advertisement, *Time*, 22 March 1954, p 109.

48 The idea of the *pharmakon*, as conceived by Jacques Derrida in "Plato's Pharmacy", is discussed in the Introduction to this volume. The article is translated in *Dissemination* by Barbara Johnson, London: Athlone Press, 1981, pp 61–172.

49 *Collier's*, 1 October 1954, p 55.

50 "Atomic Five-Year Plan", *Time*, 22 March 1954, p 68. Four additional articles on nuclear matters appear in the same issue of *Time*: "The Atom: Five Hundred Hiroshimas", p 21; "The Cold War: Facing the Facts", p 31; "Atomic Diagnosis", p 59; and "Time Clock: First Full-Scale Atomic Power Plant", p 101.

51 The explosive yield of Castle Bravo was 15 megatons, double what was expected, and the fallout from the detonation fell on the islanders of Rongelap and Utrik as well as on the crew of a Japanese fishing boat, *Lucky Dragon No. 5*, with deadly results.

52 A memoir of what it was like to be a soldier at the proving grounds at this time has been published by Michael Harris, *The Atomic Times: My H-Bomb Year at the Pacific Proving Grounds*, New York: Ballantyne, 2005.

53 Retort (Iain Boal, TJ Clark, Joseph Matthews, Michael Watts), *Afflicted Powers: Capital and Spectacle in a New Age of War*, London: Verso, 2005.

54 Quoted in Aronsen, Lawrence Robert, *American Security and Economic Relations, 1945–1954*, Westport, Conn.: Praeger, 1997, p 128.

55 Inco Annual Report for 1953, quoted in *Inco Triangle*, April 1954, p 2.

56 Since the mining of pitchblende ore began in the early 1930s at Port Radium, on the shores of Great Bear Lake in the Northwest Territories of Canada, Eldorado Mining and Refining has operated under several different names. During the Second World War, the company was nationalised and produced uranium for

the Manhattan Project. See Bothwell, Robert, *Eldorado: Canada's National Uranium Company*, Toronto: University of Toronto Press, 1984.

57 Barbara Kruger has often appropriated imagery from the 1940s and 1950s in her work. See Lippard, Lucy, *Get the Message? A Decade of Art for Social Change*, New York: EP Dutton, 1984.

58 Hatch, Kevin, *Looking for Bruce Conner*, Cambridge, MA: MIT Press, 2002, p 181, argues that because Conner altered the appropriated footage only minimally for *Operations Crossroads*, he upset "ordinary expectations of what a 'political' film should be".

59 Boyer, *By the Bomb's Early Light*, pp 352–353. Much of the fear revolved around the dangers of radioactive fallout. Martin Luther King, Jr spoke for many in an interview with John Freedom on "Face to Face" in London, England, 29 October 1961: "I don't think the choice is any longer between violence and non-violence in a day when guided ballistic missiles are carving highways of death through the stratosphere. I think now it is a choice between non-violence and non-existence."

Posing by the Cloud: US Nuclear Test Site Photography in Process

Julia Bryan-Wilson

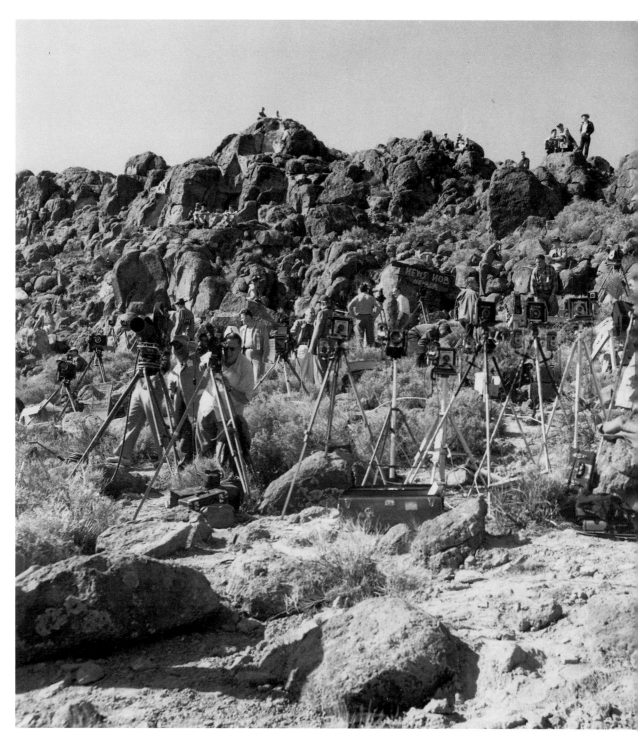

United States Department Of Energy
News Nob, Nevada Test Site, established April 22, 1952, 1952

A cluster of cameras perched on their tripods stare out from a rocky outcropping. Boxes of equipment huddle at their feet as men ready the equipment for use. What event have they gathered to capture? What sight are they eagerly facing? This is News Nob, a strategic spot positioned seven miles from the Nevada Test Site that was established in 1952 as a designated area for journalists to photograph the nearby atomic detonations. Between 1945, when the first bomb exploded in Alamogordo, New Mexico, and November 1962, more than 200 known above-ground or "atmospheric" tests were conducted by the United States military, not only in Nevada but at the Pacific Proving Ground in the Marshall Islands and other locations.[1] These tests were diligently, meticulously, even obsessively chronicled both by still cameras and movie reels, producing a vast number of images shot by amateurs and professionals alike, using every type of camera and film, and taken with devices that were stationed on specially constructed towers, slung around the necks of reporters, carried by planes overhead, or amassed at News Nob.[2]

Screen-based recording technologies and nuclear detonation were conjoined from the very birth of the atomic age: more than 50 cameras were in place and at the ready on 16 July 1945 to witness the Trinity Blast at Alamogordo, including specialised tools that had been invented by the Photographic and Optics Division at Los Alamos for the sole purpose of documenting this brand-new technology, one whose destructive powers—and visual effects—were not yet known.[3] Indeed, we have grown accustomed to the images of such blasts, including the iconic mushroom cloud, stroboscopic pictures that dissect the precise unfolding of the explosion, and aerial photographs of the cratered, devastated aftermath—this repertoire of images, which has become highly charged with symbolic and metaphoric power, has been seared into the history of the twentieth century.[4] This essay sifts through that wealth of material to hone in on a narrow archive, a subgenre within the genre of nuclear test photography: images of atomic tests in which *the camera itself also appears*. This is a somewhat typical shot within this limited category of self-referential nuclear test photographs: a row of men stand at the ready with their equipment aimed towards the white light in the distance, a brightness so blinding it can barely be registered by the photographic film.

In another photograph taken of the Nevada Test Site from 1957, we can see men—and they are always men—silhouetted against the rising plume, peering through viewfinders and standing behind movie cameras, making sure their aim is perfect. Though multiple documentary apparatuses, and the men who operate them, are placed within this frame, they are not in the end its main attraction; the dark grey mushroom cloud in the background, itself a study in tonal contrast with its right side dramatically lit, steals the show. The inclusion of both the blast and the documenters has the effect of naturalising both the presence and the proximity of cameras—

and cameramen—in the above-ground tests. Of course nuclear tests were recorded, such a photograph seems to say; of course there were devices there to do that recording; and of course there were bodies to click the shutters and reload the film. The presence of photographic devices produces an extra layer of mediation into the image; it becomes a picture about the taking of the picture.

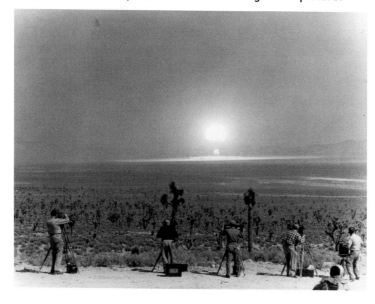

U.S. Military
Operation Teapot, Nevada Test Site,
29 March 1955

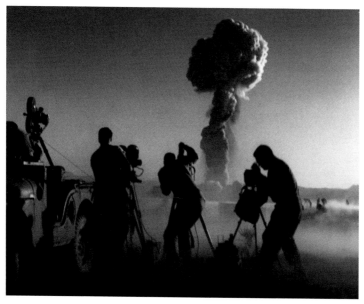

U.S. Military
Operation Priscilla, taken at the
moment of the shockwave, 1957
/ Camera Crew at Exact Moment
of Shockwave Arrival, Nevada
Test Site, 1957

It also raises questions about the uncannily close relationship between the nuclear age and photography, especially when, as in this image from 1957, the effect of the blast has had a noticeable impact on the picture taken—here, the shockwave caused the camera to move, slightly blurring the image.

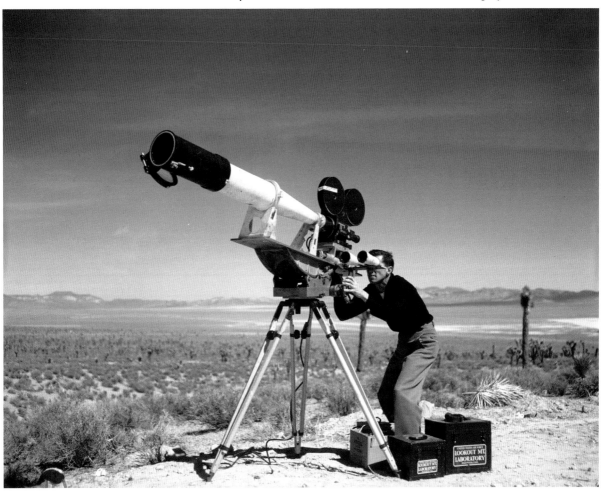

U.S. Military
Lookout Mountain cameraman,
telephoto lens and Mitchell
camera: Operation Teapot, 1955

There are many such images of nuclear tests that include cameras. Many have been collected in a book by special effects filmmaker Peter Kuran of declassified records entitled *How to Photograph an Atomic Bomb*, published in 2006. He details the development of Lookout Mountain Studios, also known as Lookout Mountain Laboratory, a highly classified Hollywood-based production facility that was subcontracted by the Department of Defense in 1947 to document nuclear tests using both still and motion pictures, outsourcing the role of recording so that the scientists at Los Alamos could focus their attention on weapons development. Though Kuran's is an impressive achievement, complete with technical specifications about film stock used and f-stop recommendations, *How to Photograph an Atomic Bomb* does not comment upon or theorise the repeated appearance of the photographic device within some of these pictures, nor does it mention or problematise the evident sustained interest these photographers had in taking pictures of themselves and their fellow high-security clearance co-workers. Notably, they frequently took pictures of one another busy on the scene; these provide more detail and texture to what nuclear test site labouring conditions looked like. Only occasionally did they wear protective gear that might shield them from the damaging health effects of the radioactivity they were

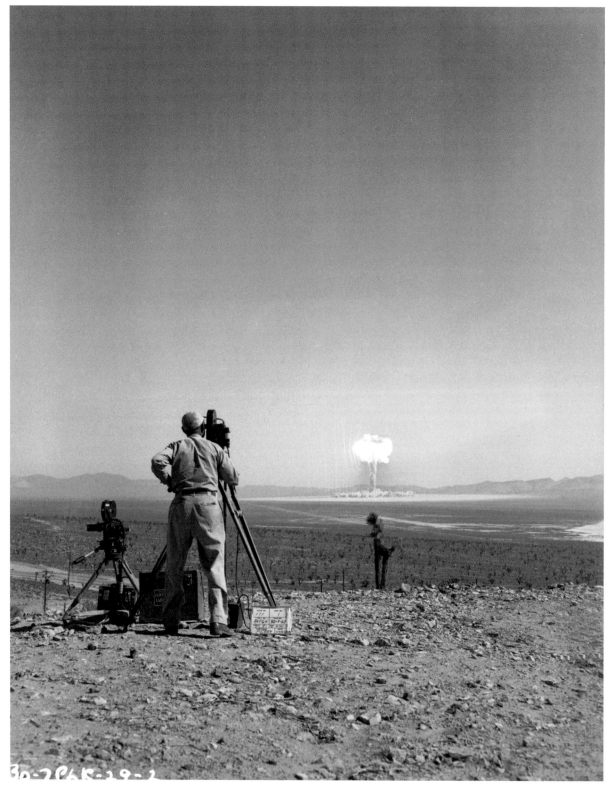

U.S. Military
Lookout Mountain Cameraman
Staff Sergeant John Kelly, Nevada
Test Site, 1958

absorbing, as is indicated in this image of Staff Sergeant John Kelly in 1958 at the Nevada Test Site. Unlike the reporters at News Nob, which was about seven miles from the blast, those working for Lookout Mountain had a greater range of access to the tests, and were able to get much closer to ground zero.

More than 250 people, including directors and producers, worked at Lookout Mountain during its existence; about 40 were cameramen sent on location to stand in the face of these blasts;

U.S. Military
Operation Dog, taken from News Nob, 1951

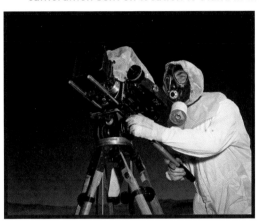

only a small handful of them appear in the images they took of themselves, often with their backs to the lens. These images signal some of the basic functions proposed by photography since the nineteenth century—that it is an ostensibly objective record of a transient event, and that it is uniquely efficient at registering details difficult for the human eye to grasp "all at once", say, an impressively carved monument. The Lookout Mountain photographers are intent on capturing as much visual data as possible given the scene at hand. But the Lookout Mountain photographers were also keen to insert bodies into the picture, even when those bodies seem excessive or superfluous to the task at hand; partly, perhaps, they are meant to indicate scale, as did such early pioneers in the history of photography as Maxime Du Camp in his voyage to Egypt.[5] It seems reasonable to claim that military photographers inserted human figures to emphasise the massive size of the mushroom cloud.

Yet the insistent presence of cameras within many of the images created by Lookout Mountain—and in some, a deliberate distortion of scale—also indicates a pervasive interest in documenting the documenters, in saying *we were here.* These images therefore have some relationship to tourist photography, but they even more fundamentally betray some of the anxieties that have shadowed photography since its inception: namely, indexicality, temporality, morbidity and violence.[6] As Susan Sontag famously opined in her *On Photography,* "There is an aggression implicit in every use of the camera.... However hazy our awareness of this fantasy, it is named without subtlety whenever we talk about 'loading' and 'aiming' a camera, about 'shooting' a film."[7]

In this image, men in khaki and plaid train their lenses on the fireball of the Teapot Military Effects Test in 1955. Taken with the use of a telephoto lens that warps scale by bringing foreground and background together, it shows the profound investment in capturing the documentary process itself, in showing that *these* bodies were in proximity to *these* blasts, wearing nothing more than street clothes to protect them. One of the truth-claims of photography is that it purports to be an indexical register, a record of something that stands with some physical immediacy in front of the lens.[8] Here that proximity is rendered almost phantasmagoric, as the dust kicked up from the explosion seems to froth at their feet. "Between photographer and subject, there has to be distance", writes Sontag, but such images might propose a radical collapse of that distance, given how radioactivity travels and works, as its particles permeate the body to immediately draw subject and object together, bound together in a toxic embrace.[9] Although increasing information about radioactivity and its long-term effects began circulating in the late 1950s and 1960s, these photographers (whether they were journalists or military functionaries) felt pressured not to protect themselves, but to get the shot they came for. As reporter Donald English stated about photographing nuclear tests in Nevada: "It was exciting, it was a mystery, and also for the photographers and press covering it, you better come back with some goods, you better have a picture."[10]

In an image of a blast in the Marshall Islands, men look out over the calm still waters into the distance, one with his camera pointed towards a large pale puff in the distance. Yet in another, the men are so awed of the enormous cloud that they have momentarily let their cameras drop—they hang unused by the sides of their bodies. Perhaps they are tourists, rather than military photographers, content to let this instant go by unrecorded. No matter: the military had plenty of other shots: one set of tests alone—Operation Crossroads, from 1946, generated more than one million still images. Along with this wealth of still photographs, the US nuclear test programme and its secret Lookout Mountain corps generated more than 6,500 films, films that were seen by few except government officials until they began to be declassified in 1997 under President Bill Clinton. More were set to be released to the public domain, but the declassification project was halted by President George W Bush in 2001 in the wake of post-9/11 fears.[11]

Along with the telephoto lenses used in the example above, virtually every possible seeing device was pressed into service to capture each aspect of these atmospheric tests, and new technologies were invented precisely to do so (including 3-D film, which was first tested at Lookout several months before it moved into the realm of commercial Hollywood).[12] One photograph shows a bank of 36 oscillograph record cameras placed within the electronic diagnostics station for the Castle Bravo operation in 1954. Note the near-eroticism between body and machine, as men with unclothed torsos press into a tangle of cables within a

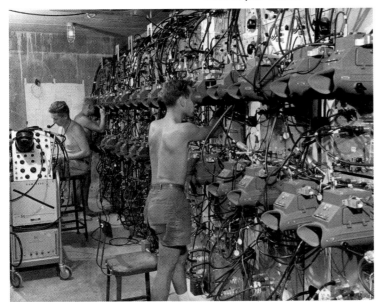

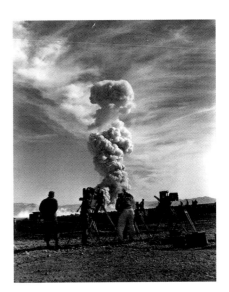

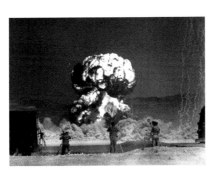

small, enclosed room. Shirtless and pipe-smoking, the men in this image demonstrate a casual familiarity towards highly specialised equipment, and a willingness to believe they are safe from the effects of these tests even when quite literally uncovered.

Part of what astonishes about these images is how unscientific they can be. In one from 1953, a Lookout Mountain camera crew takes images of the test code-named Grable (a dubious homage to the film actress Betty Grable). The cameraman who took this shot has stationed himself at a distance from the three figures in the foreground, deliberately stepped back in order to include them in his frame. Yet by doing so, he has obscured the base of the mushroom cloud, compromised its visibility in his desire to show the process of photographing. In many of these images, the photographer has detached himself slightly from his unit, moved his camera and tripod back a bit in order to highlight the presence of the camera, sometimes at risk of failing to capture the blast. Would a scientist not want to press forward rather than back, to get the clearest and closest picture, with the maximal amount of information? Or does this pulling away indicate a reasonable shirking from this deadly technology?

In the image, taken of the Priscilla test in 1957, the photographers are backlit by the intense obliterating light of the blast. The moment of explosion appears like innumerable suns condensed over the

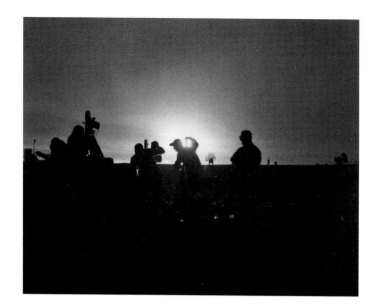

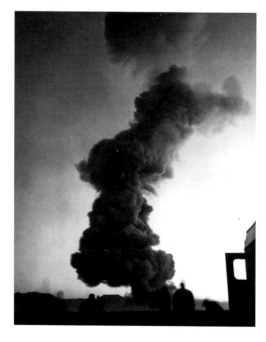

TOP LEFT
U.S. Military
*Operation Priscilla [Cameramen
Silhouetted at Moment of
Detonation, Nevada Test Site],* 1957

TOP RIGHT
George Silk
*Nevada sheriff backlit by an atomic
blast, Operation Teapot,* 1955

BOTTOM
U.S. Military
Operation Plumbbob/Hood,
5 July 1957

horizon, boring a hot white hole right through the sleeve of the
photographer. This image belongs to a subgenre of the subgenre
of nuclear test photography: pictures taken at the exact moment of
the atomic blast in which the overwhelming amount of light renders
the image difficult to read. Exposure was an extremely tricky matter
for nuclear test photographers, especially because the amount of
illumination generated by the blast varied so rapidly, such that "film
exposed properly at one moment will be overexposed at earlier times
and underexposed later".[13] In fact, former Department of Defense
photographer George Yoshitake reported that "the biggest challenge
was what kind of exposure do you use".[14] In another related shot

from 1955, a Nevada sheriff's face becomes a mask-like featureless blur as he stands proudly, one hand on his hip, the other on his car, as a bomb bleaches out the background some 40 miles away. And here, the shake caused by the shockwaves degrades the outlines of the photographers so seriously that the substance of their bodies virtually disappears, dematerialising them into phantoms or specters. This ghosting of figures echoes Akira Lippit's notion, in his suggestive book *Atomic Light (Shadow Optics)*, of how the "burning" archive of atomic imagery erases the line between visibility and invisibility.[15] In nuclear test photography, the divide between the thing itself and the representation takes on new meaning. Some soldiers who witnessed in person the Priscilla blast, which was billed as "a wonderful sight to behold", bled from every orifice of their face.[16] To look at a bomb directly is to do harm to oneself, but to look at the photo of the bomb is of a different order as that harm is neutralised.

It is important to note that the atomic tests performed in the 1940s and 1950s in the United States were for the most part public, performed in plain view of tourists and others eager to witness the spectacle. As historian Allan Winkler has stated, "Most Americans were initially enthusiastic about the tests. Recognizing that public support of the program was necessary to ensure continued congressional funding, the AEC [Atomic Energy Commission] courted the national press. The commentary that emerged played up the spectacular side of the tests and ignored potential dangers."[17] Though most of the images explored in this essay were taken by a secret corps of trained photographers and meant for military or governmental consumption, news photos of the blasts were published regularly in widely circulating venues like *Life* magazine and, in 1951, live footage was screened for the first time on television.[18]

Given the Cold War climate of competition, the lively nuclear test programme was a matter of not insignificant national pride; "open shots" were publicised and dignitaries were invited to witness the proceedings. In the photograph overleaf, a bank of nuclear test spectators, representatives from five European nations, sit on benches, as if watching polo at a country club, to watch the mushroom cloud rise. They wear no visible form of protection, as their safety goggles hang down unused. What look like security badges—they could also be dosimeters meant to measure radiation—dangle from their jacket pockets. This image is compelling not only for its nonchalance, but also because, like the others, it suggests a different kind of observer, as the person who took this photo has decided to turn away from the explosion instead of towards it. But there might have been a protective function in that act of turning away. A reporter recalls: "[W]e had explicit instructions—we were given heavy dark glasses for eye protection but even with that you couldn't look at the bomb. You had to turn around a hundred and eighty degrees [from] the area where the bomb was going to be detonated because the intensity was still so great."[19]

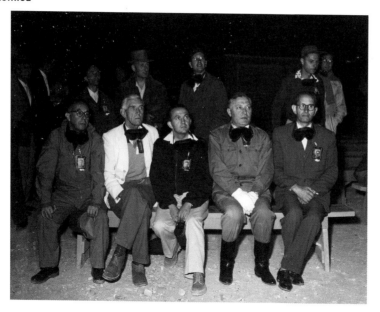

U.S. Military
Representatives of five European Nations watch the cloud formed by an atomic detonation, 24 July 1957

The flash of the bomb often acts in place of the flash of the camera in these images, and this substitution demonstrates how, in fact, there is a peculiar affinity between photography and atomic weapons, as the technology of sight and the technology of death are conjoined in an intimate marriage. As observers noted at the time, the tests photographed beautifully; their dramatic shapes were understood as spectacularly conducive to optical capture. Think back to Grable, both the actress who was famous for how the camera loved her face, as well as the atomic test blast, frozen on film: it is as if the mushroom cloud courts or solicits the camera's gaze. Yet as we have seen, the blasts also carry the potential to damage the film that desires to register them, as well as the potential to harm the bodies behind the cameras that are clicking the shutters. In one of the most widely read and cited texts on photography, Roland Barthes' *Camera Lucida*, he says photography and its referent with their "funeral immobility" are "glued together, limb to limb, like the condemned man and the corpse in certain tortures".[20] In nuclear test photography, preservation and destruction are pressed together with even more intimacy, as the deathly referent *acts upon* the photographer, with a temporal lag that is challenging to account for.

At the time, the hazards of these tests were of scant concern to the military that conducted them; atomic veterans near detonation sites went through only the most cursory decontamination procedures, including having radioactive waste brushed off of them with brooms.[21] Residents who lived near the test sites (aka "down-winders") were regularly assured that fallout would bypass their towns, and that the plumes of smoke and other debris did not pose significant health concerns.[22] Not only that, but the indigenous residents and the ecosystems of these regions were utterly ignored. As Valerie Kuletz writes in her book *The Tainted Desert*, "Native peoples and their lands constitute an invisible presence in areas heavily occupied by the US military and Department of Energy.... [This book] attempts to make visible the close proximity of Indians and military and nuclear regions

and to show how a consistent pattern of nuclear colonialism—suggesting environmental racism—might emerge."[23]

To witness these images now, some 60 years after the era of atmospheric nuclear testing in the US, is also to bear witness to a kind of injury that in fact *thwarts* photography. So while there might be an affinity between the camera and the blast, at the same time, the photograph, with its immediacy, its grasp of the instant, the way it captures *this thing here now*, is also totally unsuited to record the unique kinds of destruction wrought by radiation. It cannot depict the slowly blooming invisible damage that accompanies these blasts and shoots itself into our atmosphere and into bodies, damage that can in fact take years, even decades to reveal itself. In a photograph from 1957, five volunteers shield the light of a bomb from their eyes with their hands. They are standing right at ground zero as an air-to-air nuclear missile is detonated 10,000 feet above their head, with no protective goggles or outfits. The man who took this image (and is hence not pictured, but hovers implicitly outside the frame), George Yoshitake, is one of two of these men who is still alive; all of them have had cancer.[24]

Yoshitake recalls asking what sort of protection he would be given, and when the answer was "none", he brought a baseball hat; unlike the others, he was not a volunteer. He recounts: "I thought it was just another job to do."[25] It was a job with consequences: the life expectancy for atomic workers is on average 57 years, and they have above average rates of cancer, infertility, heart conditions, chronic respiratory illness, skin carcinomas, hepatitis c and leukaemia.[26] Diseases caused by exposure to radiation can have latency periods of 40 years or more, and are not just contained to a single body; children of atomic workers have high rates of cancer, genetic mutations and birth defects.[27] This intergenerational unfolding of lingering effects is something that a photograph, which has an insistently present temporality, is not well-equipped to capture. Faced with the temporality of radiation, the fundamental insufficiency of photography as a document of causality is revealed.

Photographs have been used—often unsuccessfully—to try to prove governmental culpability in the US and elsewhere for illnesses faced by nuclear weapons workers and servicemen. An article published in 2002 in the British *Sunday Mirror* makes the paradox very clear. It focuses on a single photograph of four British officers in the Pacific, as "behind them a giant mushroom cloud balloons in the sky, one of Britain's biggest A-bomb tests".[28] Three of these men suffered serious health concerns, including cancer and diabetes, yet the British Ministry of Defense refused to acknowledge that they had been put in harm's way. One veteran says, "The photograph proves it. But when I asked the MoD for a pension they said I was not in an area affected by radiation. They even said the film badge must have been issued to me as part of a simulation exercise." The photograph was considered insufficient indication of proximity to radiation, and even the presence of dosimeters on their uniforms was not reliable or convincing enough.

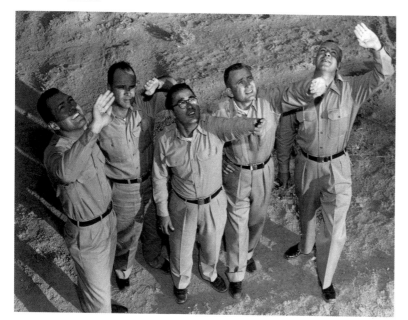

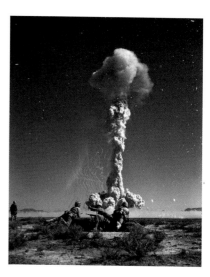

Because of its truth claims, photography can appear convincingly transparent, but it is also subject to manipulation and simulation, and can unravel in the face of demands for hard evidence or conclusive scientific proof. Again, to quote Barthes: "the photograph is a certain but fugitive testimony".[29] Photography becomes unfixed as evidence for long-term damage because it cannot connect the *then* to the *now* with any firm causality.

At the same time that governments shrewdly and disingenuously deny the weight of photographic "proof", photography has persistently been marshalled by activists and artists to provide affective, moving witness regarding the negligence and disregard faced by nuclear workers and "down-winders".[30] In 1993, Carole Gallagher published her book *American Ground Zero*, an important document regarding the devastation caused by the US nuclear weapons. One image places a wife and daughter in front of a blown-up photograph of a man, Hap Lease, who worked at the Nevada Test Site for 14 years. The photograph-within-the-photograph is a close-up of Lease, taken when he was about to die of thyroid cancer showing his neck ravaged by large ulcerating tumors. Their caption: "A Gift From Our Government! Cost: A Life and $193,000". Photos like this have not always been enough to convince the US military that its Cold War operations were irresponsible and careless—and many veterans still have received very little monetary compensation for the illnesses wrought on themselves and their families by their duties.

Barthes' grim but wholly apt assessment about "the rather terrible thing which is there in every photograph: the return of the dead" is true in a new way when looking at images of nuclear test photography, as so many of these men died before their time.[31] Recall his certain words when gazing at a handsome young man named Lewis Payne in his cell as he waited to be hanged: *"he is going to die"*.

LEFT
U.S. Military
Five Air Force officers are observers at Ground Zero during the explosion of the first air-to-live atomic rocket ever fixed from a manned aircraft, 1957

RIGHT
U.S. Military
Operation Tumbler-Snapper, 1952

A GIFT FROM OUR
GOVERNMENT !
COST:
A LIFE AND
$ 198,000.00

Carole Gallagher
*Bonnie McDaniels
and Marjorie Lease*, June 1986

In this photograph of the Tumbler-Snapper test shot at Yucca Flat, Nevada, the handsome young Marine in the middle has turned away from the bomb. Our eyes may be drawn to the cloud with all its powers of destruction, but to look at this man, whose face meets ours as he poses and points for a camera, is also to stare at death: SMILE.

NOTES

1 Though this essay is focused on the United States, other countries, most prominently the Soviet Union, also conducted atmospheric nuclear tests in this period. Most tests were sent underground after the passing of the Limited Test Ban Treaty in 1963, though France and China, who were not signatories, continued this practice until at least 1980. Histories (both academic and anecdotal) of the United States nuclear weapons testing programme can be found in Jane Dibblin, *Day of Two Suns: US Nuclear Testing and the Pacific Islanders,* New York: New Amsterdam Books, 1990; Richard Miller, *Under the Cloud: The Decades of Nuclear Testing,* New York: Free Press, 1986; A Constandina Titus, *Bombs in the Backyard: Atomic Testing and American Politics,* Reno, Nevada: University of Nevada Press, 1986.

2 Donald E English furnishes a first-person account of photographing blasts as a reporter from News Nob in his oral history with Michael Childers, conducted on 25 March 2004 as part of the Nevada Test Site Oral History Project, University of Las Vegas, Nevada. http://digital. library.unlv.edu/api/1/objects/nts/1178/bitstream.

3 Kuran, Peter, *How to Photograph an Atomic Bomb,* Santa Clarita, CA: VCE, 2006, p 18.

4 Images of the immense destruction wrought by the US atomic bombing of Hiroshima and Nagasaki in August 1945 are perhaps the most powerful of their kind, yet they are lesser known, and arguably still relatively unassimilated, within US culture. By contrast, the mushroom cloud quickly ascended to American pop cultural status, as evidenced by works such as James Rosenquist's *F-III* from 1964–1965, which was painted just as the era of above-ground testing ceased. Artist Takashi Murakami has discussed the cultural importance of Hiroshima and Nagasaki and the shadow of atomic threat, both explicit and repressed, within Japanese culture in his exhibit and accompanying book *Little Boy: The Arts of Japan's Exploding Subculture,* New York: Japan Society, 2005.

5 Du Camp famously used a Nubian sailor named Hajj-Ishmael rather than himself or one of his travel companions as the human registrar of scale in his photos from Egypt; for more on the rhetoric of inertness, class, and racial difference within these images, see Julia Ballerini, *The Stillness of Hajj-Ishamael: Maxime Du Camp's Photographic Encounters,* New York: iUniverse Inc, 2010.

6 For more on tourist photography, see Richard Chalfen, "Tourist Photography", *Afterimage,* summer 1980, pp 26–29.

7 Sontag, Susan, *On Photography,* New York: Vintage, 1977, pp 7, 14.

8 One touchstone text that both affirms and complicates this notion is Rosalind Krauss, "Notes on the Index, Part I", 3 October, spring 1977, pp 68–81.

9 Sontag, *On Photography,* p 13.

10 English, Oral History, p 4.

11 Broad, William J, "The Bomb Chroniclers", *The New York Times,* 13 September, 2010, D1.

12 Kuran, *How to Photograph an Atomic Bomb,* p 38.

13 Kuran, *How to Photograph an Atomic Bomb,* p 71.

14 Quoted in Kuran, p 71.

15 Lippit, Akira Mizuta, *Atomic Light (Shadow Optics),* Minneapolis: University of Minnesota Press, 2005, p 9.

16 Gallagher, Carole, *American Ground Zero: The Secret Nuclear War,* New York: Random House, 1993, up.

17 Winkler, Allan, *Life Under a Cloud: American Anxiety about the Atom,* New York and Oxford: Oxford University Press, 1993, p 91.

18 For more on the popular cultural reception of nuclear technology in this era, see Paul Boyer, *By the Bomb's Early Light: American Thought and Culture at the Dawn of the Atomic Age,* New York: Pantheon Books, 1985. More specific information on civil defense campaigns is found in Tracy C Davis, *Stages of Emergency: Cold War Nuclear Civil Defense,* Durham: Duke University Press, 2007.

19 English, Oral History, p 9.

20 Barthes, Roland, *Camera Lucida: Reflections on Photography,* New York: Hill and Wang, 1981, p 6.

21 A news photograph of a solider brushing off nuclear fallout with a broom, from 1952, appears in Titus, *Bombs in the Backyard,* p 117.

22 See Fradkin, Philip L, *Fallout: An American Tragedy,* Tucson, AZ: University of Arizona Press, 1989.

23 Kuletz, Valerie L, *The Tainted Desert: Environmental and Social Ruin in the American West,* New York: Routledge, 1998, p xv. See also the essays in *The Atomic West,* Bruce Hevly and John Findlay, ed, Seattle, WA: Washington University Press, 1998.

24 Stenovec, Timothy, "George Yoshitake, Nuclear Test Photographer, Recalls Filming Nuclear Blast 55 Years Ago", *The Huffington Post,* 20 July 2012, http://www. huffingtonpost.com/2012/07/20/george-yoshitake-nuclear-test-five-5-men-nevada_n_1687233.html.

25 Quoted in Stenovec, "George Yoshitake, Nuclear Test Photographer, Recalls Filming Nuclear Blast 55 Years Ago".

26 Baggs, Albert C, "Under a Cold War Cloud: British Servicemen who witnessed post-WWII atomic

tests over the Pacific blame the bomb—and the
government—for a constellation of illnesses", *Time*
magazine, 30 March 1998.

27 Gallagher, *American Ground Zero,* xxv.

28 Rimmer, Alan, "Curse of the A-Bomb: Ministry of
Defense Deny These Troops Were Ever Exposed to
Radiation, So Why Has Disease Struck Down Three of
Them?", *Sunday Mirror,* 8 December 2002.

29 Barthes, *Camera Lucida*, p 93.

30 In a somewhat different realm, nuclear technologies
have been fodder for fine-arts photographers who
are drawn to it in part for aesthetic purposes. See, for
instance, Jim Sandborn *Atomic Time; Pure Science and
Seduction*, Washington, DC: Corcoran Gallery of Art, 2004;
and Michael Light, *100 Suns* , New York: Knopf, 2003.

31 Barthes, *Camera Lucida*, p 9.

Hiroshima and Nagasaki

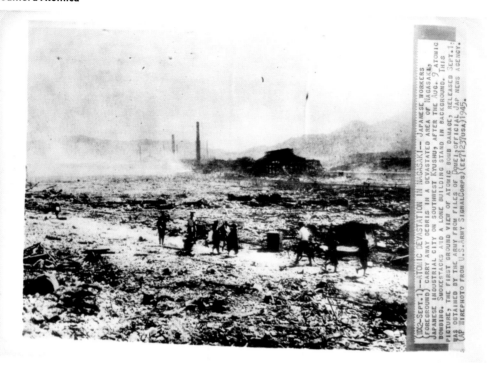

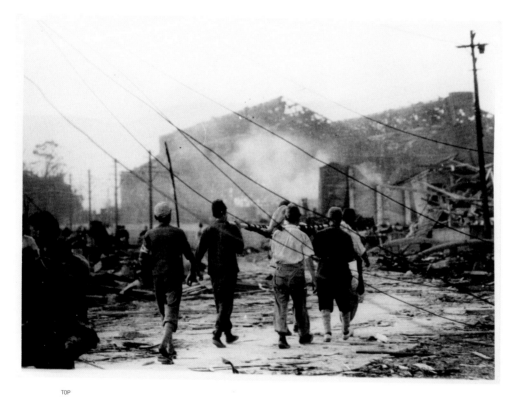

TOP
Yosuke Yamahata
View south from hill east to prefectural road near Hamaguchimachi, about 250m from epicenter. On left center, there stand only walls of Mitsubishi Arsenal Hamaguchimachi dorm, 10 August 1945, c 1 pm

BOTTOM
Yosuke Yamahata
Rescue Activity. The buildings behind are Mitsubishi Steel Factory 1 and 3. South edge of Iwakawamachi near Urakami station, about 1km from epicenter, 10 August 1945, c noon

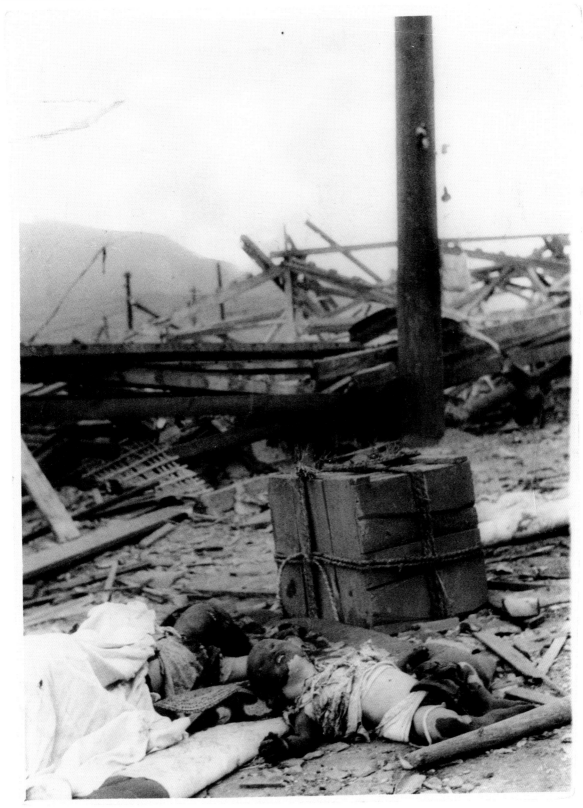

Yosuke Yamahata
*Dead mother and child. The black areas of the bodies were vermilion
brown and the face of the child was swollen. Kawaguchimachi (formely
Iwakawamachi), about 1km south of epicenter,* 10 August 1945, c noon

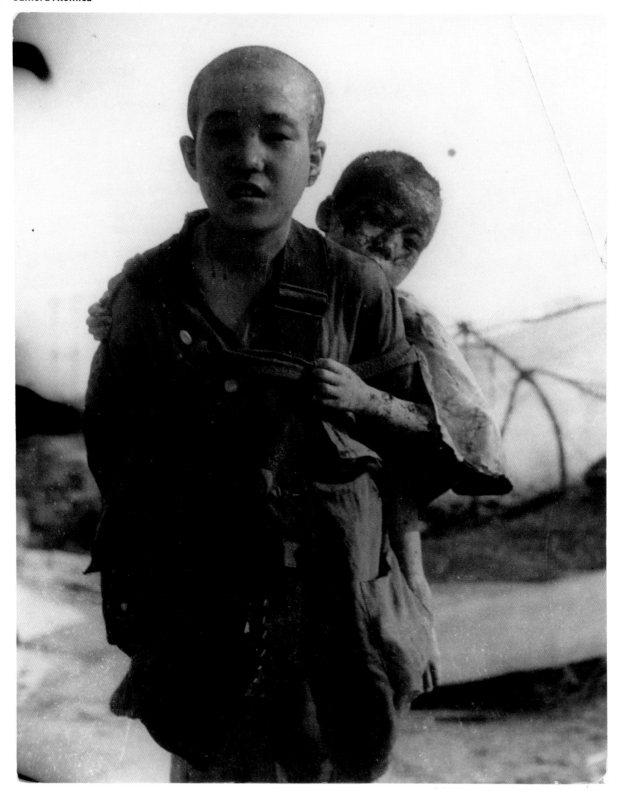

Yosuke Yamahata
Boy carrying his wounded brother on his
back searching for relatives, near Nagasaki
station, 2.2km south of epicenter,
10 August 1945, morning

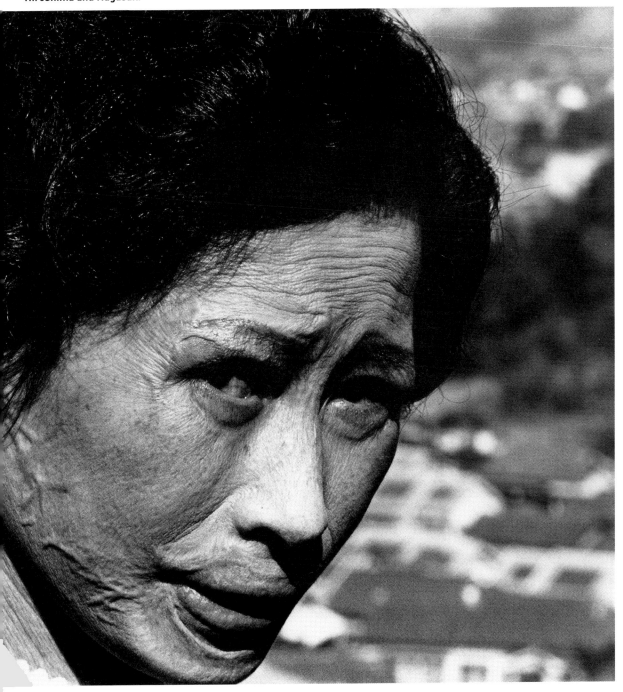

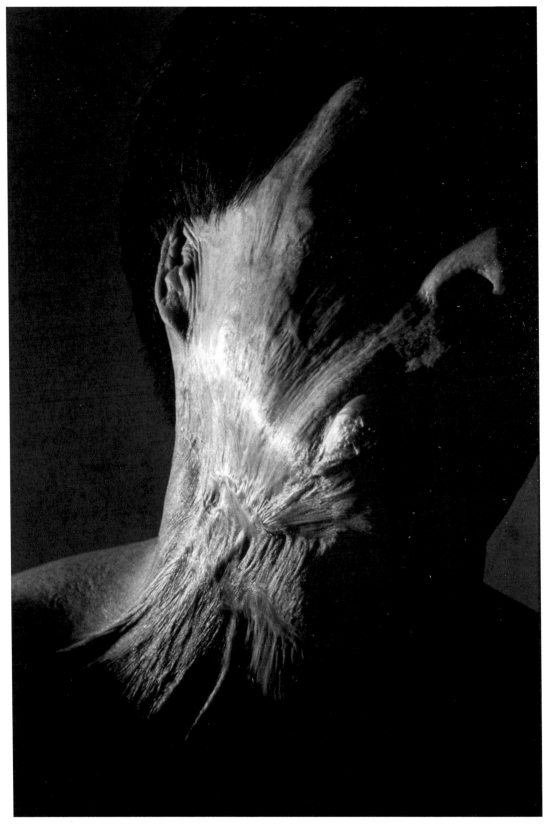

Shomei Tomatsu
Hibakusha Senji Yamaguchi, Nagasaki,
1962; printed 1980

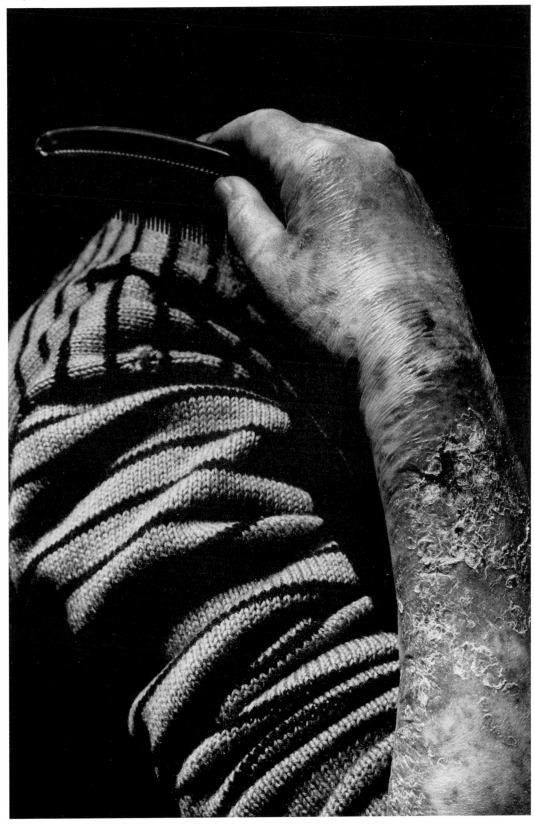

Shomei Tomatsu
Woman Suffering from an Atomic
Disease, 1961

Shomei Tomatsu
Girl Who Experienced the Atomic
Bomb Explosion While Still in her
Mother's Womb, 1961

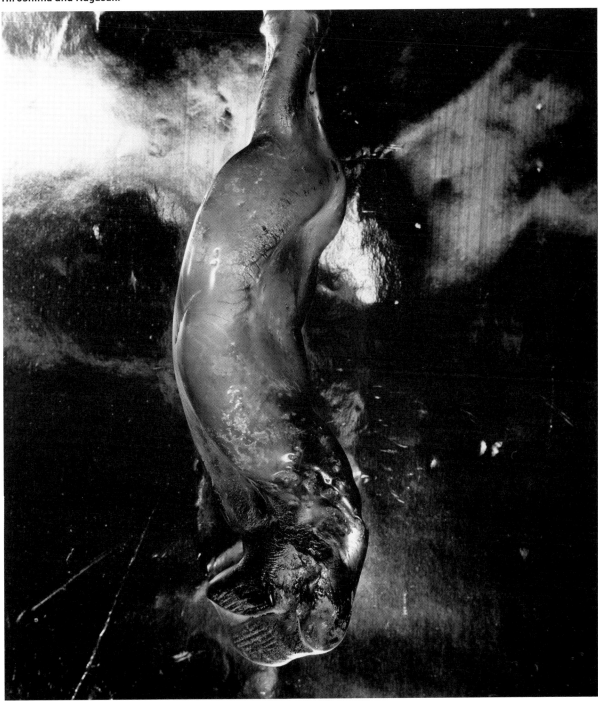

Shomei Tomatsu
Beer Bottle After the Atomic Bomb
Explosion, 1961

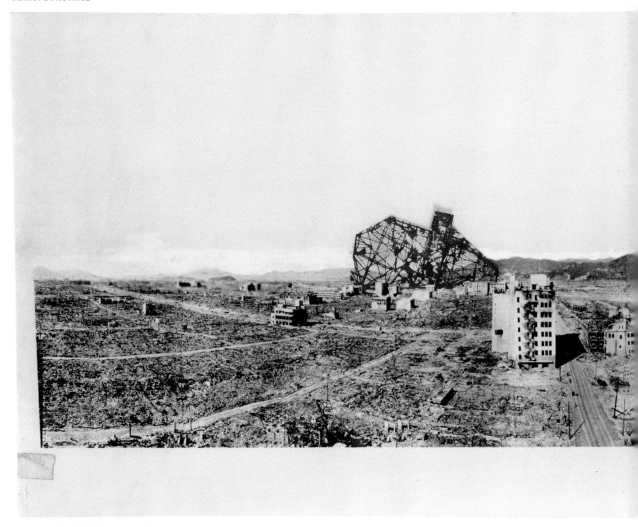

Arata Isozaki
Re-ruined Hiroshima Project,
Hiroshima, Japan, Perspective, 1968

Arata Isozaki '68

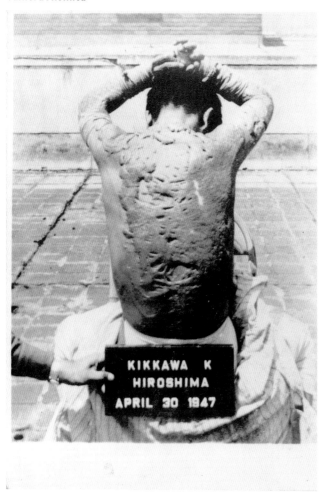

Unknown
Atomic Bomb Victim No. 1,
Kiyoshi Kikkawa, 30 April 1947

John Launois
On the Atomic Bomb Memorial Day, 1961

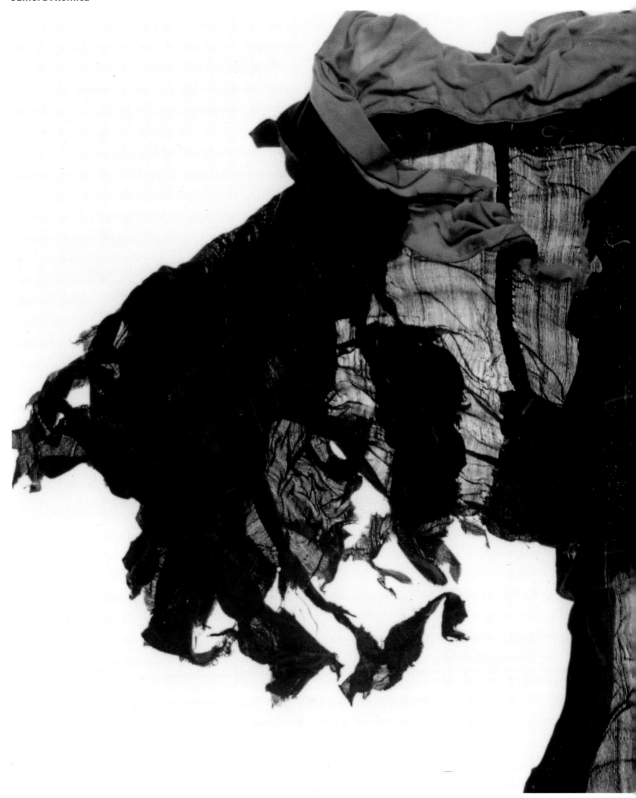

Ishiuchi Miyako
ひろしま/*hiroshima #13,*
Girl student's jacket, 2007

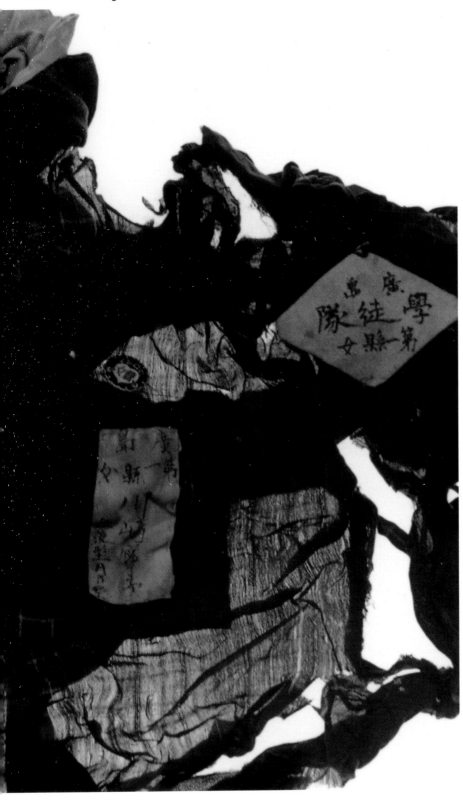

Ishiuchi Miyako
ひろしま/*hiroshima #21,*
Girl student's uniform, 2007

Ishiuchi Miyako
ひろしま/*hiroshima #5,*
Dress, 2007

elin o'Hara slavick
Groundskeeper Broom, 2008–2011

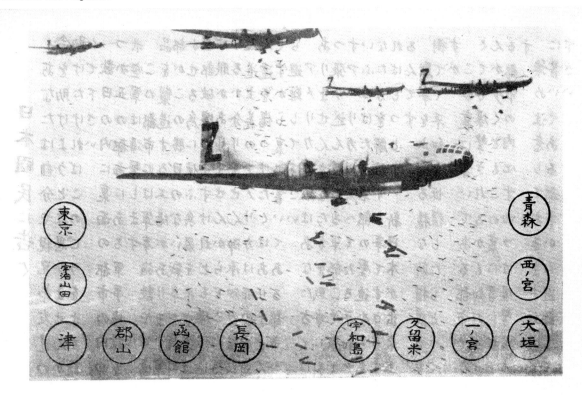

U.S. Army Air Force
Leaflet Dropped on Japanese Cities
Prior to the Bombing of Hiroshima
and Nagasaki, 27 July 1945

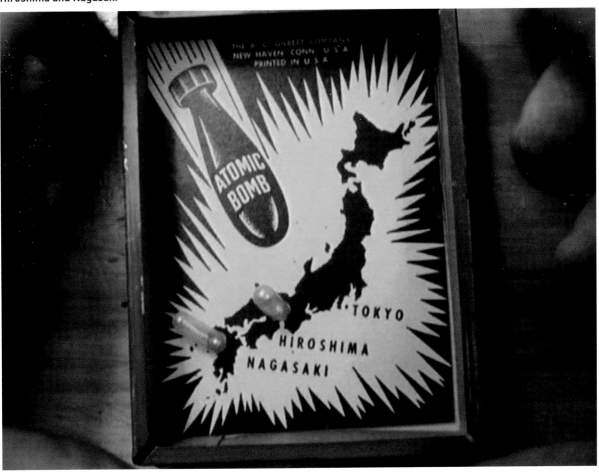

Jeremy Borsos
A. C. Gilbert Company, 2008

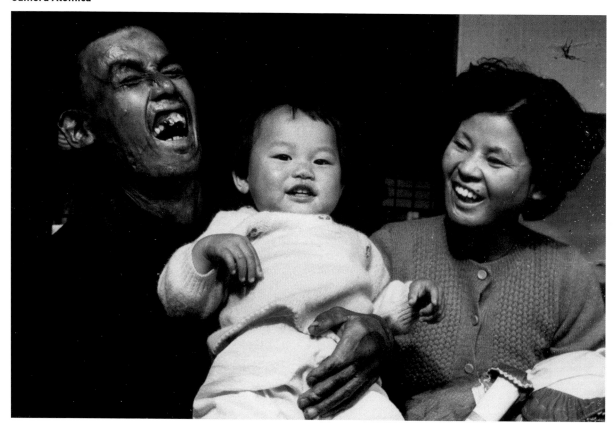

Ken Domon
Mr and Mrs Kotani: Two Who Have
Suffered from the Bomb, 1957

Ken Domon
Untitled [Girl on a Swing], 1957

Hidden and Forgotten Hibakusha: Nuclear Legacy

Hiromitsu Toyosaki

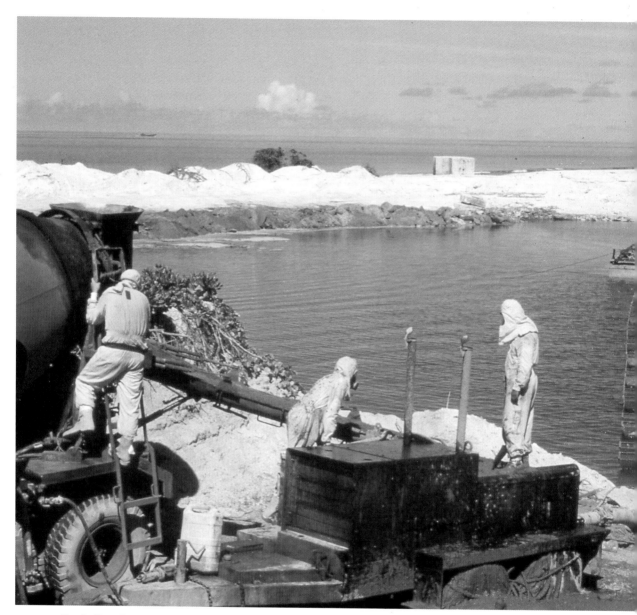

Hiromitsu Toyosaki
*Enewetak Atoll: A Cleanup Campaign to
Eliminate Residual Radiation Ended in
Failure,* September 1978

The year 2012 marked the seventieth anniversary of two events: the beginning of the Manhattan Project to develop the atomic bomb and the creation of the first successful self-sustaining nuclear fission reaction at the University of Chicago.

The first atomic bomb utilising nuclear fission was tested by the United States in the New Mexican desert on 16 July 1945. About three weeks later, on 6 August, the United States dropped the first of its newly developed atomic bombs on Hiroshima, and on 9 August a second on Nagasaki, killing and injuring several hundred thousand people. Those people were the first *hibakusha*, but the more than 2,050 nuclear tests that have been conducted since 1945 by the United States, the former Soviet Union (USSR), Great Britain, France, China, India, Pakistan and North Korea have created many more.[1]

Nuclear fission is also used in nuclear power generation. In 1954, the USSR began use of its first commercial nuclear power plant, located in the city of Obninsk. By late 2011, commercial nuclear power plants housing about 580 reactors were, or had been, in operation in 31 countries, and accidents involving meltdowns and explosions at the Three Mile Island Nuclear Power Plant in the US, the Chernobyl Nuclear Power Plant in the USSR, and the Fukushima Daiichi Nuclear Power Plant in Japan had all resulted in the release of large amounts of radiation, creating many more *hibakusha*.

Hibakusha resulting from uranium mining

Nuclear weapons, nuclear tests and nuclear power plant accidents are not the only ways *hibakusha* are created. Some are created by the mining and milling of uranium, the radioactive element used in the production of nuclear weapons and power.

Uranium mining was begun in the eighteenth century and mining companies have long known of the dangers of radiation, but the knowledge has not been shared with miners and communities located near uranium mines. In 1942 when the United States began the Manhattan Project, uranium was mined in the Belgian Congo (Democratic Republic of the Congo), Port Radium in the Northwest Territories of Canada, Czechoslovakia, and the American states of Arizona and Utah.

According to George Blondin, a member of the indigenous Dené Nation and a resident of Port Radium, "Uranium mines were run by white people. We lived in front of the mine, and were told that drinking water released from the mine was prohibited, but a lot of people drank it anyway. I lost my wife and sister to cancer. They drank water from the mine."[2]

Joe Billy, a Native American and member of the Navajo Diné Nation, worked as a miner in Arizona and developed lung cancer. "The mining company would hire anyone who was over the age

of 16 and had a shovel. They did not tell us that uranium was dangerous. Inside the mine there was a lot of dust and we got very thirsty, so we would often drink spring water. We ate our lunch in the mine, too."[3] Uranium mining and milling on Diné reservations in Arizona, Utah, New Mexico and Colorado was conducted from 1942 to 1986. The mines were not filled in after they were closed, and piles of uranium waste and mill tailings were just left exposed.

The infant mortality rate of the Diné is higher than the US national average. One cause is believed to be the waste and tailings dumps located in the vicinity of where many people live. Another is that the materials used by many Diné for housing construction contain uranium.

In 2012, uranium was being mined and milled in 19 countries. Regardless of the location, when mines and mills are closed, the waste and tailings are dumped and no effort made for decontamination, restoration or recovery. Left exposed to the elements, radiation from these dump sites has continued to damage the natural environment and the health of people living nearby.

Hibakusha resulting from nuclear testing

Of the 2,050 nuclear tests that have occurred worldwide, those that resulted in the largest number of *hibakusha* were the more than 500 atmospheric tests conducted between 1945 and 1980 by the US, USSR, Great Britain, France and China.

The first nuclear test conducted after the Second World War was at Bikini Atoll in the Marshall Islands in July 1946. American officials told the Bikinians that they had to leave their island so that it could be used, "For the good of mankind and to end all world wars", and by 1958 the US had conducted 23 atmospheric tests there. During that time, the Bikinians were moved from island to island in the Marshalls, at times even falling in danger of starvation. In 1968, the US government declared that Bikini Atoll had been decontaminated and was "safe for rehabitation". The Bikinians believed this declaration and moved back to their island, but soon found that their internal radiation levels had risen due to the contamination of local foods such as coconuts. In August, 1978, they were again made to leave their island, and are still not able to return. In 2010, Bikini Atoll was listed by UNESCO as a World Heritage Site, but no one can go there.

In addition to Bikini Atoll, the United States chose Enewetak Atoll for nuclear testing in the Marshall Islands. After moving the residents to another island, the US conducted 44 atmospheric tests there between 1948 and 1958. In 1978, work to remove residual radiation was begun. Contaminated soil was mixed with concrete and dumped into the crater left by a nuclear bomb explosion. In 1980, the cleanup was declared complete and the

Hiromitsu Toyosaki
Bikini Atoll: Contamination Forces
Islanders to Move On, August 1978

residents moved back. However, in spite of decontamination efforts, entry into the northern part of the atoll was prohibited due to radiation. The people of Enewetak were able to return to their atoll, but could live only on the three southernmost islands.

Of all the nuclear tests conducted by the United States in the Marshall Islands, a series of six hydrogen bomb tests conducted in the vicinity of Bikini Atoll between March and May 1954 called Operation Castle resulted in the most *hibakusha*. In particular, the enormous amount of radioactive fallout from the 1 March hydrogen test Bravo (15 megatons: 1,000 times the power of the Hiroshima atomic bomb) created many new *hibakusha*.

On Rongelap Island, 180 kilometres from the blast, radioactive fallout described by local people as "white powder" or "something like snow" began falling before noon and by sundown was four centimetres deep, Medadrik Kepenli recalled that day. "I saw a plane flying, so I thought the Americans were dropping white flour. When the powder fell on my arms, it was hot. I tasted it, but it was bitter so I knew it wasn't flour."[4] Jabwe Jorju, a health aide, said that, "In the evening I

Hiromitsu Toyosaki
*Enewetak Atoll: Concrete Grave for
Dirt Contaminated by Radiation from
Nuclear Tests*, September 1994

felt nauseous and didn't want to eat anything. The children said they felt nauseous too, and didn't eat, so I thought we were all going to die."[5] The 86 Rongelap Islanders (including four in utero) suffered from acute symptoms such as nausea, vomiting and burns and were evacuated by the US military, but not until about 51 hours had passed. By then, the people had been exposed to 2,200 millisieverts (msv) of radiation, an amount which, if calculated as an annual exposure rate, would result in death for half of the exposed population.

Others contaminated by the Bravo shot included 28 US soldiers at a weather station on Rongerik (270 kilometres away) who were exposed to 400 msv of radiation, and 166 residents of Utrik (including nine in utero) who were 470 kilometres away from the blast and exposed to 140 msv. Radioactive fallout from the Bravo hydrogen bomb test also fell on the northeastern islands of the Marshalls, causing many people to become *hibakusha*.

On 1 March, the Japanese tuna boat *Lucky Dragon No. 5* was working outside of the exclusion zone of the Bravo test. The 23 crew members were exposed to similar amounts of radioactive fallout as the Rongelap Islanders, and displayed similar symptoms such as nausea, vomiting, burns and loss of hair when they returned to their home port in Japan on 14 March.

In 1957, three years after being contaminated by radioactive fallout from nuclear tests, the Rongelap Islanders returned to their island. What they had not been told was that the fallout on the island had not been removed. According to the 1957 *Medical Survey of Rongelap and Utrik People* by the Brookhaven National Laboratory, "The habitation of these people on the island will afford most valuable ecological radiation data on human beings." After the Islanders returned, women began to experience miscarriages and stillbirths. Later, people developed thyroid abnormalities, leukaemia and cancer. In the 1980s, deformities of the internal organs, hands and feet began to appear in third generation babies. In May 1985, having determined there was still radioactive fallout on the island, the entire population relocated to Mejato, an island about 190 kilometres south of Rongelap, citing as their reason, "the future of our children."

Between 1951 and 1962, the United States conducted 86 atmospheric nuclear tests at the Nevada Test Site. As a result, 170,000 people living in downwind areas in Nevada, southern Utah and northwestern Arizona became *hibakusha*.

The USSR conducted more than 200 atmospheric nuclear tests between 1949 and 1962 in Kazakhstan at the Semipalatinsk Test Site and at Novaya Zemlya Island. About 1.5 million Kazaks living in the steppes became *hibakusha*. The Nenet people living on Novaya Zemlya were forced to evacuate the island before the tests were conducted, and the explosions made *hibakusha* of indigenous Nenet and Komi people living on the coast of the Barents Sea.

The British conducted 24 atmospheric nuclear tests between 1952 and 1962 in Australia, and on Malden and Christmas Islands (part of the present Republic of Kiribati) in the South Pacific. Australian Aborigenes and South Pacific islanders in the vicinity of the test sites became *hibakusha*.

France conducted four atmospheric nuclear tests in the Sahara Desert in Algeria between 1960 and 1966. Algerians and nomadic Tuareg people became *hibakusha*. In addition, between 1967 and 1974, France conducted 44 atmospheric nuclear tests at the South Pacific atolls of Moruroa and Fangataufa, causing many Polynesians to become *hibakusha*.

Between 1960 and 1980, China conducted 22 atmospheric nuclear tests at the Lop Nor Nuclear Test Site in the Xinjiang Uygur Autonomous Region, but no information about *hibakusha* resulting from the tests or harm to the local Uygur people has been made public. In the Altai region where the borders of China, Kazakhstan, Russia and Mongolia converge, however, there have been reports of abnormal births in yaks and a high incidence of liver cancer in humans. As this region is located downwind of both the Soviet Semipalatinsk nuclear test site and the Chinese Lop Nor test site, the cause is believed to be exposure to radioactive fallout from atmospheric nuclear tests.

All of the above countries mobilised soldiers to prepare for the nuclear tests and engage in decontamination and other tasks

afterwards. Large numbers of these soldiers became *hibakusha*. The majority of these "nuclear soldiers" were made to participate in military exercises held under the mushroom clouds from nuclear tests to simulate nuclear war conditions. In the United States, these soldiers were called "human radiation meters" or "human dosimetres".

The spread of radioactive fallout to locations far removed from the atmospheric nuclear test sites began in 1953 when the United States exploded the world's first hydrogen bomb. A year later, 1954, the six hydrogen bomb detonations comprising Operation Castle spread fallout over the entire world. According to a report released by the United Nations Scientific Committee on the Effects of Atomic Radiation in 2000, atmospheric nuclear tests have released approximately three million petabecquerels of radioactive fallout which has dispersed around the globe. This means that the term *hibakusha* applies not only to people in the vicinity of nuclear test sites, but to the entire human race.

Hibakusha resulting from nuclear plant accidents

In the 1960s, as American advances in technology made the use of light water reactors practical, operation of commercial nuclear power plants expanded around the world. Light water reactor fuel requires large amounts of slightly enriched uranium, so many uranium processing workers became *hibakusha*. In addition, the increase in light water reactors meant that workers in the plants who were responsible for the running, maintenance and inspection of the reactors, as well as workers involved in the disposal and processing of spent fuel and nuclear waste joined the growing numbers of *hibakusha*.

On 28 March 1979, not long after the commercial use of nuclear power had become international, a meltdown resulting in the release of radiation occurred in the Number Two Reactor at the Three Mile Island Nuclear Power Plant in Harrisburg, Pennsylvania. This exploded the myth that "nuclear power is cheap and safe". Mary Osborne lived about ten kilometres north of the plant. She had just stepped outside to see her husband off to work when she sensed a metallic taste to the air. Two days later, on 30 March, the governor of Pennsylvania announced that due to radiation released during the accident, people living within eight kilometres of the plants should evacuate, and those living within 16 kilometres should refrain from going outside. Mary took her children and went to stay with friends living 80 kilometres away. She returned eight days later but she made sure to clean thoroughly and to wash their clothes every day. "I felt I could smell the radiation from the accident and I couldn't stand it. I guess I must have been in bad shape mentally."[6]

The power company reported that there had not been much radiation released, but after the accident large numbers of birds were found dead of unnatural causes in the areas surrounding the

On 11 March 2011, an earthquake and tsunami originating in the Pacific Ocean off the coast of northeastern Japan caused meltdowns and explosions in four reactors at the Fukushima Daiichi Nuclear Power Plant, releasing a large amount of radiation and making *hibakusha* of approximately two million residents of Fukushima Prefecture as well as many other people in Japan. About 150,000 people living in the vicinity of the plant were forced to evacuate to places outside of Fukushima Prefecture. Today, three years after the accident, they are still unable to return to their homes.

Within about two weeks of the accident, radiation from the Fukushima Daiichi plant had spread across the northern hemisphere, and about a month later it had reached Australia, Papua New Guinea and other places in the southern hemisphere. An enormous amount of radioactive water continues to leak into the Pacific Ocean.

Hibakusha **and human rights**

Hibakusha are created at every phase of the nuclear cycle—uranium mining and milling, production and testing of nuclear weapons, production of nuclear fuel, operation of nuclear power plants and treatment of nuclear wastes. For the past 70 years, *hibakusha* the world over have suffered from damage not only to their health, but also to their mental well-being. Nuclear contamination has forced *hibakusha* to leave their homes, often for long periods of time or permanently. Protracted relocation destroys communities, local culture and traditions. Nuclear contamination also destroys the natural environment, essential for the survival of all human and other life.

Of all the people who have been hurt by the nuclear cycle, those who have suffered most are indigenous peoples whose lives depend on living in harmony with nature. In September 1992, at the World Uranium Hearing in Salzburg, Austria, the representative of indigenous peoples from the 120 participating countries and regions stated, "75 per cent of uranium mining and milling takes place on our land, indigenous land, and is destroying our sacred places which are at the center of our lives. All of the nuclear test sites are in places inhabited by indigenous people. It is not enough that we have been hurt by uranium mining and milling and nuclear testing. Now nuclear waste is being dumped on our land. This is modern nuclear racism which forces indigenous peoples to bear the brunt of damage from the nuclear cycle." The UN Declaration on the Rights of Indigenous Peoples adopted in September, 2007, calls for respecting the rights of indigenous peoples, but damage to indigenous communities from the nuclear cycle continues unabated.

In 2012, the UN Human Rights Commission Special Rapporteur conducted an investigation of the *hibakusha* resulting from US nuclear testing in the Marshall Islands and from the Fukushima Daiichi Nuclear Power Plant accident. With regard to the Marshall Islands *hibakusha*, the Special Rapporteur noted that the failure of

the United States to fully disclose the extent of the damage from the nuclear tests threatened their health and ability to procure safe food and water, destroying their capacity for sustainable livelihoods, and that insufficient monetary compensation and medical treatment also constitute violations of their human rights. Moreover, rights violations clearly occurred when nuclear contamination forced Islanders to become "refugees", leaving their homes and scattering to other islands.

The Rapporteur also noted violations of human rights in those affected by the Fukushima Daiichi Nuclear Power Plant accident. Failure to provide information to the public about the release of radiation immediately after the accident caused harm to many people; distribution of iodide to prevent thyroid cancer was not conducted properly; and follow-up health checks for those affected have been insufficient. In addition, the level of permissible radiation set by the Japanese government is too high, and was established in order to encourage people to return to their communities, not to ensure their safety.

Hibakusha have the right to know the origin and amount of radiation to which they have been exposed. They also have the right to proper treatment and compensation for the loss of their health and property, and to be protected from exposure to excessive amounts of radiation. The Special Rapporteur noted that exposure to radiation ignores the fundamental right of people to live in safety and health.

There are many people around the world who suffer from contamination incurred at each step of the nuclear cycle, but the ones we know about are only very few of the total number of *hibakusha*; the rest remain hidden. All incidences of contamination must be disclosed immediately, and all *hibakusha* offered proper treatment, compensation, and the opportunity for a safe and healthy life.

Ronni Alexander
English translation

NOTES

1 *Hibakusha*: someone exposed to an injurious dose of radiation.

2 George Blondin interviewed by the author, Salzburg, Austria, 1992.

3 Joe Billy Interviewed by the author, Arizona, USA, 1980.

4 Medarik Kepenli interviewed by the author, Rongelap, Marshall Islands, 1985.

5 Jabwe Jorju interviewed by the author, Rongelap, Marshall Islands, 1985.

6 Mary Osborne interviewed by the author, Harrisburg, Pennsylvania, USA, 1987.

7 Klos Klemtesson interviewed by the author, Jemtland, Sweden, 1996.

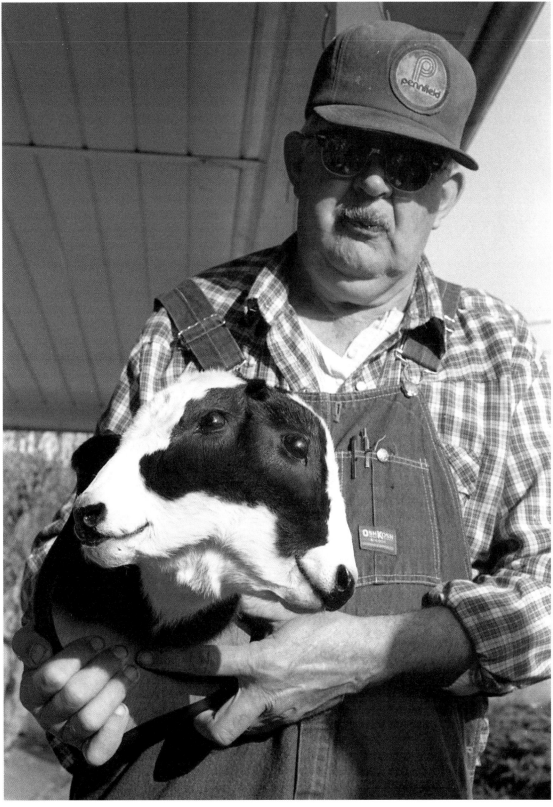

Hiromitsu Toyosaki
Herbert Mayer's Farm, 15 Kilometres Northwest of the
Three Mile Island Plant, March 1989

Acknowledgements
I would like to thank Roger I Simon, whose guidance as my
dissertation supervisor greatly informed an earlier version of
this essay and who is sadly no longer with us. I would also like to
thank Robert Del Tredici, co-curator of the exhibition *The Atomic
Photographers Guild: Visibility and Invisibility in the Nuclear Era* for
introducing me to the work of the Guild and for sharing his many
insights on the work of atomic photographers.

Atomic Photographs Below the Surface

Blake Fitzpatrick

Blake Fitzpatrick
The Diefenbunker: Air Vents, 2001

Photography exhibitions provide an opportunity to think about the relations that exist between photographic content and the cultural context of the exhibition site itself.[1] Anthropologist Elizabeth Edwards emphasises this relational dynamic, noting that viewers "look into photographs and through them into culture, both the culture portrayed and the representing culture".[2] Photographs depicting past events come with histories attached, but when exhibited their meanings are further shaped by presentational contexts that modify and respond to them.

In this essay, I discuss the staging of photography exhibitions that depict nuclear subjects. One of the two exhibitions discussed is of the work of the Atomic Photographers Guild (of which I am a member). Founded in 1987 by Canadian photographer Robert Del Tredici and American photographer Carole Gallagher, the Atomic Photographers Guild (sometimes referred to hereafter as the Guild) is an international collective of photographers dedicated to making visible the locations and legacies of atomic weapons and nuclear energy production. In 2001, Del Tredici and I co-curated a group exhibition of this expanding collective of artists and documentary photographers. The Atomic Photographers Guild: Visibility and Invisibility in the Nuclear Era was exhibited in three public galleries and in the Diefenbunker, a decommissioned atomic fallout shelter.[3] Built in Carp, Ontario, between 1959 and 1961, the Diefenbunker (named after then-Prime Minister John Diefenbaker) was constructed by the government of Canada as an atomic fallout shelter to house and protect senior members of the national government in the event of an atomic attack. Closed in 1994 and reopened as "Canada's Cold War Museum" by a local citizens group in 1998, the Diefenbunker is, according to its own literature, an amazing artefact that has as its goal the "[telling of] a story that will never let you be complacent about the Cold War again!".[4] To help achieve this goal, a permanent exhibition of archival photographs titled Requiem depicts nuclear destruction in the cities of Hiroshima and Nagasaki at the close of the Second World War. The nuclear atrocities experienced in Japan play a crucial role in the historical narrative of the Cold War museum as it seeks a non-complacent public response to the dangers of nuclear weapons and to the warnings that atomic photographs convey.

The nuclear era is a contested subject in representation. In particular, nuclear war has been called "an impossible subject, the subversive force in the account which seeks to master it".[5] Indeed, given its absolute destructive force, the meaning of nuclear war will always exceed the partiality of any representational frame. How then might the site-specificity of the exhibition space and the mode of display confirm or confront a public in their understanding of such a social, political and emotionally demanding subject? This essay examines that question through the example of public exhibitions of nuclear photographs in order to assess how the nuclear era is to be visualised, understood and remembered. Linking photographic records of the nuclear destruction of Hiroshima

and Nagasaki on one level of the Diefenbunker to contemporary photographs of ongoing nuclear experience on another floor of the museum allows for a juxtaposition of nuclear continuity within the specificity of the Diefenbunker's overarching atomic mises-en-scène. Such encounters are at once theatrical and evidential and point to exhibitionary practices that undo the autonomy of images and artefacts by emphasising the dependency of such objects on the conditions of their presentation.[6]

Exhibition strategies in a fallout shelter: Requiem

Paul Virilio has said that "war is at once a summary and [its own] museum".[7] As a form of architecture designed to ward off the brutal encounter of nuclear war, the Diefenbunker houses Cold War artefacts within a museum that is its own artefact. The bunker as artefact brings visitors closer to the historically real by metonymically staging an encounter with the Cold War it both references and actualises. The Diefenbunker is part of a trend that shifts the emphasis from artefacts in display cabinets toward forms of museum learning that rely more heavily on discursive narrative and experiential modes of historical knowledge production.[8] Diefenbunker visitors must book ahead to join a walking tour of the bunker that is narrated by one of the museum's volunteer animators. The combination of the Cold War artefacts, the animators' conversational (and often humorous) narrative and the walking tour itself are orchestrated in such a way as to bring history to life interactively and to encounter the Cold War in a personal, entertaining way.

Visitors to the bunker enter the museum through a passageway cut into the side of a hill. Overhead, air vents puncture the grassy cover of the Diefenbunker in an irregular pattern of clunky Cold War-era technology. These vents function like visible tombstones for a facility with a massive and formerly top-secret subterranean presence. Cold and humid, the underground physicality of the structure is staggering. Supported by 32,000 tons of concrete and 5,000 tons of reinforcing steel, the bunker's Cold War aura overwhelms visitors with its 358 rooms buried four levels below ground. Designed to accommodate up to 535 people underground for 30 days, the windowless labyrinth structure now echoes with the muffled footsteps of tour groups. For Cold War tourists, the Diefenbunker narrative is both an encounter with historical technology as well as an encounter with the space itself. There is an overwhelming sense of walking through an empty military base, or a sci-fi ghost town filled with Cold War phantoms and incongruent traces from another era.

For example, visitors are taken to the former cafeteria, a large structure complete with a full banquet hall and kitchen. An enlarged colour photograph of an open, rugged landscape with distant mountains (perhaps the Canadian Rockies) hangs in the dining area. One tries to imagine what purpose such a photograph

Blake Fitzpatrick
The Diefenbunker: Cafeteria, 2007

would perform, particularly in the event of a nuclear attack. Is this photograph an ironic substitute for a picture window in an underground vault—a visual breath of fresh air in a tomb-like space that would increasingly be without fresh air? Is this what Cold War survivors would be down there remembering, or is this what radiation looks like, an invisible scrim that poisons the air of the most picturesque landscape? Exposed in these unanswerable questions is the discrepancy between the finality of nuclear war and the ambiguous distances through which it is presently remembered. This is a discrepancy that becomes particularly acute in the Diefenbunker's permanent display of archival photographs, Requiem.

The 20 photographs that comprise the installation Requiem were selected from the archives of the Physicians for Global Survival. Opened on 5 May 1999, the exhibition documents the immediate aftermath of the atomic bombing of Hiroshima and Nagasaki and depicts in photographic detail the ruinous pain and destruction caused by atomic weapons on the civilian populations of these cities.[9] The installation is situated on the third level of the buried museum, discursively located in a historical narrative that takes visitors back to the beginning of the nuclear era in a photographic documentation of Ground Zero. The atomic bombing of Japan is thus the museum's rhetorical and moralising reminder, as the destruction of Hiroshima

and Nagasaki carry us back in time to revisit an atomic subtext that informs the whole. If the Cold War bunker was a response to atomic fear, Requiem visualises that fear and provides warnings still relevant to contemporary viewers. As Jill Bennett suggests, "[A]n exhibition is always in part a live event, unfolding in the here and now: an orchestration of present affects rather than a retrospective analysis. It connects as it exhibits."[10] In the Diefenbunker's strategically installed historical narrative, the museum utilises archival photographs to reproduce nuclear subjects of the past and to produce them in the present as well.

The staging of props and images within the atomic museum reminds us that an encounter with the bomb is always mediated. "Fabulously textual" is how Jacques Derrida once described atomic weapons, highlighting the fact that, except for the atomic bombing of Japan and the atomic testing of nuclear weapons during the Cold War, a nuclear war has not taken place.[11] Because we lack the direct experience of nuclear war, and because the structures of atomic language, codes and terminology are abstract and technologically unprecedented, the terms through which we know atomic weapons are necessarily rhetorical, symbolic and affecting.[12] Accordingly, the rhetorical structure of Requiem has been curated "to provoke thought among visitors about the consequences of nuclear war through a display of graphic images that will provide visitors with an emotional experience."[13]

The emotional experience of the exhibition is actualised through gallery design and installation. As originally suggested by the proposal, gallery walls have been painted black to "reinforce the theme of death, mourning and reflection", wooden picture frames have been painted red, "the colour of blood and life" and Mozart's Requiem is heard softly playing in the background of the gallery, "to complete the atmosphere and appeal to the visitor's senses".[14] In addition, the proposal called for the installation of a small Japanese bench placed on a rectangle of white sand or stone in the centre of the room, lit from above by dramatic theatre lighting and a border of crushed stones to be installed along the perimeter of the gallery wall to enhance the atmosphere of a Japanese garden.[15] The bench in a museum or gallery is an installation standard as it offers visitors a place to sit and to contemplate the works on view. In this instance, the museum protocol of a bench is thematically transformed into a highly coded prop, designed to encourage empathetic identification between the viewer and atomic victims in Japan. However intended, such mechanisms of public participation may paradoxically function to short-cut the profundity of atomic loss and contribute to a feeling of entrapment if viewers perceive that they have been set up for an obviously emotional experience. The reprieve offered by the bench is thus not a reprieve at all if it forecloses the shock of atomic death into preexisting platitudes concerning nuclear history and victims. Writing on the issue of 'difficult' exhibitions, Roger Simon and Jennifer Bonnell suggest that these encounters may become

Blake Fitzpatrick
The Diefenbunker: Requiem Installation, 2008

transformative only when they make one's present relation to history more 'difficult', forcing visitors to "revisit their own assumptions and alter in some way their own experience of the world".[16]

Yoshito Matsushige as lynchpin

The Atomic Photographers Guild exhibition at the Diefenbunker, installed one floor above Requiem, concluded a visitor's tour. One of its tasks was to address the lingering affects of images depicting nuclear atrocities with the evidence of nuclear continuities updated into the present.

The installation introduced viewers to the work of Atomic Photographers Guild members through an introductory text written by Del Tredici and the work of the first two atomic photographers—Berlyn Brixner and Yoshito Matsushige. Brixner's photographic documentation of the first atomic test in the Alamogordo Desert of New Mexico, conducted on 16 July 1945—code-named "Trinity"—was juxtaposed with Matsushige's five photographs of a ruined Hiroshima taken on the day that the city was bombed. The co-presence of Brixner and Matsushige within the Guild mark the delimiting frames of atomic photography with a technological breakthrough on the one end and its human cost on the other.

As curators of the exhibition, Del Tredici and I recognised that one of Matsushige's five photographs, a depiction of atomic survivors on the Miyuki-bashi Bridge in Hiroshima, was also included in Requiem.

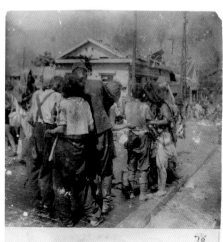

LEFT
Blake Fitzpatrick
*The Diefenbunker: Installation,
Berlyn Brixner and Yoshito
Matsushige,* 2001
Courtesy of the artist

RIGHT
Yoshito Matsushige
*[Dazed survivors huddle together
in the street ten minutes after the
atomic bomb was dropped on their
city, Hiroshima],* 6 August 1945

Thus, the photograph forms something of a lynchpin to connect the two exhibitions. I want to look briefly at Matsushige's work in order to comment on the cultural invisibility of nuclear weapons and to connect image and exhibition site in the depiction of nuclear history.

On 6 August 1945, at exactly 8.15 am, an atomic bomb exploded over Hiroshima. At the time of the attack Yoshito Matsushige was at home, 2.7 kilometres from the hypocentre. In an interview with Robert Del Tredici, Matsushige explained that his professional duty as a photojournalist and a military photographer compelled him to photograph what he saw, but that the horror encountered in the grey darkness of the bomb's cloud made it impossible to take more than five photographs.

Matsushige's photographs are proto-documentary records remarkable more for what they do not show than for what they do. What is not seen in his images, and what remains to be imagined by the viewer, are the dead who haunt his five photographs through their absence. Lifton and Mitchell report:

There are no corpses in these photographs, yet they capture the horror of the atomic bomb far better than images of blackened trees or twisted girders. That is because [the subjects] are still experiencing the bomb itself. The weapon has not finished with them or their city.[17]

Where does one turn a camera to not see the one who dies before you? Matsushige's answer is found in the production of random and indeterminate images. His photograph of survivors on the Miyuki-bashi Bridge refuses not only to picture the dead but also to picture the living, those who are the walking dead, at a distance and with their backs to the camera. The absence of the dead in his photographs, supports a paradoxical assertion made by Del Tredici after

years photographing the nuclear industry: "the closer you get to nuclear weapons the harder it is to see them".[18] If we can say that the death of nuclear victims is traumatically invisible in Matsushige's photographs, we might also add that nuclear experience was rendered officially invisible by a seven-year publication ban of information concerning Hiroshima and Nagasaki by the US military censors following the Second World War. Thus, the profound invisibility of atomic weapons is a characteristic of the era entrenched from the beginning.[19] It is fitting that Matshushige's photographs of that terrible morning in Hiroshima may now be found below ground, in a bunker that was once a top-secret facility, closed to public scrutiny, hidden from view.

Guild photographs in a fallout shelter

The Canadian photographers participating in the exhibition included David McMillan, Mark Ruwedel, Robert Del Tredici and myself. In Del Tredici's work, cause and effect historical relationships with nuclear weapons were established by juxtaposing his photographic documentation of Cold War nuclear weapons production facilities with a post-Cold War mapping of contaminated nuclear sites. For example, in one of his post-Cold War photographs, barrels of transuranic waste contaminated with traces of plutonium are lined up on a concrete storage pad.[20] Del Tredici's caption for the photograph cites the fact that "more that 300,000 barrels of such waste from nuclear weapons production are buried or stored around the United States". Captions are a way of making known that which exceeds the photograph. In this example, the numbers are important as they establish a part for whole relation, multiplying the evidence provided in this one photograph to invisible accumulations of plutonium waste across the nation. The large-scale accumulation of nuclear waste buried or stored around the United States is a by-product of what Paul Virilio and Sylvere Lotringer have called 'pure war'. Pure war

Robert Del Tredici
The Transuranic Drums /
Transuranic Waste Storage Pads,
E Area Burial Grounds, Savannah
River Site, South Carolina,
7 January 1994

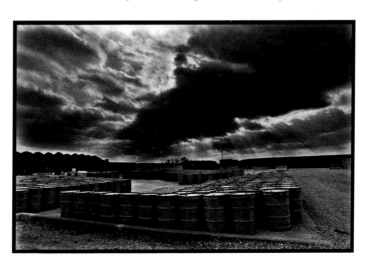

is not about total war, nor does it spell out in a nuclear context the drama and spectacle of doom. Instead, pure war proposes the active preparation of war during peacetime, war "which isn't acted out in repetition but in infinite preparation".[21]

The ongoing preparation for nuclear war was depicted in Paul Shambroom's photographs of post-Cold War atomic weapons installations in contemporary American military bases. Shambroom's photographs were installed in the same room that displayed Brixner's inaugural photographs from the beginning of the nuclear era, thus drawing a connection between Trinity, the first nuclear weapon, and their continued regeneration. In one of Shambroom's images, a diagonal line of eight bombs and evidence of routine labour are juxtaposed as a military technician sweeps the floor. The title of the photograph informs viewers that we are looking at *B83 One-Megaton Nuclear Gravity Bombs in Weapons Storage Area, Barksdale Air Force Base, Louisiana*, 1995. [22] Richard Rhodes has commented that it would take only two of these B83 bombs to equal the destructive force of all the explosives used in the Second World War. [23] Thus in this singular space, extreme banality and the potential for extreme destruction coexist in an image that conjoins everyday activity to the unthinkable destructive power of these weapons. One might ask if domestic acts such as sweeping the floor domesticate terror or give as Daniel Pick puts it, "the entirely other a more or less familiar meaning"?[24] Perhaps what is really confronted in this photograph is our uncanny ability to normalise nuclear weapons into the fabric of everyday life.

Shambroom's straightforward, if neutral stance constitutes a strategic practice for some atomic photographers. For example, when seeking permission to photograph America's nuclear arsenal, Shambroom clarified in letters to military officials: "my intention is neither to criticize nor glorify nuclear weapons".[25] Shambroom's self-effacing posture raises the issue of neutrality as a critical strategy or a potential compromise for access to the regimes of an otherwise hidden atomic power.[26] However, a seemingly neutral approach to a subject of prohibited visibility may function in a subtly subversive way. Gaining access to the culturally invisible realms of atomic weapons not only renders a secret subject visible, but it may also make visible a refusal to participate with regimes of power that would routinely block a public's right to see and by extension know, what the governing authorities and the military are developing and stockpiling in its name. It is important to note that Shambroom made his nuclear photographs in the mid-1990s. The time is significant as it falls between the opening up of the Berlin Wall in 1989 and the Twin Towers coming down in 2001. This was a moment of historic visibility in the West, a brief period in which it was possible to see what could not be seen before and what may not be seen again.

Also included in the Atomic Photographers Guild exhibition, and installed in the introductory suite with the photographic work

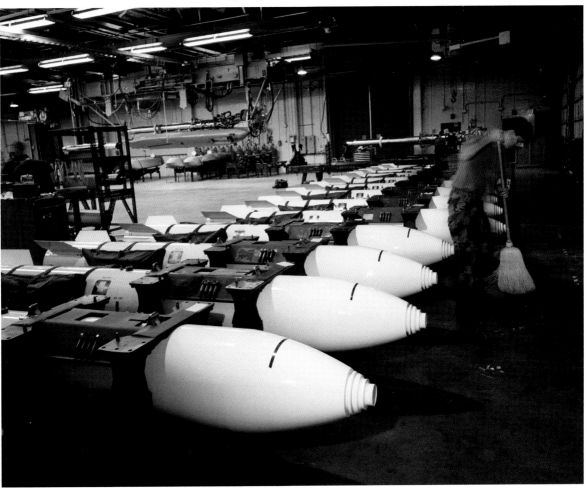

Paul Shambroom
*B 83 One-Megaton Nuclear Gravity
Bombs in Weapons Storage
Area, Barksdale Air Force Base,
Louisiana, 1995*

of Brixner, Matsushige and Shambroom, was a photographic
montage of Japanese atomic tourists at the Trinity monument
by Patrick Nagatani. Berlyn Brixner's photographs of the Trinity
explosion is a point of origin returned to by many members of
the Guild including Mark Ruwedel, Robert Del Tredici, Peter
Goin (not included in the exhibition) and Harris Fogel. These
acts of return result in the production of contemporary atomic
photographs that speak back to earlier events and their originating
images while questioning the ideological construction of a history
monumentalised from the victors' vantage point.

Nagatani's return to the Trinity site updates Brixner's photographs
of the first atomic explosion with staged images of the monument that
commemorates the event. Mounted to the surface of the monument
is a plaque that reads in block letters: "TRINITY SITE WHERE THE
WORLD'S FIRST NUCLEAR DEVICE WAS EXPLODED ON JULY 16,
1945". The plaque is a dangerously incomplete text that refuses to
call the device a bomb and that, like the monument itself, works to
distance visitors from Hiroshima and Nagasaki, the cities linked in
their destruction to the Trinity test.

This structured absence is forcefully questioned by Patrick
Nagatani's post-Trinity montage. Nagatani's photograph functions

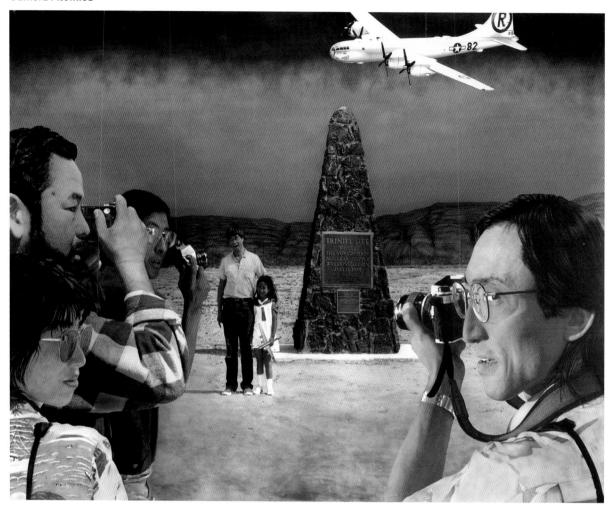

Patrick Nagatani
Trinity Site, Jornada Del Muerto, New Mexico (Nuclear Enchantment), 1988 and 1989

like a history painting in which Japanese 'atomic tourists' pose before the monument to the first atomic explosion as visualised in a burnt-red landscape. Above the monument and in the hand of the girl who is posing for the portrait are models of the Enola Gay, the fighter-bomber that was used to drop the atomic bomb on Hiroshima. The photograph draws an explicit connection between the Hiroshima bomb and its rehearsal at the Trinity site. The relationship of Japanese tourists to the Trinity site is important because it brings to contemporary consideration a figure of historic loss that the monument and its militaristic curators so wilfully want to forget.

No longer capable of witnessing the atomic testing of the Trinity site or the destruction of Hiroshima or Nagasaki directly, Nagatani's photograph of these now invisible events supplements an experience of that past reality through the unreality of their fictionalised construction in the present. We may ask, does Nagatani's approach sensationalise or neutralise the reality of atomic weapons by turning them into a fiction? Does fiction compromise the truth of historical representation and play into conditions of denial—a practice that

the monument is already engaged in? Writing on this issue, James Young suggests that the use of potentially questionable conceptual strategies is unavoidable for a generation of artists that link the recovery of historical events to the present conditions under which they are encountered and then interpreted. [27]

In the Atomic Photographers Guild installation, Nagatani's highly rhetorical image of Japanese atomic tourists looking out of the frame was positioned to potentially confront a Diefenbunker tourist looking in. Such reciprocal confrontations may implicate viewers in their own acts of atomic tourism, and draw a connection between the institutional site, the photographic image and nuclear history.

More than the content of individual photographs is at stake when the conditions of display form an unsettling relation with image, site and the present settings through which history is encountered. For example, in Paul Shambroom's photographs of atomic bombs now installed in a bomb shelter, the existence of contemporary nuclear weapons is brought into a dialogic relation with a bygone shield designed to keep weapons out. That the shield is outdated technologically there can be no doubt. But the belief that we may now peer down at the Diefenbunker as an obsolete technology for our now obsolete fears is revealed as a false dichotomy when undermined by images of nuclear weapons, their development, storage and contaminating effects as evidenced by Guild photographs. Paul Shambroom has commented that for him, "the bomb takes up a lot of emotional space, mostly far below the surface".[28] This is an insight that finds an architectural parable in the subterranean atomic bunker where photographs of present nuclear dilemmas mix with their surrounds to reveal nuclear blind spots from above ground in a space that is hidden below.

NOTES

1. This revised essay was originally published in a different form under the title "Atomic Photographs in a Fallout Shelter", in Carol Payne and Andrea Kunard, eds, *The Cultural Work of Photography in Canada*, Montreal and Kingston: McGill–Queen's University Press 2011.

2. Edwards, Elizabeth, "Introduction", *Anthropology and Photography 1860–1920*, New Haven and London: Yale University Press 1992, p 14.

3. Due to gallery space restrictions, the 20-plus members of the Atomic Photographers Guild was limited to 13 participants in this exhibition, with some priority given to recent members, including: James Crnkovich, Blake Fitzpatrick, David McMillan, Mark Ruwedel, Hiromi Tsuchida and Paul Shambroom. Also included in the exhibition were established atomic photographers Berlyn Brixner, Robert Del Tredici, Harris Fogel, Carole Gallagher, Kenji Higuchi, Yoshito Matsushige and Patrick Nagatani. In addition to the above, and at the time of this writing (2014), membership in the Guild includes: Jessie Boylan, Dan Budnik, Pablo DeSoto, Elizabeth Ellsworth and Jamie Kruse, Nancy Floyd, Peter Goin, Cornelia Hesse-Honegger, John Hooton, Mary Kavanaugh, Igor Kostin, Juir Kuidin (deceased), James Lerager, Clay Lipsky, Thomas Luettge, Barbara Norfleet, elin o'Hara slavick, Jan Smith, Vaclav Vasku, and Gunter Zint. I thank Robert Del Tredici for providing me with a list of present members. Blake Fitzpatrick and Robert Del Tredici, personal communication, 2014.

4. Public Brochure, *The Diefenbunker, Canada's Cold War Museum*, 3911 Carp Road, Ottawa, Ontario.

5. Pick, Daniel, *War Machine: The Rationalization of Slaughter in the Modern Age*, New Haven and London: Yale University Press 1993, p 8.

6. Bal, Mieke, "Guest Column: Exhibition Practices", *PLMA* 125, 1, 2010, pp 9–25, cited in Simon, Roger I, "A Shock to Thought: Curatorial Judgment and the Public Exhibition of 'Difficult Knowledge'", *Memory Studies* 4, 4, 2011, p 437.

7. Virilio, Paul, *Bunker Archeology*, Paris: Demi-Circle 1994, p 27.

8. Belting, Hans, "Place of Reflection or Place of Sensation?" in Peter Noever, ed, *The Discursive Museum*, Ostfildern-Ruit, Germany: Hatje Cantz Verlag 2001, p 80.

9. I thank Connie Higginson-Murray, of the volunteer Program and Exhibition Committee at the Diefenbunker for providing me with information on the concept, logistics and opening ceremonies for the Requiem exhibition. Blake Fitzpatrick and Connie Higginson-Murray, personal communication, 2008.

10. Bennett, Jill, *Practical Aesthetics: Events, Affects and Art after 9/11*, London and New York: IB Tauris and Co Ltd 2012, p 37.

11. Derrida, Jacques, "No Apocalypse, Not Now (full speed ahead, seven missiles, seven missives)", *diacritics* 14, 1984, p 24.

12. I am grateful to John O'Brian for drawing my attention to this elaboration in his response to an earlier draft of this paper presented at: *The Cultural Work of Photography in Canada: A Scholarly Workshop*, Ottawa, 2008.

13. Moreau, Robert, Proposal to the Board of Directors of the Diefenbunker (revised 29 February 1998).

14. Moreau, Proposal to the Board of Directors of the Diefenbunker.

15. Moreau, Proposal to the Board of Directors of the Diefenbunker.

16. Bonnell, Jennifer, and Roger I Simon, "'Difficult' Exhibitions and Intimate Encounters", *Museum and Society*, 5 July (2), 2007, p 76.

17. Lifton, Robert and Greg Mitchell, *Hiroshima in America: 50 Years of Denial*, New York: GP Putnam's Sons 1995, p 61.

18. Del Tredici, Robert, "Romancing the Atom", *Views: The Journal of Photography in New England* 10:3, 1989, pp 3–6.

19. I am grateful to Robert Del Tredici for discussion on this point. Blake Fitzpatrick and Robert Del Tredici, personal communication, 2008.

20. For an extended analysis of Robert Del Tredici's post-Cold War photographs, see Blake Fitzpatrick, "Atomic Afterimages", *History of Photography* 2, no 2, summer 2008, pp 176–187. See as well the original publication of this photograph in, Robert Del Tredici, *Linking Legacies: Connecting the Cold War Nuclear Weapons Production Processes to Their Environmental Consequences*, US Department of Energy, DOE/EM-0319 1997.

21. Virilio, Paul, and Sylvere Lotringer, *Pure War*, New York: Semiotext(e), Columbia University 1997, p 92.

22. This photograph figures prominently on the
 cover and as plate 3 in Paul Shambroom, *Face to
 Face with the Bomb: Nuclear Reality after the Cold
 War*, Baltimore: The John Hopkins University
 Press, 2003.
23. Rhodes, Richard, "Introduction", in Paul
 Shambroom, *Face to Face with the Bomb: Nuclear
 Reality after the Cold War*, p 3.
24. Pick, Daniel, *War Machine: The Rationalization of
 Slaughter in the Modern Age*, p 261.
25. Shambroom, Paul, "Prologue", *Face to Face with
 the Bomb: Nuclear Reality after the Cold War*,
 p xiii. For a perceptive essay on the question of
 neutrality in Paul Shambroom's photographs,
 see Helena Reckitt, "Neither to Criticize not
 Glorify: Paul Shambroom's Studied Neutrality",
 Paul Shambroom Picturing Power, Minneapolis:
 Weisman Art Museum, University of Minnesota
 2008, pp 32–45.
26. See my discussion of nuclear access, complicity
 and criticality in relation to Robert Del Tredici's
 work with the US Department of Energy in
 "Atomic Afterimages", *History of Photography* 2,
 no 2, summer 2008, pp 176–187.
27. Young, James E, *At Memory's Edge: After-
 Images of the Holocaust in Contemporary Art and
 Architecture*, New Haven: Yale University Press
 2000, p 24.
28. Shambroom, Paul, "Prologue", *Face to Face with
 the Bomb: Nuclear Reality after the Cold War*, p xii.

Uranium
and
Radiation

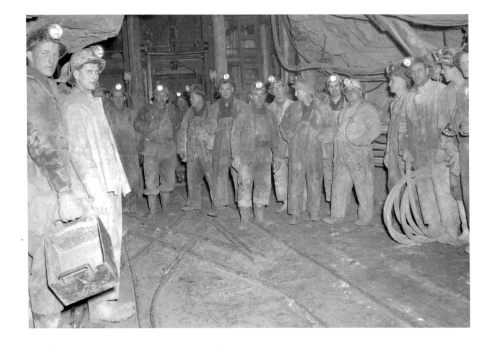

TOP
Henry Busse
Commemorative Plaque, Port Radium, c 1950s

BOTTOM
Henry Busse
Miners Underground, Eldorado Mine, Port Radium, c 1950s

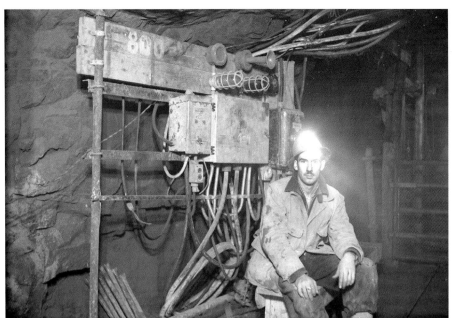

TOP
Henry Busse
*Miner with Headlamp, Port
Radium*, c 1950s

BOTTOM
Henry Busse
*Port Radium Minesite on a
Winter Night*, c 1950s

Richard Finnie
Sacks of Pitchblende
Concentrate, Port Radium, 1939

OPPOSITE TOP
Press Agency Photo
Uranium Stock Price Board, J. A.
Hogle and Company, Salt Lake
City, 8 June 1954

OPPOSITE BOTTOM
Associated Press
Entrance to Uranium Mine,
Colorado , 30 August 1952

L.A. 19-INP- SOUNDPHOTO-MIRACLE HOT SPRINGS,CALIF. 6/3/55. MEL MELVIN AND JACK WRIGHT OF A POSSE CHECK GUNS BEFORE GOING ON PATROLS.KERN COUNTY SHERIFF LEROY GALYEN ORDERED A MOUNTED POSSE OF 53 MEN, ALL ARMED AND SOME EQUIPPED WITH WALKIE-TALKIES, INTO THE 4-MILE SQUARE AREA TO MAINTAIN ORDER. (LOS ANGELES EXAMINER PHOTO BY PHIL GLICKMAN) SENT P.M........PS.............BM.........

INP Soundphoto by Phil Glickman
Posse Maintaining Order During Uranium Boom,
Miracle Hot Springs, California, 3 June 1955

AP Wirephoto
*Atomic Dirt-Sitters Seek Pain
Relief*, 10 July 1955

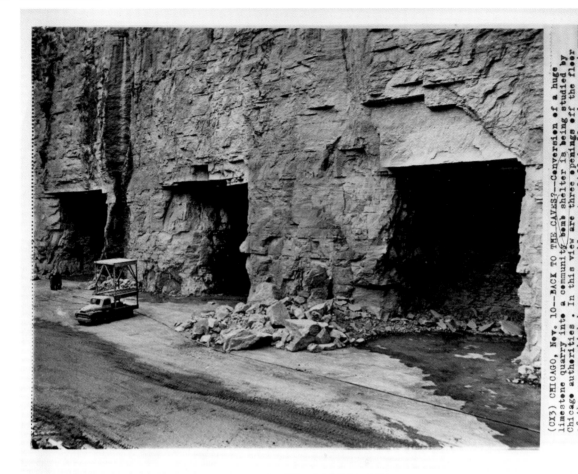

(CX3) CHICAGO, Nov. 10--BACK TO THE CAVES?--Conversion of a huge limestone quarry into a community bomb shelter is being studied by Chicago authorities. In this view are three openings off the floor of the quarry which bear a resemblance to cliff dwellers' caves. A group of men stand near opening at left. Quarry is located about three miles southwest of the downtown business district, at 27th and Halstead St. (AP Wirephoto)(wkm345amer.) 1961

AP Wirephoto
Community Bomb Shelter in Limestone Quarry,
4 December 1961

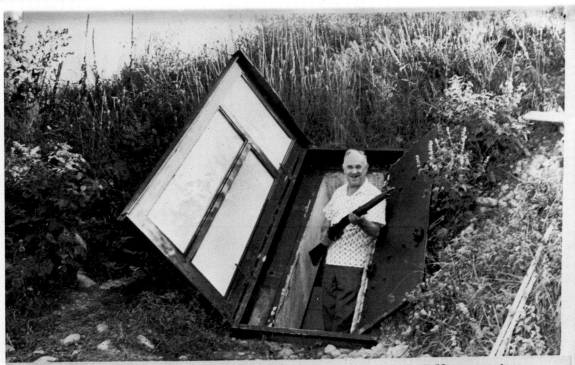

(RU1) CALEDONIA, N.Y. Sept.28 IF ATTACK CAME - -Dr.Hugo Maria Kellner says he would take stand as he does here with Enfield rifle to keep all but his family out of huge underground shelter here. (AP WIREPHOTO)

AP Wirephoto
Dr. Hugo Maria Kellner, 9 April 1951

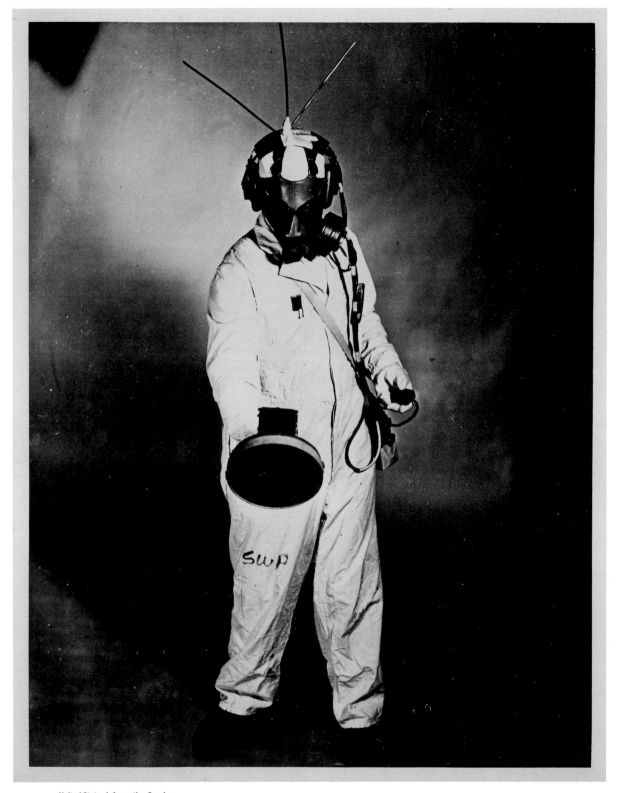

United States Information Service
*Nuclear Worker in Suit with Geiger
Counter*, c 1950s

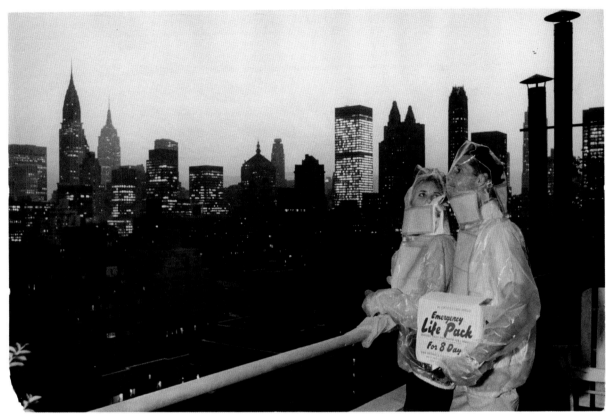

Max Scheler
The Fallout Suit for $21, c 1950

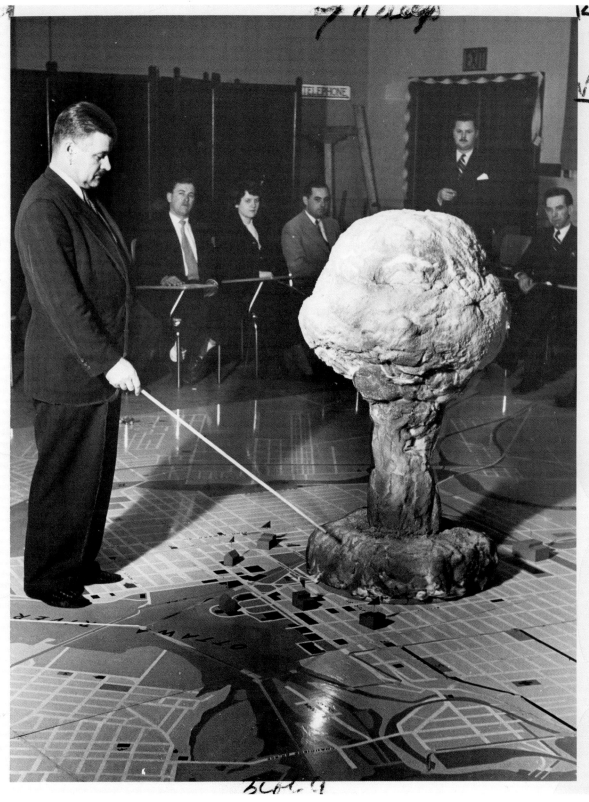

Federal Newsphoto
*Model of an Atom Bomb Test on
a Map of Ottawa,* 26 April 1952

TOP
Peter G Gordon
*Displaying a Geiger Counter
at Atomic Survival Exhibit*,
19 March 1952

MIDDLE
Toronto Telegram
*Government Approved Bomb
Shelter*, 26 September 1961

BOTTOM
Harold Whyte
*Canada's First Underground
H-Bomb Shelter*,
30 October 1961

Harold Whyte
*Stocking Groceries for Bomb
Shelter*, 4 December 1960

Paul Quarrington
Burn Victim in Mock Casuality Test,
9 April 1960

Patrick Nagatani
Radium Springs, New Mexico, 1989

Patrick Nagatani
Radiation Therapy Room,
Albuquerque, New Mexico, 1989

Atomic Energy of Canada Limited
*Personal Dosimeter and Photo
Identification Badge Presented to Dr.
B.N. Brockhouse, Co-Winner of the
1994 Nobel Prize in Physics, 1994*

TOP
**Canadian Conservation
Institute**
*Connelly Containers Fallout
Shelter Medical Kit C*, 2011

BOTTOM
**Connelly Containers,
Pennsylvania**
Fallout Shelter Medical Kit C,
February 1963

Unknown
Publicity still from *Dr. Strangelove or:
How I Learned to Stop Worrying and Love
the Bomb*, 1964

TOP
Kristan Horton
dr0275-s016-10, 2003–2006

BOTTOM
Kristan Horton
dr0276-s016-11, 2003–2006

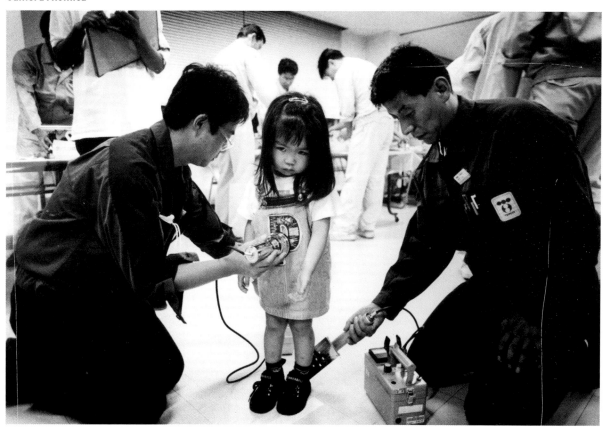

Kenji Higuchi
Nuclear Criticality Accident of JCO
in Tokaimura, Ibaraki Prefecture, 1999

Carol Condé and Karl Beveridge
No Immediate Threat (detail),
1985–1986

AP Wirephoto
Testing Meat for Radiation,
England, 28 October 1957

Associated Press
Checks for Radioactive
Contamination, NRX Reactor,
Chalk River, Ontario,
29 December 1947

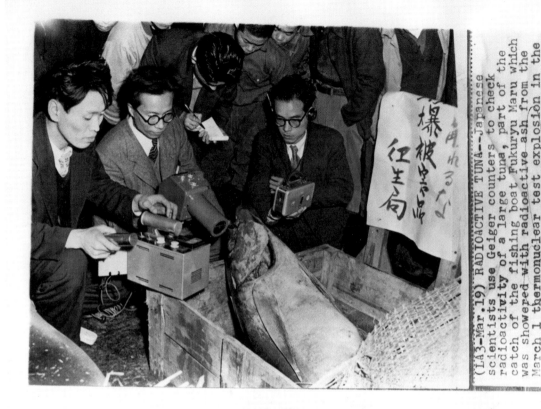

(LA3—Mar.19) RADIOACTIVE TUNA——Japanese scientists use Geiger counters to check radioactivity of a large tuna, part of the catch of the fishing boat Fukuryu Maru which was showered with radioactive ash from the March 1 thermonuclear test explosion in the Bikini area. Part of the boat's catch reached the market, causing a sharp drop in prices but officials said they believed most was recovered.(AP Wirephoto)(bl13stok)

AP Wirephoto
*Scientists Checking Tuna
for Radiation, Japan,*
24 March 1954

AP Newsfeatures Photo
Another Fallout Shelter by the
Nuclear Survival Corp.,
28 September 1961

In the 1930s, Eldorado Gold Mines opened a radium mine in the Northwest Territories at a site the company named Port Radium. Radioactive ore was shipped from Port Radium to the town of Port Hope for processing in an old warehouse on the town's waterfront. During World War II, the Port Hope refinery became a crown corporation and supplied processed uranium oxide for atomic weapons research carried out under the Manhattan Project.

Dennis Morgan

Walter Pidgeon

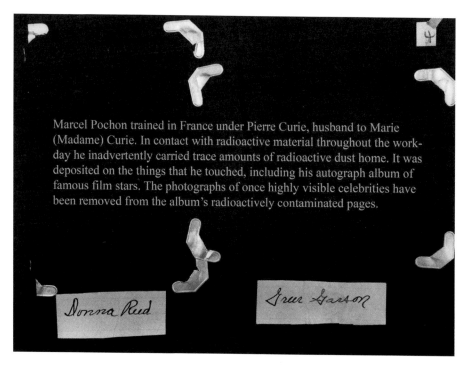

Marcel Pochon trained in France under Pierre Curie, husband to Marie (Madame) Curie. In contact with radioactive material throughout the workday he inadvertently carried trace amounts of radioactive dust home. It was deposited on the things that he touched, including his autograph album of famous film stars. The photographs of once highly visible celebrities have been removed from the album's radioactively contaminated pages.

Donna Reed

Greer Garson

Blake Fitzpatrick
Radioactive Autograph Album, 2002

TOP
Mark Klett
*Drinking rainwater from a
pothole below Hack Canyon
Uranium Mine, 23 May 1992*

MIDDLE
Mark Klett
*Nuclear Generating Station,
Palo Verde: 50 Miles from
Phoenix, 1986*

BOTTOM
Mark Klett
*Fishing on the Columbia River,
Washington, 22 April 1981*

On being invited to write an essay for the occasion of *Camera Atomica*, we both agreed instantly that this was an opportunity we must not miss. For us, the problem grappled with here has long been an urgency, and we are all too aware that serious confrontations with it in the era of permanent, so-called war on terror are a rarity. After much discussion and reflection about how to respond to the curatorial intelligence at work here, we have opted to unfold a number of arguments by constellating quotations, descriptions of social facts, and photographic images. We hope the reader will find the chosen form a good tool for thinking with. Our aim has been to leave enough openness for a real process of reflection and insight: we did not want, here, to deliver a sermon or rant, nor merely to repeat what we each have said already in other contexts. In any case what follows does not belong, we trust, to the artworld genres of glib appropriation or pastiche: arguments are at work.

Three decades ago now, EP Thompson warned us that the Bomb is not a Thing: it must be grasped as a condensation of social relations and processes that constitute a complex but quite historically specific nexus of domination. We have tried to indicate the contours of this nexus, without reduction or evasion. Certainly there is much more to say and consider. But given the social force-field that generated the history on view in this exhibition, we are convinced that what follows will at least carry us behind the veil and deep into enemy territory. We have summoned what we take to be among the best work done on this problem, as well as a range of exemplary technocratic utterances and instruments. We have not repressed divergences between positions—least of all among those we admire. A constellation is no harmonious unity: it illuminates more through the mutual critical encounter between its elements than would any of those elements alone or in simple addition.

Anyone who does not want to talk about capitalism had better keep silent about nuclear physics. What Thompson called "exterminism"—whether in fullblown MAD regalia or merely displaying a passive indifference to the meltdown of the biosphere—emerges from the antagonisms of enclosure and capital accumulation, the exploitation of labour, commodity production and war. From its beginnings, modern science—increasingly, capital's way of knowing the world—was caught in this force field. If the following reflections on technology end by posing again the question of an alternative science, such a possibility—or let us say, promise—entails struggle and a passage to new social forms. To that horizon we turn our eyes, scanning.

Through the Lens, Darkly

Iain Boal and Gene Ray

Measuring instruments, calculating machines

"In the ongoing 'quarrel of ancients and moderns', those who argued the superiority of recent times against the record of antiquity increasingly relied on the innovations of craftsmen and technicians as a conclusive demonstration of historical progress. These had long been regarded as 'base' activities in contrast to the refined pursuits of high culture, but this attitude was subjected to sustained attack and eventually was reduced to a minority opinion.... Philosophers had begun to reflect on the methodological principles of the technicians and to insist that logic should incorporate them."

William Leiss
The Domination of Nature, New York: George Braziller, 1972, p 77.

Galileo's Military Compass
"Next to the stereometric lines Galileo's compass carried his most important help to the artist of war: 'metallic lines', scaled as the inverse cube roots of the densities of the materials.... Do you want to know the weight of a cannon ball of any material and any size from knowledge of the size and weight of a standard cannon ball, and hence the relative charges needed to fire them? The calculation will not be pursued here lest it fall into the wrong hands.... Having mastered all this, the student was only half way through his course. He could acquire an additional device from Galileo to turn the compass into a surveying instrument good for taking distances to enemy locations and fixing the elevations of muzzles."

JL Heilbron
Galileo, p 102.

"Galileo's assertion that having heard of the Dutch telescope he reconstructed the apparatus by mathematical calculation must of course be understood with a grain of salt; for in his writings we do no find any calculations and the report, by letter, which he gives of his first effort says that no better lenses had been available; six days later we find him on the way to Venice with a better piece to hand it as a gift to the Doge Leonardi Donati. This does not look like calculation; it rather looks like trial and error. The calculation may well have been of a different kind. And here it succeeded, for on 25 August 1609 his salary was increased by a factor of three."

E Hoppe
Die Geschichte der Optik (1926), quoted in Paul Feyerabend, *Against Method*, London: Verso, 1978, p 105.

"Discovery is really a mixture of instinct and method. One must, of course, ask whether such a mixture is in the strict sense philosophy or science—whether it can be knowledge of the world in the ultimate sense, the only sense that could serve us as a genuine understanding of the world and ourselves. As a discoverer, Galileo went directly to the task of realizing his idea, of developing methods for measuring the nearest data of common experience; and actual experience demonstrated (through a method which was of course not radically clarified) what his hypothetical anticipation in each case

demanded; he actually found casual interrelations which could be mathematically expressed in 'formulae'."

Edmund Husserl
The Crisis of European Sciences, [written 1934–1936, first published 1954], David Carr, trans, Evanston: Northwestern University Press, 1970, p 40.

"For all the exceptional characteristics Galileo perceived in the telescope in August 1609, he still presented it to the doge Leonardo Donà as a military instrument. The telescope was a marvel, but not one tailored for any specific patron.... Quite correctly, at this point Galileo still perceived the telescope as belonging to the same patronage category as the military compass, the only important difference being that the telescope was much more useful than the compass and therefore could trigger the interest and curiosity of a much wider audience. At this point in Galileo's career, the telescope was still simply an instrument. It was neither a messenger of dynastic destiny nor a ticket to court. From his correspondence of the period we see that until he discovered Jupiter's satellite, Galileo did not make any serious attempt to use the telescope to move to the Medici court."

Mario Biagioli
Galileo Courtier: The Practice of Science in the Culture of Absolutism, U Chicago Press, 1993, p 127.

Galileo's Military Compass
"By 1610 [Galileo] had sold some 300 instruments. At 150 lire each, they brought him 4500 lire a year for over a decade. If expenses for materials and [Marcantonio] Mazzoleni [the Arsenale coppersmith Galileo engaged as a live-in instrument maker] amounted to half of that, he cleared say 2000 lire or 400 ducats a year, about half his academic salary over the decade."
JL Heilbron
Galileo, p 103.

"Mathematics as a realm of genuine objective knowledge (and technology under its direction)—that was, for Galileo and even before him, the focal point of 'modern' man's guiding interest in philosophical knowledge of the world and a rational praxis. There must be measuring methods for everything encompassed by geometry, the mathematics of shapes with its *a priori* ideality. And the whole concrete world must turn out to be a mathematizable and objective world if we pursue those individual experiences and actually measure everything about them which, according to the presuppositions, comes under applied geometry—that is, if we work out the appropriate method of measuring."

Edmund Husserl
The Crisis of European Sciences and Transcendental Phenomenology, p 38.

"Despite his estrangement from mathematics, [Lord Chancellor Francis] Bacon arrived at the basic

orientation of the science that came after him. The happy marriage between human understanding and the nature of things, as he had it in mind, is patriarchal: the understanding that conquers superstition should have dominion over disenchanted nature. The knowledge that is power knows no bounds, neither in its enslavement of all creation nor in its submission to the masters of the world. Just as it is at the disposal of the bourgeois economy in the factory and on the battlefield, so it is ready to serve the entrepreneurs without regard to origins. Kings control technology no more directly than do the businessmen: it is just as democratic as the economic system by which it developed. Technology is the essence of this knowledge.... The 'many things' that according to Bacon are 'reserved' are themselves but instruments: the radio as sublimated printing press, the dive bomber as more effective artillery, the remote control as a more reliable compass."

Max Horkheimer and Theodor W Adorno
Dialectic of Enlightenment [1944], Edmund Jephcott, trans, Stanford University Press, 2002, p 4, translation modified.

Rand Bomb Damage Effect Computer
"The Rand Corporation, one of the more venerable think tanks, has for sale (only $3) a 'Bomb Damage Effect Computer.... The movable scale is calibrated for numbers of bombs; on the outer disc one plots the single-shot probability; the middle disc registers distance from target; and the inner disc has two scales, one in black on which one places the pounds per square inch for a surface burst, and another, in red, which has three subscales for different pounds per square inch of air bursts at 300, 600, and 900 feet. You put all your data together, then read what you want to know through two windows on the inner disc, one for fireball radius (up to 10,000 feet) and the other for effective yield (from 1 kiloton to 100 megatons). Simple and clean. No more guesswork."

Joel Kovel
Against the State of Nuclear Terror, p 66.

"Born to a leading Elizabethan courtier and educated at Cambridge, Bacon was a philosopher who advocated inductive reasoning and scientific experimentation, and a politician who lost favor with the queen but regained it under James by betraying his erstwhile friends. He connected utopian thought with practical projects, writing *New Atlantis*, "Of Empire", and "Of Plantations" while investing in the Virginia Company. He drafted his essay "Of Seditions and Troubles" after the Enslow Hill Rebellion (1596), in which food and antienclosure rioters in Oxfordshire planned to march to London to join rebellious apprentices. Bartholomew Steere, a carpenter and one of the rioters, predicted, 'We shall have a merrier world shortly... I will work one day and play the other.' Steere suffered two months of examination and torture in London's Bridewell Prison at the hands of Bacon and other officials."

Peter Linebaugh and Markus Rediker
The Many-Headed Hydra: Sailors, Slaves, Commoners, and the Hidden History of the Revolutionary Atlantic, Boston: Beacon Press, 2000, p 37.

"One means of understanding the mode of abstraction which guides modern science is to realize that it

devalues the cognitive significance of all those things (sense qualities, final causes, aesthetic values) which do not aid in man's domination of things; simultaneously, it asserts the cognitive priority of those aspects of natural phenomena which fit the scheme of prediction and control.... An *a priori* principle of selection is at work in the observation of natural phenomena which provides the foundation for a new concept of science and objectivity. Scientific knowledge is attained only in respect to observably measurable phenomena: a proposition makes no sense whose affirmation or denial would not result in a difference that could ultimately be expressed in some measurable form. Out of the totality which is given in experience certain factors are isolated: bodies, movement, spatiotemporal causality, and relations of magnitude. These factors are then united and related in a symbolized manner—for modern science, in the language of advanced mathematics.... Those aspects of experience excluded by the selective mechanism, that is, those aspects which cannot be represented in the chosen symbolic language of mathematics (such as aesthetic intuition), are not considered as an additional order of experience, but rather are assigned a fundamentally different status: they belong to the realm of the 'subjective' and the 'unscientific'."

William Leiss
The Domination of Nature, pp 110–111.

"One of the things a scientific community acquires with a paradigm is a criterion for choosing problems that, while the paradigm is taken for granted, can be assumed to have solutions. To a great extent these are the only problems that the community will admit as scientific or encourage its members to undertake. Other problems, including many that had previously been standard, are rejected as metaphysical, as the concern of another discipline, or sometimes just too problematic to be worth the time. A paradigm can, for that matter, even insulate the community from those socially important problems that are not reducible to the puzzle form, because they cannot be stated in terms of the conceptual and instrumental tools the paradigm supplies."

Thomas S Kuhn
The Structure of Scientific Revolutions [1962], second edition, University of Chicago Press, 1970, p 37.

Nuclear Bomb Effects Computer
"Nature, before and after quantum theory, is what can be registered mathematically; even what cannot be assimilated, the insoluble and irrational, is fenced in by mathematical theorems. In the preemptive identification of the thoroughly mathematicized world with truth, enlightenment believes itself safe from the return of the mythical. It equates thought with mathematics. The latter is thereby cut loose, as it were, turned into an absolute authority."

Max Horkheimer and Theodor W Adorno
Dialectic of Enlightenment, p 18.

"On closer analysis we even find that science knows no 'bare facts' at all but that the 'facts' that enter our knowledge are already viewed in a certain way and are, therefore, essentially ideational."

Paul Feyerabend
Against Method, p 19.

Laws of social motion, logics of accumulation

"Until the Battle of Lepanto, Venetian triremes sat three men to a bench, each with his own oar. That suited a regime in which most of the labor was neither convict nor slave. After Lepanto, Venice adopted the practice of other navies, used convict labor, and chained as many as eight men to work a single oar. The system reduced the effects of variations among individuals and suggested the treatment of octets of oarsmen as a complex cog in a great machine. Officials at the state arsenal, which made all Venetian warships, wanted to know whether any changes in the length, shape, and support of the oars, and the situation and technique of the rowers, would improve the cog's efficiency.... Did it matter where the oarlock was placed? Galileo answered no, since the oar acts like a lever and only the ratio of the distances of the forces from the fulcrum count. Contarini must have felt himself lucky to have such a mathematician to hand, for Galileo, on his own accounting, was perhaps the first person to understand the mechanism of rowing. The standard explanation, given in the Aristotelean Mechanica, made the sea the resistance, the rower the force, and the oarlock the fulcrum. In Galileo's version, the ship, acting at the lock, is the resistance and the water, when the oar first attacks it, the fulcrum."

JL Heilbron
Galileo, Oxford University Press, 2010, p 78.

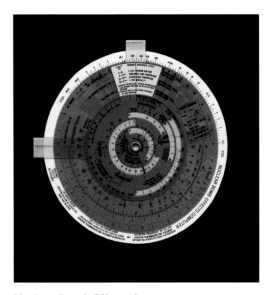

Nuclear Bomb Effects Computer
"Bomb Power translates directly to information power. Secrecy emanated from the Manhattan Project like a giant radiation emission.... And the power of secrecy that enveloped the Bomb became a model for the planning or execution of Anything Important, as guarded by Important People. Because the government was the keeper of the great secret, it began to specialize in secret keeping."

Garry Wills
Bomb Power, p 137.

"By the last half of the seventeenth century, capitalists had organized the exploitation of human labor in four basic ways. The first of these was the big commercial estate for the practice of capitalist agriculture, whose American equivalent was the plantation, in many senses the most important mercantalist achievement. Second was petty production such as the yeoman farmer or prosperous artisan enjoyed. Third was the

putting-out system, which had, in Europe, begun to evolve into the system of manufactures. In Africa and the Americas, European merchants put out firearms, which were used by their clients to capture people (to sell as slaves), to kill animals (for their furs), and to destroy a wealth of common ecologies. The fourth means of organizing the exploitation of labor was the mode of production that united all the others in the sphere of circulation—namely, the ship."

Peter Linebaugh and Markus Rediker
The Many-Headed Hydra, p 149.

"Sea trade is an integral component of the world-industrial system, but we are distracted from the full implications of this insight by two powerful myths. The first is that the sea is nothing more than a residual mercantalist space: a reservoir of cultural and economic anachronisms, relics of an older and obsolete economy—a world of decrepitude, rust, and creaking cables, of the slow movement of heavy things. The second is that we live in a post-industrial society, that cybernetic systems and the service economy have radically marginalized the 'old economy' of heavy material fabrication and processing. Thus the fiction of obsolescence mobilizes reserves of sentimental longing for things which are not really dead.... Today, over 90 per cent of the world's cargo moves by sea. Without a 'revolution' in ocean-going cargo-handling technology, the global factory would not exist, nor the phenomenon of globalization itself. What began in the mid-1950s as a modest American improvement in cargo logistics has now taken on world-historical importance. The cargo container—a standardized metal box, easily transferred from ship to truck to train—has radically transformed the space and time of port cities and ocean passages."

Allan Sekula and Noël Burch
"The Forgotten Space", *New Left Review* 69, May–June 2011, p 78.

"Mopping-up operations are what engage most scientists throughout their careers. They constitute what I am here calling normal science. Closely examined, whether historically or in the contemporary laboratory, that enterprise seems an attempt to force nature into the preformed and relatively inflexible box that the paradigm supplies. No part of the aim of

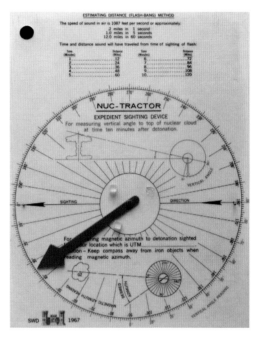

Nuc-Tractor Expedient Sighting Device
"Nuclear war will be the war of nuclear states, and the nuclear state is what the nation-state has become since it set out to make nuclear weaponry an instrument of its policy. From one angle, this was a far-reaching transformation; from another, a continuation of tendencies present since the modern era began."

Joel Kovel
Against the State of Nuclear Terror, p xi.

normal science is to call forth new sorts of phenomena; indeed those that will not fit the box are often not seen at all. Nor do scientists normally aim to invent new theories, and they are often intolerant of those invented by others. Instead, normal-scientific research is directed to the articulation of those phenomena and theories that the paradigm already supplies."

Thomas S Kuhn
The Structure of Scientific Revolutions, p 24.

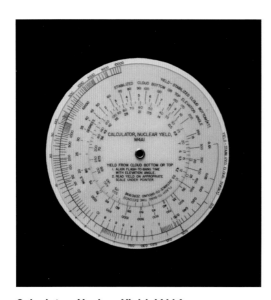

Calculator, Nuclear Yield, M4A1
"The screen is a dim page spread before us, white and silent. The film has broken, or a projector bulb has burned out. It was difficult even for us, old fans who've always been at the movies (haven't we?) to tell which before the darkness swept in. The last image was too immediate for any eye to register. It may have been a human figure, dreaming of an early evening in each great capital luminous enough to tell him he will never die, coming outside to wish on the first star. But it was not a star, it was falling, a bright angel of death."

Thomas Pynchon
Gravity's Rainbow [1973], New York: Penguin, 2006, p 775.

"The technology and technics applied in the economic process are more than ever the instruments of social and political control. The satisfaction of needs (material and intellectual) takes place through scientific organization of work, scientific management, and the scientific imposition of attitudes and behavior patterns which operate beyond and outside the work process and precondition the individuals in accord with the dominant social interests."

Herbert Marcuse
Soviet Marxism, quoted in William Leiss, *The Domination of Nature*, p 204.

Vectors of nuclearism

"With my father I already spoke across a continent, but it was together with my son that I first saw the moving images of the explosion in Hiroshima."

Bertolt Brecht
"A Short Organum for the Theater", [1949], in *Brecht on Theater*, John Willett, ed, New York: Hill and Wang, 1992, p 184.

"No universal history leads from the wild man to humanity, but there is one leading from the slingshot to the mega-bomb."

Theodor W Adorno
Negative Dialectics [1966], EB Ashton, trans, New York: Continuum, 1995, p 320, translation modified.

"The Bomb is, after all, something more than an inert Thing. First, it is, in its destructive yield and its programmed trajectory, a thing of menace. Second, it is a component in a weapons system: and producing, manning, and supporting that system is a correspondent social system—a distinct organization of labor, research and operation, with distinctive hierarchies of command,

rules of secrecy, prior access to resources and skills, and high levels of policing and discipline: a distinctive organization of production, which, while militarist in character, employs and is supported by great numbers of civilians (civil servants, scientists, academics) who are subordinated to its discipline and rules."

EP Thompson
"Notes on Exterminism, the Last Stage of Civilization", in *Exterminism and Cold War*, *New Left Review*, London: Verso, 1982, p 4.

"In the late Autumn and early winter of 1946-47, more than a year after the atomic bombings of Japan, as the Baruch Plan for international control of atomic energy was going down in defeat in the nascent United Nations, two influential articles appeared in respected national magazines justifying the 1945 attacks on Hiroshima and Nagasaki. In the December 1946 *Atlantic Monthly*, physicist Karl T Compton, MIT's president and a wartime atomic-energy adviser, published 'If the Atomic Bomb Had Not Been Used'. Two months later, in February 1947, a more extended treatment of the issues appeared in *Harper's Magazine* as 'The Decision to Use the Atomic Bomb', under the authorship of Henry L Stimson, the wartime secretary of war who had helped to guide America's use of the two bombs.... There was a rich and revealing history behind the creation and publication of these two A-bomb defenses. The ventures were conceived, and urged, by James B Conant, Harvard's president and a wartime atomic policymaker."

Barton J Bernstein
"Seizing the Contested Terrain of Early Nuclear History", in Kai Bird and Lawrence Lifschultz, eds, *Hiroshima's Shadow*, Stony Creek, CT: Pamphleteer's Press, 1998, pp 163–164.

"President Conant has written to me that one of the principle reasons he had for advising me that the bomb must be used was that was the only way to awaken the world to the necessity of abolishing war altogether. No technological demonstration, even if it had been possible under the conditions of war—which it was not—could take the place of the actual use with its horrible results."

Henry L Stimson to Raymond Gram Swing
(4 February 1947), quoted by Barton J Bernstein
"Seizing the Contested Terrain of Early Nuclear History", in Kai Bird and Lawrence Lifschultz, eds, *Hiroshima's Shadow*, p 177.

Edward Teller with Slide Rule
"Nuclear weapons are like slavery—there is no compromising with them; they are an evil which has to go."

Joel Kovel
Against the State of Nuclear Terror, p 227.

"The first statesman to be tried on charges arising from the bombing of Hiroshima was Mr Stimson, and he was tried on his own admission contained in an article which he had published in 1947 in *Harper's*. The prosecution pointed out that the 'defense' put forward by Mr Stimson in that article was untenable. Mr Stimson's point was that, had the bomb not been used, millions would have perished in an invasion of Japan. The prosecutor, a Dutchman, quoted from a memorandum prepared after the surrender of Japan by the United States Strategic Bombing Survey which showed that the United States could have won the war against Japan without invasion, just by sitting tight, since Japan was essentially defeated before the bomb was dropped on Hiroshima. He further quoted passages from the book *Secret Mission*, by Ellis M Zacharias, published in 1946, which showed that Japan's desperate position must have been known to Mr Stimson, since it was fully disclosed in the reports prepared by the United States Naval Intelligence."

Leo Szilard
"My Trial as a War Criminal", in *The Voice of the Dolphins and Other Stories*, New York: Simon and Schuster, 1961, p 81.

Radiation Dosage Calculator
"The public never understood how arbitrary the tolerance dose was. The quantification of radiation into roentgens and curies and recommended dosages sounded scientific. The numbers sent a false message of safety. Giving a number to something fearful is a way of mastering it.... It was not officially acknowledged that the amount of radiation an individual absorbed is cumulative."

Bettyann Kevles
Naked to the Bone: Medical Imaging in the Twentieth Century, New Brunswick, NJ: Rutgers University Press, 1997, pp 90–91.

"It was James B Conant, then president of Harvard University, who first introduced me to the history of science and thus initiated the transformation in my conception of the nature of scientific advance. Ever since that process began, he has been generous of his ideas, criticisms, and time—including the time required to read and suggest important changes in the draft of my manuscript."

Thomas S Kuhn
The Structure of Scientific Revolutions, second edition, p xi.

"By 1949–50, federal expenditures for weapons-related research had topped $1 billion, more than 15,000 separate projects, the majority in industry but a rising per centage at universities. Then, when the Korean War added urgency to this activity, Pentagon spending for science instantly ballooned, almost tripling in the next two years to reach $1.6 billion in fiscal 1952. Many people and institutions that had previously resisted the Pentagon's blandishments now succumbed. A 1951 survey discovered physicists at 750 US colleges and universities devoting seventy per cent of their time to 'defense research'. By the

time of the cease-fire in 1953, which signified no letup in the Cold War, 98 out of every 100 dollars spent by the government on academic physics came from the Defense Department or the AEC. Lured by Faust and Uncle Sam, vast battalions of American scientists, never really demobilized after World War II, gratefully accepted a lucrative commission to reenlist."

James G Hershberg
James B Conant: Harvard to Hiroshima and the Making of the Nuclear Age,
Stanford University Press, 1993, p 555.

"The bomb merely marked the thunderous climax of an evolutionary process that wove science together with wider societal forces, Conant explained. From around 1700, when modern science 'first reached the walking and talking stage', until World War I, each generation gathered up the beneficial inventions of previous ages and looked forward expectantly to further progress. Then the twentieth century's two global wars and the development of atomic weapons had completely changed the social role and context of science—changes that paralleled those in Conant's own life, though he did not mention them, from teenage tinkerer to World War I poison-gas maker to Du Pont consultant to top-secret wartime administrator. The Second World War, he asserted, taught the general public about a new reality that modern industry already appreciated: the old-fashioned scientist... had turned into an inventor, relied on by state, business and society alike for destructive weapons, miraculous cures, and 'tremendous transformations of man's relation to his material environment'."

James G Hershberg
James B Conant, pp 572–573.

"A possible answer begins with the redefinition of our passivity in the face of the nuclear threat. If we can see this in political terms rather than as the result of mental mechanisms, it may be possible to unlock the fatal subjective grip of the state apparatus. Put bluntly, we should learn to regard our experience of the nuclear age as a form of oppression. There may be a psychology of oppression, but oppression itself is non-psychological. To look at it means taking seriously the other who is doing the oppressing. We need to

Calculator, Downwind Toxic Vapor Hazard, Point Source
"What had been hopeless with pencil and paper might possibly be made to work with digital computers. These extraordinary machines, feverishly developed during the Second World War to break enemy codes and to calculate how to explode an atomic bomb, were leaping ahead in power as the Cold War demanded more and more calculations. In the lead, energetically devising ways to simulate nuclear weapons explosions, was a brilliant and ambitious Princeton mathematician, John von Neumann. He saw parallels between weather prediction and his nuclear explosion simulations (both involved rapidly changing fluids). In 1946, von Neumann began to advocate using computers for numerical weather prediction. The idea drew support from the US Weather Bureau, the Army, and the Air Force, as well as the ubiquitous Office of Naval Research. Von Neumann told the Navy that his efforts had a dual goal: not only to predict daily weather changes, but to calculate the general circulation of the entire atmosphere, trade winds and all. That was not because he was interested in global climate change. He and his military sponsors knew they had to understand the general circulation if they were to hope to twist the climate in a given region, to their benefit or their enemy's harm."

Spencer R Weart
The Discovery of Global Warming, pp 57–58.

"recognize the nature of the tie between the nuclear state of being and the state nuclear apparatus, and call it by its right name, that of terrorization."
Joel Kovel
Against the State of Nuclear Terror, p 30.

The administered world and the security-surveillance state

"We do not stand by everything we said in the book in its original form. That would be incompatible with a theory which attributes a temporal core to truth instead of contrasting truth as something invariable to the movement of history. The book was written at a time when the end of the National Socialist terror was in sight. In not a few places, however, the formulation is no longer adequate to the reality of today. All the same, even at that time we did not underestimate the implications of the transition to the administered world."
Max Horkheimer and Theodor W Adorno
Dialectic of Enlightenment [1944], "Preface to the New Edition", 1969, p xi.

Luis Alvarez and the 'Great Artiste'
"We had gone away as boys, so to speak, and came back as men. We had initiated large technical projects and carried them to completion as directors of teams of scientists and technicians... Wise parents let their children solve all the problems they can but stand by to help when a problem proves too difficult."
Luis Alvarez
Scientific observer shadowing 'Enola Gay' over Hiroshima 6 August 1945, quoted in Glenn Seaborg, *Adventures in the Atomic Age*, New York: Farrar, Straus and Giroux, 2001, pp 132–123.

"In 1945 and 1946, the rudiments of the National Security State were being gestated in secret, in unauthorized efforts at a peacetime intelligence agency, in bureaucratic scurrying, in internal documents. But in 1947, this backstage activity became a visible surge. That was the year when the instruments of war in peace were locked into place."
Garry Wills
Bomb Power: The Modern Presidency and the National Security State, New York: Penguin, 2010, p 70.

"By exposing NSA programs like PRISM and Boundless Informant, Edward Snowden has revealed that we are not moving toward a surveillance state: we live in the heart of one. The 30-year-old whistleblower told *The Guardian*'s Glenn Greenwald that the NSA's data collection created the possibility of a 'turnkey tyranny', whereby a malevolent future government could create an authoritarian state with the flick of a switch. The truth is actually worse. Within the context of current economic, political and environmental trends, the existence of a surveillance state doesn't just create

a theoretical possibility of tyranny with the turn of a key—it virtually guarantees it."

Trevor Paglen
"Turnkey Tyranny, Surveillance and the Terror State", *Guernica, A Magazine of Art and Politics*, 25 June 2013.

"The National Security State was formed in and by the Cold War. It was modeled on entities from World War II—the OSS, the Manhattan Project, the wartime FBI, among other things. It was continued and intensified during the war on terror, with even greater secrecy, executive unaccountability, and projects like torture and extraordinary rendition. The whole structure is outside the Constitution.... The National Security State is in permanent constitutional crisis."

Garry Wills
Bomb Power, pp 98, 102.

"Instead of having the liberating effect of making us rethink the whole history that had led us to such a pass, the fear of nuclear weaponry was turned into an allegiance to the one force that could and would use them. We let the instruments of a state—men who go about in the form of technocrats—decide our nuclear fate for us, instead of taking that fate in our hands. We did not freely delegate our powers to them; rather, we let our powers become alienated through terrorization. We submitted to the normalization and mystification of the bomb; we allowed the state to present itself to us as a protector instead of the perpetrator of nuclear politics; we sat back as a terror bureaucracy grew up in secret and entwined itself about our lives; we fell for the delusions of Soviet wickedness as an excuse for the state's lawlessness; we allowed the press to bamboozle us; and we swam in a sea of jingoism and technocracy. All this was the price for accepting the bomb, of integrating it into our lives and living through the era of deterrence."

Joel Kovel
Against the State of Nuclear Terror, p 70.

"While civic parts of the state have been in retreat, institutions of the Terror State have grown dramatically. In the name of an amorphous and never-ending 'war on terror', the Department of Homeland Security was created, while institutions such as the CIA, FBI and NSA, and darker parts of the military like the Joint Special Operations Command (JSOC)

IBM Ad, "100 Extra Engineers"
"Formal logic was the great school of unification. It offered Enlightenment thinkers a schema for making the world calculable.... Number became Enlightenment's canon. The same equations dominate bourgeois justice and commodity exchange.... Bourgeois society is dominated by equivalence."

Horkheimer and Adorno
Dialectic of Enlightenment, p 5, translation modified.

have expanded considerably in size and political influence. The world has become a battlefield—a stage for extralegal renditions, indefinite detentions without trial, drone assassination programs and cyberwarfare. We have entered an era of secret laws, classified interpretations of laws and the retroactive 'legalization' of classified programs that were clearly illegal when they began. Funding for the secret parts of the state comes from a 'black budget' hidden from Congress—not to mention the people—that now tops $100 billion annually. Finally, to ensure that only government-approved 'leaks' appear in the media, the Terror State has waged an unprecedented war on whistleblowers, leakers and journalists. All of these state programs and capacities would have been considered aberrant only a short time ago. Now, they are the norm."

Trevor Paglen
"Turnkey Tyranny, Surveillance and the Terror State",
Guernica, 25 June 2013.

Rand Progress Curve Computer
"The principle of this apparatus is technocracy: domination projected through science."
Joel Kovel
Against the State of Nuclear Terror, p xi.

Biospheric convulsions

"Is human technology a force of geophysical scope, capable of affecting the entire globe? Surely it is not, thought most people in 1940. Surely it is, thought most in 1965."

Spencer R Weart
The Discovery of Global Warming, Cambridge, MA: Harvard University Press, 2003, p 40.

"Here, far from the pieties, one encounters the effects of capital's ruthless pressure to expand. Imperialism was such a pattern, manifest politically and across nations. But this selfsame ever-expanding capital was also the superintendent and regulator of the industrial system whose exhalations were trapping solar energy. What had proven true about capital in relation to empire could be applied, therefore, to the realm of nature as well, bringing the human victims and the destabilizations of ecology under the same sign. Climate change was, in effect, another kind of imperialism. Nor was it the only noxious ecological effect of capital's relentless growth. There was also the sowing of the biosphere with organochlorines and other toxins subtle as well as crude, the wasting of the soil as a result of the 'green revolution', the prodigious species losses, the disintegration of

Amazonia, and much more still—the spiraling, interpenetrating tentacles of a great crisis in the relationship between humanity and nature."

Joel Kovel
The Enemy of Nature, London: Zed Books, 2007, p xii.

"Nobody advised Gilbert Plass to study greenhouse warming. The Office of Naval Research supported him to do theoretical calculations for an experimental group at Johns Hopkins University who were studying infrared radiation. As Platt later recalled, he got curious about climate change only because he read broadly about topics in pure science. He happened upon the discredited theory that the ice age could be explained by changes in CO_2. Plass took to studying how CO_2 in the atmosphere absorbed infrared radiation, as an adjunct to his official work. Before he finished his analysis, he moved to southern California to join a group at the Lockheed Aircraft Corporation, studying questions of infrared absorption directly related to heat-seeking missiles and other weaponry. Meanwhile he wrote up his results on the greenhouse effect—'in the evening', as he recalled, taking a break from his weapons research."

Spencer R Weart
The Discovery of Global Warming, p 23.

"[Roger Revelle's] group was already studying the question of how fast the ocean's surface waters turned over. It was a matter of national interest, for the Navy and the US Atomic Energy Commission were concerned about the fate of fallout from bomb tests. The Japanese were in an uproar over contamination of the fish they relied upon.... Back in 1946, the Navy had sent Commander Revelle (he had taken the naval rank during the war) to Bikini Atoll, at the head of a team that studied the lagoon in preparation for a nuclear bomb test. The seas are not just salt water but a complex stew of chemicals, and it was not easy to say what adding more chemicals would mean for, say, the carbon in corals. Through the following decade Revelle kept trying out calculations and abandoning them, until one day he realized that the peculiar chemistry of seawater would prevent it from retaining all of the carbon that it might take up.... Revelle calculated that in sum, the ocean surface could not really absorb

much gas—barely one-tenth the amount earlier calculations had predicted. Whatever CO_2 humanity added to the atmosphere would not be swallowed up promptly, but only over thousands of years."

Spencer R Weart
The Discovery of Global Warming, pp 28–29.

"A variety of motives converged to make the IGY [International Geophysical Year of 1957–58] possible. The scientist organizers hoped chiefly to advance scientific knowledge, and thereby to advance their individual careers. The government officials who supplied the money, while not indifferent to pure scientific discovery, expected the new knowledge would have civilian and military applications. The American and Soviet governments and their allies further hoped to win practical advantages in their Cold War competition. Under the banner of the IGY they could collect global geophysical data of potentially military value. Along the way, each nation hoped to gather intelligence about its rivals, and meanwhile enhance its own prestige. Some scientists and officials, conversely, hoped the IGY would help set a pattern of cooperation between the opposed powers—as indeed it would. It is a moot question whether, in a more tranquil world, governments would have spent so much to learn about seawater and air. For whatever motives, the result was a coordinated effort involving several thousand scientists from 67 nations."

Spencer R Weart
The Discovery of Global Warming, p 35.

"A time that possesses all the technical means necessary for the complete transformation of the conditions of life on earth is also a time—thanks to that same separate technical and scientific development—with the ability to ascertain and predict, with mathematical certainty, just where (and by what date) the automatic growth of the alienated productive forces of class society is taking us: to measure, in other words, the rapid degradation of the very conditions of survival, in both the most general and the most trivial senses of that term."

Guy Debord
"A Sick Planet", Donald Nicholson-Smith, trans, *Oeuvres*, Paris: Gallimard, 2006, p 1063.

"Contemporary nuclear, chemical, ecological, and biological threats are (1) not limitable, either socially or temporally; (2) not accountable according to the prevailing rules of causality, guilt, and liability; and (3) neither compensable nor insurable... [Risk society] means an epoch in which the dark sides of progress increasingly come to dominate social debate. What no one saw and no one wanted—self-endangerment and the devastation of nature—become the motive force of history.... Threats are produced industrially, externalized economically, individualized juridically, legitimized scientifically, and minimized politically. The key question is, How can a policy of ecological self-limitation, by contrast, gain power and enforceability?"

Ulrich Beck
Ecological Enlightenment: Essays on the Politics of the Risk Society, M Ritter, trans, Amherst: Humanity Books, 1995, p 2.

"Of course it had long been understood that a pencil balanced on its point, for example, could fall left or right depending on the tiniest difference in initial conditions. Most scientists supposed that this kind of situation only arose under exceptionally simplified circumstances, far from the stable balance of huge and complex global systems like climate. Only a few, like Brooks, Ewing, and Donn, imagined that the entire climate system might be so delicately balanced that a relatively minor perturbation could trigger a big shift. If that really could happen, it would be because the perturbation was amplified by feedbacks—a term and a concept that came into fashion in the 1950s. A new science of 'cybernetics' was announced by mathematician Norbert Wiener, whose wartime work on automatic gun-pointing mechanisms had shown him how easily physical systems could wobble out of control. Wiener was at the Massachusetts Institute of Technology, where several groups were enthusiastically building numerical models of weather among many other things."

Spencer R Weart
The Discovery of Global Warming, p 61.

"Like the rich man through the eye of a needle, ecological revolutions must pass through each individual's rethinking and changing of even the smallest actions. Certainly, there are general objectives, general limiting conditions, and general

risks of failure. But these can only be achieved or avoided in the millipede revolution of many million small steps, from above and below, in which the possibilities of an ecological expansion of democracy are tested and fought for."

Ulrich Beck
Ecological Enlightenment, p 12.

"Only a basic change in patterns of production and use can allow ecologically appropriate technologies to have their beneficial effect. But this means a basic change in need patterns and in the whole way life is lived, which means an entirely different foundation for society. To the extent that expectation of technological fixes blinds us to this, technology may be said to stand in the way of resolving the ecological crisis. In truth, technology does not stand in the way; it is part of the way. Technology is not a collection of techniques and tools but a pattern of social relationships centering on the extension of the body as an instrument for transforming nature."

Joel Kovel
The Enemy of Nature, p 172.

"Nature does not yet exist."

Theodor W Adorno
Aesthetic Theory, Robert Hullot-Kentor, trans, Minneapolis: University of Minnesota Press, 1997, p 74.

Science in common?

"The domination of nature, so the imperialists teach, is the purpose of all technology. But who would trust a cane wielder who proclaimed the mastery of children by adults to be the purpose of education? Is not education above all the ordering of the relationship between generations and therefore domination, if we are to use this term, of that relationship and not of children? And likewise technology is not the domination of nature but of the relation between nature and man."

Walter Benjamin
"To the Planetarium" [1925–26], in *One-Way Street* [1928], Edmund Jephcott, trans, London: Verso Books, 1997, p 104, translation modified.

"An alternative science is always possible."
Ulrich Beck
Ecological Enlightenment, **p 50.**

"The only principle that does not inhibit progress is: anything goes."
Paul Feyerabend
Against Method, **p 23.**

"For what reason do you labor? I take it the intent of science is to ease human existence. If you give way to coercion, science can be crippled, and your new machines may simply suggest new drudgeries. Should you then, in time, discover all there is to be discovered, your progress must then become a progress away from the bulk of humanity. The gulf might even grow so wide that the sound of your cheering at some new achievement would be echoed by a universal howl of horror."
Bertolt Brecht
Galileo, 1947 version, Charles Laughton, trans, quoted in *Life of Galileo*, **p 261.**

"Progress would be the very establishment of humanity in the first place, whose prospect opens up in the face of its extinction."
Theodor W Adorno
"Progress", in *Critical Models: Interventions and Catchwords*, **Henry Pickford, trans, New York: Columbia University Press, 1998, p 145.**

"The existing connection between scientific rationality and political domination is to be found in the 'absolutization' of a particular scientific method as the only valid source of objective knowledge. This is Horkheimer's point, and I think Marcuse's work as a whole is in accord with it."
William Leiss
The Domination of Nature, **p 209.**

"The long-term policy toward threats should be: slowing down, revisability, accountability, and, therefore, the ability for consent as well; that is to say, the expansion of democracy into previously walled-off areas of science,

technology, and industry. The opportunities of risk society are not being recognized or utilized. What is important is to exploit and develop the superiority of doubt against industrial dogmatism."
Ulrich Beck
Ecological Enlightenment, **p 17.**

"If it is a whole way of being that needs changing, then the essential question of 'what is to be done?' takes on new dimensions, and ecological politics is about much more than managing the external environment. It has to be thought of, rather, in frankly revolutionary terms.... There is a big problem with these ideas, namely, that very few people take them seriously."
Joel Kovel
Enemy of Nature, **p xiii.**

Visible and Invisible

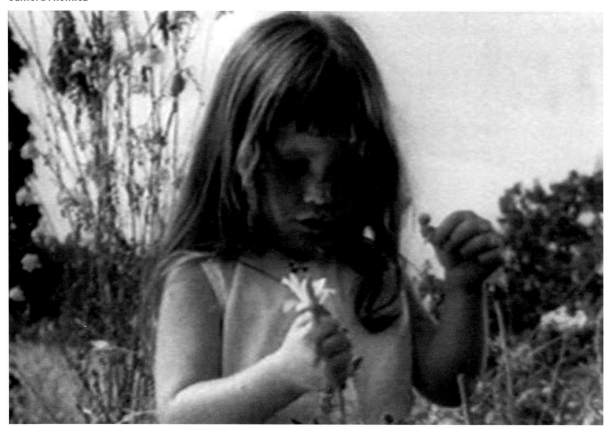

Tony Schwartz with Doyle Dane Bernbach
Peace Little Girl (Daisy Ad), 1964

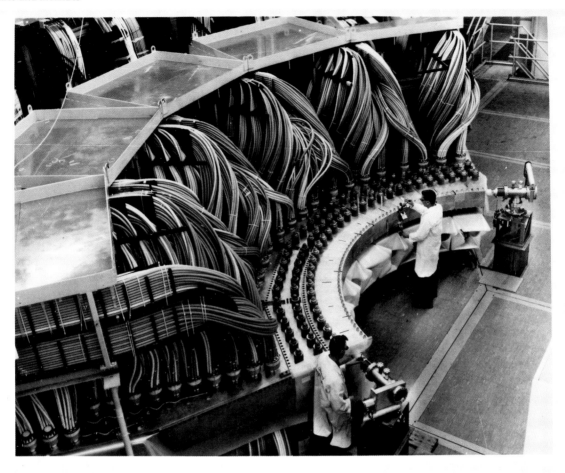

IPS - 73-1531c

Los Alamos Scientific Laboratory
*Segment of large scylia controlled
thermonuclear research device at
Los Alamos Scientific Laboratory,
New Mexico*, c 1950s

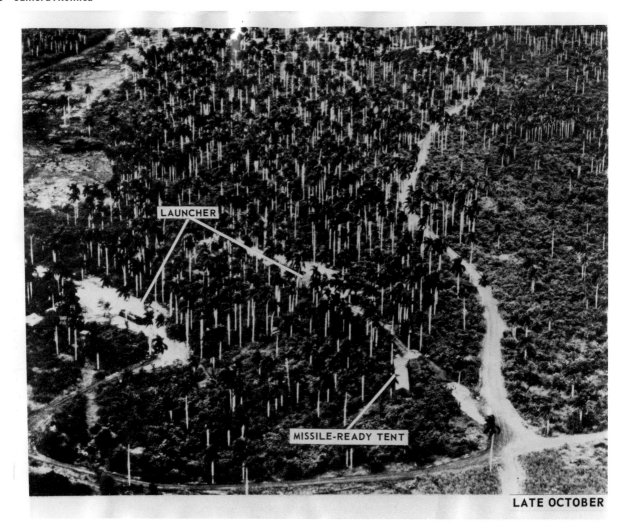

Associated Press
Medium Range Nuclear Ballistic
Missile Site at Sagua La Grande, Cuba,
late October 1962

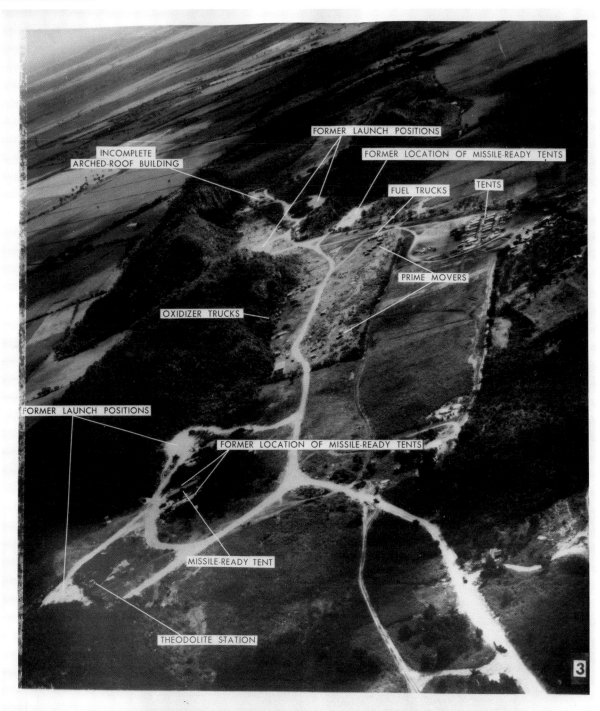

INCOMPLETE ARCHED-ROOF BUILDING

FORMER LAUNCH POSITIONS

FORMER LOCATION OF MISSILE-READY TENTS

FUEL TRUCKS

TENTS

PRIME MOVERS

OXIDIZER TRUCKS

FORMER LAUNCH POSITIONS

FORMER LOCATION OF MISSILE-READY TENTS

MISSILE-READY TENT

THEODOLITE STATION

Associated Press
Medium Range Nuclear Ballistic
Missile Site at Sagua La Grande, Cuba,
3 November 1962

William Eggleston
Huntsville, Alabama, c 1969

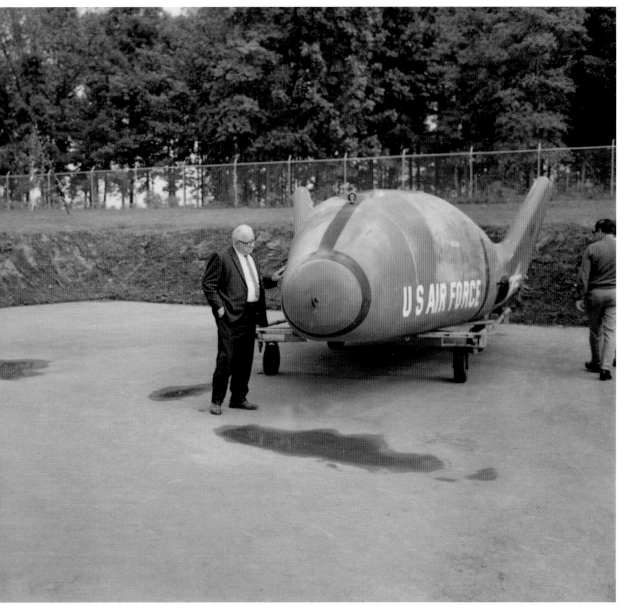

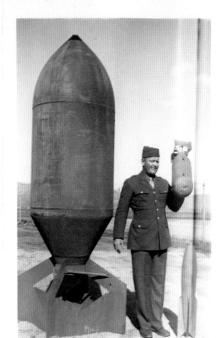

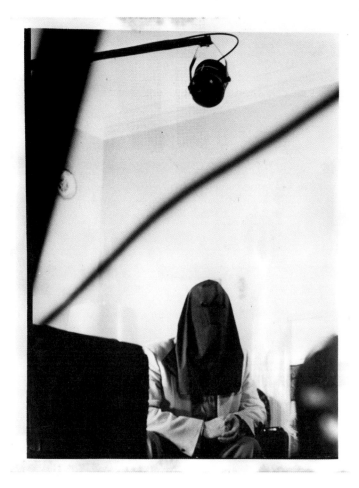

LEFT
Unknown
Tom & Big Boy & Baby Bomb, 1956

RIGHT
International News Photo
Soviet Defector Igor Gouzenko
Wearing a Hood, 29 January 1954

David McMillan
Sinking Boat on the Pripyat River,
Chernobyl, October 1998

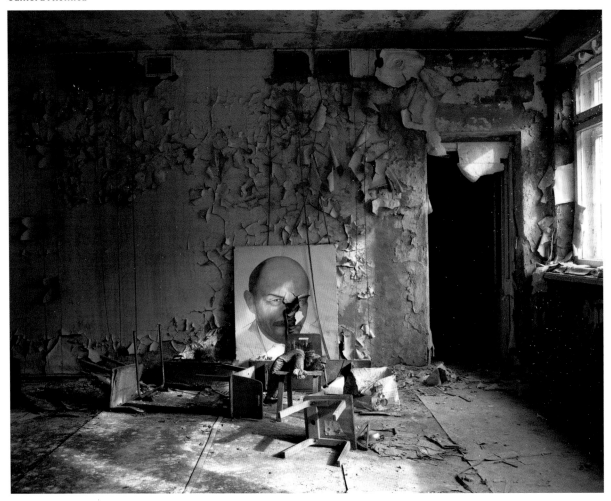

David McMillan
*Nursery School Classroom,
Pripyat*, October 1997

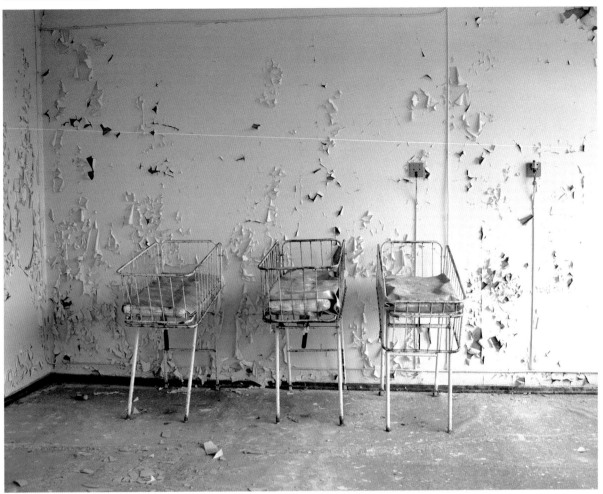

David McMillan
Nursery, Pripyat Hospital, 1995

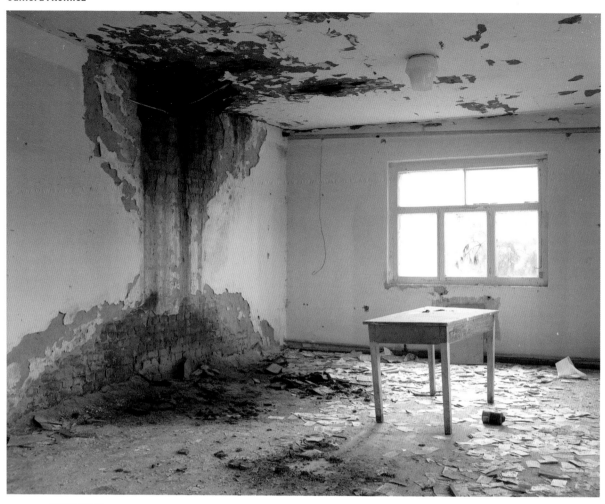

David McMillan
Village Office with Damaged Roof,
October 1996

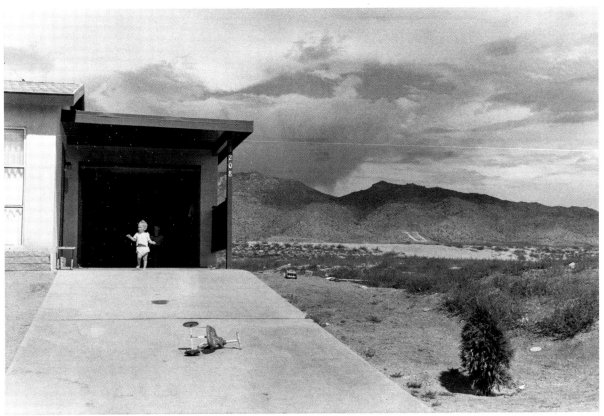

Garry Winogrand
Albuquerque, New Mexico, 1957

Ken + Julia Yonetani
*Crystal Palace: The Great Exhibition
of the Works of Industry of All Nuclear
Nations (Canada)*, 2013

Mike Mandel and Larry Sultan
*Untitled [Scale Model prior to the
Start of Construction of a Nuclear
Power Project]*, from the installation
Evidence, 1977

Garry Winogrand
White Sands National Monument, 1964

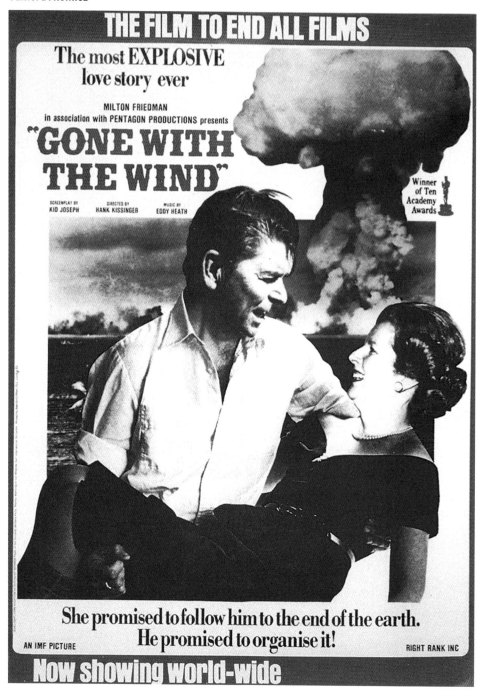

Bob Light and John Houston
Gone with the Wind, c 1983

Unknown
President Kennedy and Glenn Seaborg,
Chair of the Atomic Energy Commission,
Presenting the Enrico Fermi Award at
the White House, 1961

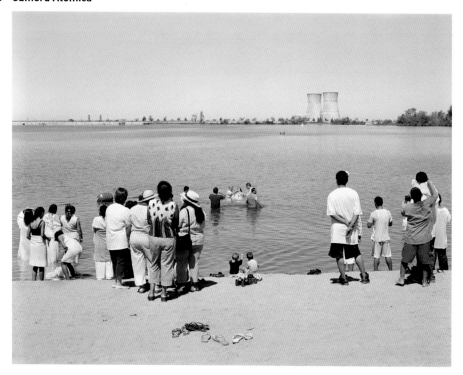

TOP
Mitch Epstein
*Ranch Seco Nuclear Power
Plant, Herald, California,* 2005

BOTTOM
Edward Burtynsky
*AMARC #5, Tuscon, Arizona,
USA,* 2006

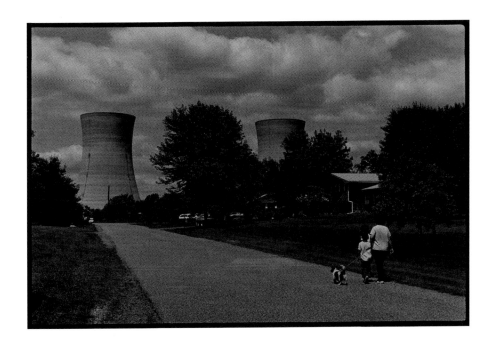

TOP
Bill Burke
Industry Shipping, c 1970

BOTTOM
Robert Del Tredici
*Peck's Road, Londonderry
Township*, 20 June 1979;
printed 1981

TOP
Mike Mandel and Larry Sultan
Untitled [General Atomic, San Diego, Man Working in a Drum], from the installation *Evidence*, 1977

BOTTOM
Mike Mandel and Larry Sultan
Untitled [Man with Radioactive Plants], from the installation *Evidence*, 1977

TOP
Barbara Norfleet
*Measuring Cosmic Rays, Los Alamos
National Laboratory: 43 Square
Miles, Los Havro*, 1988

BOTTOM
Barbara Norfleet
*House on Fringe of Simulated
American Town Over Which a
Nuclear "Device" Exploded*, 1991

Robert Adams
Untitled, from the series
*Our Lives and Our Children:
Photographs Taken Near the
Rocky Flats Nuclear Weapons
Plant*, c 1980

POUR
VISITEURS

FOR
VISITORS

OPPOSITE
Todd Eberle
Model Emergency Button in the
Visitor's Center, Large Hadron
Collider, c 2009

TOP
Todd Eberle
Hard Hats Large Hadron
Collider, c 2009

U.S. Atomic Energy Industry
Meet Citizen Atom—Your
Partner in Progress, 1960

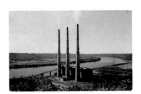
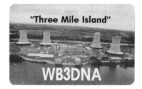

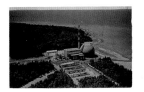
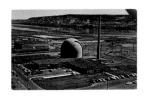

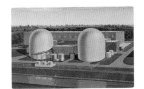

John O'Brian
*Sixteen Nuclear Power
Stations*, 2013

John Scott
The Collaborationist, 1986

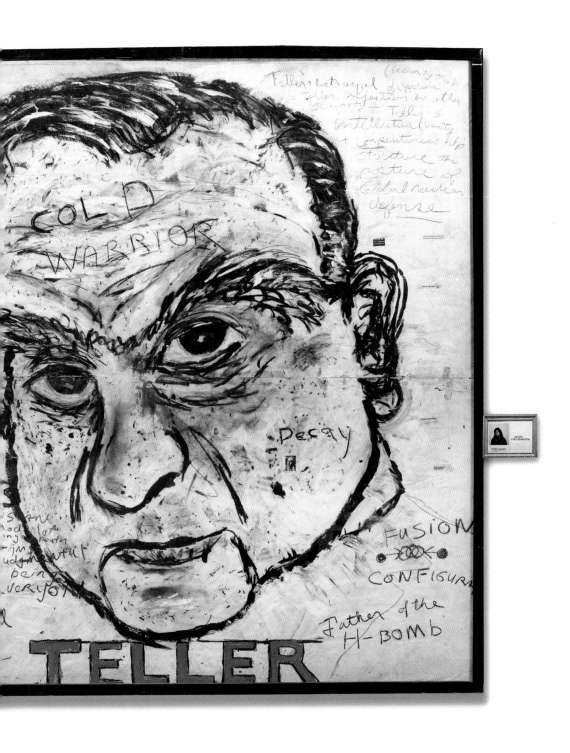

The
Wrong
Sun

Douglas Coupland

The first time I ever visited a McDonald's restaurant was on a rainy Saturday afternoon, 6 November 1971. It was Bruce Lemke's tenth birthday party, and the McDonald's was at the corner of Pemberton Avenue and Marine Drive in North Vancouver, British Columbia. The reason I can pinpoint this date is that it was also the date and time of the Cannikin nuclear test on Amchitka Island in the Aleutians—a Spartan Missile warhead of between four and five megatons was detonated at the bottom of a 1.5 mile vertical shaft drilled into this Alaskan island. The press had made an enormous to-do over this blast, as it was to be roughly four times more powerful than any previous underground detonation.

According to the fears of the day, the blast was to occur on seismic faults connected to Vancouver, catalysing chain reactions that in turn would trigger the great granddaddy of all earthquakes. The Park Royal shopping centre would break in two and breathe fire; the Cleveland Dam up the Capilano River would shatter, drowning whoever survived in the mall below. The cantilevered L-shaped modern houses with their "Kitchens of Tomorrow" perched on the slopes overlooking the city would crumble like so much litter—all to be washed away by a tsunami six hours later.

I remember sitting on my purple vinyl stool being unable to eat, gazing out the window, waiting for the flash, waiting for the cars to float up into the sky, for the Hamburglar statue to melt, for the tiled floor to break apart and expose lava.

Of course, nothing happened. A half hour later we were driving away in Mrs Lemke's station wagon to see *The Railway Children* at the Park Royal Twin Theatres. But connections had been made in my mind, however—connections which are hard for me to sever even now, 20 years later: one, that McDonald's equals evil; two, that technology does not always equal progress.

Another nuclear episode, a cherished family story. It is the night of 20 October 1962, and my mother is attending a dance in the officers' mess of the Canadian Air Force base at Baden-Söllingen, West Germany, my birthplace. I am 294 days old. My father is in Switzerland on air force business that evening. An aide-de-camp enters the dance and begins whispering into the ears of the jet fighter pilots. Within minutes, the pilots melt away from the dance, off to the runway where they are then strapped into their jets and placed on 24-hour shifts, and the women are left confused and standing by themselves in Dior "New Look"-inspired dresses. They shuffle perplexedly back to the private married quarters—the PMQs—where they pay the babysitters and search through their cupboards for supplies of powdered milk. The Zenith shortwave radio is turned on and is not turned off for the next three days.

The next day, the PX is closed. Mothers take shifts watching the children in the sandboxes and monitoring the radio reports. They are probably calmer about the situation than civilian wives might be. Already base wives have been through other crises and alerts, though none as large as this. Europe in 1962 is an arena of fear. To

the side of the Autobahn in the scrawny firs of the Schwarzwald lurk untold thousands of camouflaged tanks. Jets buzz the base every day. The Iron Curtain is never more than a tank of gas away.

The crisis builds. For the first time the women are escorted into the "bunkers"—unused furniture storage lockers with windows on the ground floors of the PMQs. There is no furniture inside, nor food nor supplies—no diapers, tranquillizers, bandages or clean water. Oddly there *is*, though, six tins of caviar sitting in a corner. When the women complain they are told by base authorities that they are expendable. *"You should have known that before you came overseas with your husbands."*

The women sit in the semi-dark and monitor the radio while the babies cry. The women look up at the skies, wondering what comes next. Finally from the Zenith there are the relieving words: *"The Soviet ships appear to be turning around."* Life resumes; time resumes.

Miscellaneous images: in high school—Sentinel Senior Secondary, West Vancouver, British Columbia—up on the mountain overlooking the city of Vancouver, in physics class hearing a jet pass overhead, turning around surreptitiously and waiting for the pulse of light to crush the city.

At the age of eight: hearing the sirens wail at the corner of Stevens Drive and Bonnymuir Drive in a civil defence drill, and noticing that nobody seemed to care.

The 1970s and disaster movies: seeing *The Poseidon Adventure* for the first time—the first movie I venture downtown to see on my own at the Orpheum Theatre to watch a world tip upside down. *Earthquake*; *The Omega Man*; *The Andromeda Strain*; *Soylent Green*; *Towering Inferno*; *Silent Running*, films nobody makes anymore because they are all projecting so vividly inside our heads—to be among the last people inhabiting worlds that have vanished, ignited, collapsed and been depopulated.

In art school a decade ago I learned that the best way to memorise a landscape is to close your eyes for several seconds and then blink in reverse. That is, open your eyes just briefly, allowing those images before you to burn themselves onto your retina in an instant rather than with an extended gaze. I mention this because this is essentially the same principle that is in operation when one's world is illuminated by the nuclear flash.

This flashing image is a recurring motif in both my everyday thoughts and in my dream life. My most recurring flashing image is of me sitting on the top floor of a 1970s cement apartment building along the ocean waterfront of West Vancouver, on the twentieth floor, looking out over the ocean. One of the people in the room with me says, *"Look"*, and I look and see that the sun is growing too large too quickly, life a Jiffy pop popcorn foil dome, glowing orange, like an electric stove element. And then I am awake.

Another recurring image: I am on the high school soccer field in PE class. There is a rumble and as a team we stop kicking the ball and walk over to the chain-link fence and look through it to the

south, far beyond the horizon to where we know Seattle is supposed to be, 110 miles away. Instead of Seattle we see a pillar of grey dust and rubble pounding on heaven, the earth launched up into the universe, so far up that it will never return—the earth has become the sky.

A third recurring image, very simple: at my parents' house, in their living room looking out through the front window framed by pyrocanthus berries, out at the maple tree on the front lawn; The Flash flashes; I am awake.

When you are young, you always expect that the world is going to end. And then you get older and the world still chugs along and you are forced to re-evaluate your stance on the apocalypse as well as your own relationship to time and death. You realise that the world will indeed continue, with or without you, and the pictures you see in your head. So you try to understand the pictures instead.

In modern middle-class culture, the absence of death in most people's early years creates a psychic vacuum of sorts. For many, thoughts of a nuclear confrontation are one's first true brush with nonexistence, and because they are the first, they can be the most powerful and indelible. Later in life, more sophisticated equations for death never quite capture that first intensity—the modern sex/death formula; mysterious lumps; the mental illness of friends; the

actual death of loved ones—all of life's painful gifts. At least this is what I tell myself to explain these pictures in my head that will not go away.

And these images are more common than I had realised before, and they are not only particular to me. I have asked many of the people I know, and have interviewed many strangers, and I have heard their stories, tales of their blinkings in reverse. And while the pictures vary greatly from one person to the next—some people witness the flash with their family, some with lovers, some with strangers, some with pets, many alone—there is one common thread, and the thread is this: The flash may occur over the tract suburbs of the Fraser River delta, over Richmond and over White Rock; the flash may occur over the Vancouver harbour, over the Strait of Juan de Fuca, over the Pacific Ocean; the flash may occur over the American border, over Seattle, over Bremerton, over Tacoma, Anacortes, and Bellingham. But the Flash—flashing bright, making us remember in an instant what *was*, making us nostalgic before our time—is always flashing to the South—always to the South, up in the sky, up where we know the sun was supposed to have been.

Reprinted from Douglas Coupland,
Life After God, New York: Pocket Books, 1994, pp 95–111,
and illustrated by the author.

Radical
Contact
Prints

Susan Schuppli

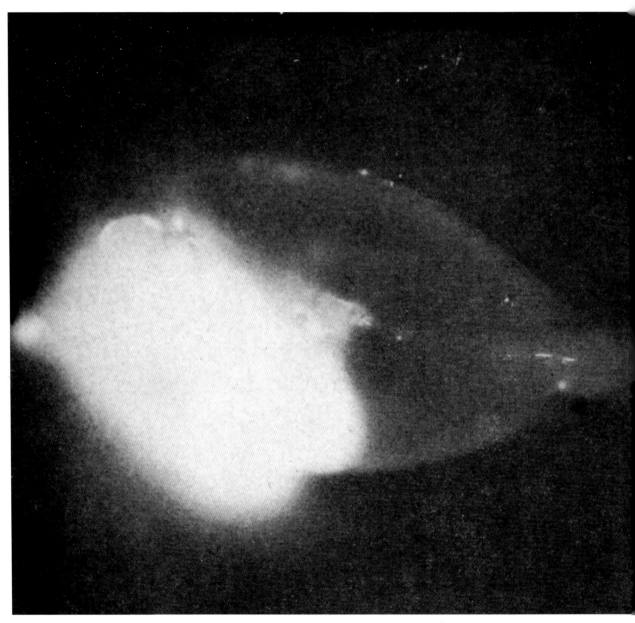

U.S. Military
*Radio-autograph of a tropical puffer
fish*, from the book *Operation
Crossroads: The Official Pictorial
Record*, 1946

A small fish is carefully sliced along the length of its body, splayed open and arranged so that its exposed tissue presses against a photographic plate. After several hours the fish is removed and the film developed. This whole process is carried out in complete darkness without the aid of an enlarger or light source to generate the negative imprint of the object as might be expected when producing a contact print. Instead the ghostly apparition that emerges out of the developing solution is a direct capture of the gradient levels of radioactivity present within the soft tissue of a tropical puffer fish caught in the aftermath of the atomic testing in the Bikini Atoll in 1946. Its contaminated flesh the energetic source of its own radiological recording. Inside the fish's stomach sits a deposit of radioactive algae or 'hot' supper, which has yet to be digested and redistributed to the regions around the gills, liver, intestines and reproductive organs where toxicity settles in greater concentrations.[1] The variance in light and shadow produced by the nuclear signature of such tropical fish was used during the post-war period as a kind of bio-calculus for measuring the degree to which radiation exposure could accumulate within living tissue. Designated radio-autographs, nuclear scientists used these natural species as atomic test prints because their planar morphology and relatively consistent tissue depth made them ideal living analogues to the photographic image plate. Not only could their irradiated tissue render the nuclear visible, but it was also the source of its spontaneous illumination, in that, radioactive decay and the emission of energetic particles was capable of lighting the object from within.

Contacts prints are typically made by placing objects with varying degrees of material opacity directly onto photo-sensitive paper and exposing them. The resulting image registers these objects as a reversal that depicts the relative imperviousness of each to projected light. Photographic contact sheets are produced in a similar manner by exposing film negatives sandwiched between glass and paper. Radio-autographs, while technically contact prints did not require the intercession of an external agent to bring the dynamics of mutating matter into the field of vision, as the radiological object in effect 'automatically' exposes itself. Chief amongst early users of radio-autography was army medical doctor, David Bradley who worked as a radiological monitor or "Geiger man", during Operation Crossroads the first post-war atomic weapon's test. A radio-autograph is seemingly incommensurable with the retinal drama of an atomic blast, but what photography accomplishes in its capture of these two events is to remediate their scalar difference. The radiological wound revealed within the defective tissue of a fish is no less spectacular than that of the mushroom cloud but its proximity to the living renders its radical a-visuality all the more disturbing.[2]

Designed to assess the effects of aerial as well as underwater nuclear explosions on naval assets and biological specimens, Operation Crossroads was executed in the remotely populated area of the Marshall Islands known as the Bikini Atoll in what the army

U.S. Military
*Photographic Engineering
Section of Operations
Crossroads, 1946*

referred to as the Pacific Proving Grounds. On the afternoon of
1 July 1946 more than half of the world's supply of motion picture
film was exposed as 18 tons of cinematography and camera equipment
were loaded aboard US Army Air Forces planes and dispatched to
the Bikini Atoll. Included amongst its photographic cargo was the
world's largest still camera with a 48-inch focal length telephoto
lens, as well as ultra high-speed cameras capable of taking 10,000
fps and motion picture cameras set to capture events at an equally
astonishing frame-rate of 2,000 fps. Boeing F-13 planes had also
been retrofitted as "photographic ships" with the installation of motion
picture cameras into their gun turrets—machine guns literally
converted into massive point and shoot cameras. In total the day
generated more than 50,000 still images and several million feet
of moving image matter as the radioactivity from atomic bomb
detonations registered their lethal fallout on film.

The massive mobilisation of an imagine-regime as a first-
responder to a crime-scene marks this date in history as the
day the world turned unequivocally into a picture. When Martin
Heidegger famously stated in 1938 that "the fundamental event of
the modern age is the conquest of the world as picture" he looked
into the immediate-future in which the image of two cataclysmic
explosions over Japan would inaugurate the era of the technogenic
disaster as well as the primary means by which such events would
come to register publicly, that is to say, as media-events. The
atomic detonations over Japan, followed one year later by further
nuclear experimentation in the Pacific, stand at the "crossroads"
that Heidegger so presciently invoked: namely the transformation
of all material—human or otherwise—into media-matter hybrids.[3]
Indeed, the thermonuclear weapons testing of the hydrogen bomb and
the approaching nuclear accidents at Three Mile Island, Chernobyl,
and Fukushima were already lurking within the first image of the
atomic age produced in the desert of New Mexico on 16 July 1945.

While the image-rapture induced by the lethal combustion of
atomic energy has tended to occlude the morality that circumscribes
the unleashing of such large-scale bio-chemical testing, the
mushroom cloud finds its counter-archive within the radiological
contact print. Unlike the image of the mushroom cloud, which
separates the visual field from the material conditions that it
documents, the radiological contact print is immanent to and

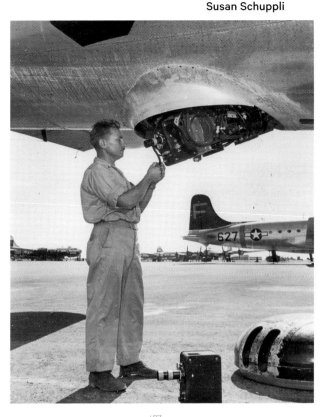

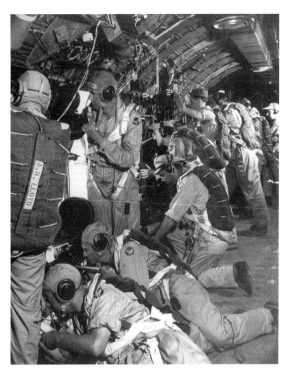

LEFT
Frank Scherschel
*Joseph R. Cermak of Wright Field
installing camera in gun turret
of a plane which will record atom
bomb tests over Bikini Atoll during
Operation Crossroads, July 1946*

RIGHT
Frank Scherschel
*Cameramen watchingfrom one of the
73 planes which observed the atomic
explosion, 1 July 1946*

continuous with the event. By this I mean that the violence out of which the image emerges is directly encoded in the image as the very means by which it comes into the world. When two atomic bombs were detonated over Hiroshima and Nagasaki their searing heat rays transformed the material surfaces of these cities quite literally into photographic contact prints as ghostly photograms of damaged bodies and buildings were etched into concrete and stone. Exposed by the radical intensity of the blast, and without the mediation of a filmic negative, these "atomic shadows" document life at the very moment of death. They too are a kind of radio-autograph —a spontaneous recording of an external event to which it can actively bear material witness.[4]

While we have photographs of the Trinity Test along with subsequent documentation from Nagasaki and Hiroshima, none were specifically orchestrated as image-events. The significance of Operation Crossroads is distinguished by the advance recognition that recorded image-data would provide substantial, if not the most comprehensive *scientific* accounts of the various aerial and underwater tests as well as enabling detailed observation and analysis of their radiological aftermath. Vision machines were placed at the centre of the army's tactical operations with aerial documentation complimented by fixed-shore installations all in the service of capturing the immediate effects of radiation on matter. In short, media, with its technical capacity to capture, arrest, magnify and narrate the dynamic properties and behaviours of matter, particularly under conditions of stress or in novel configurations, would become crucial to the ways in which all phenomena was

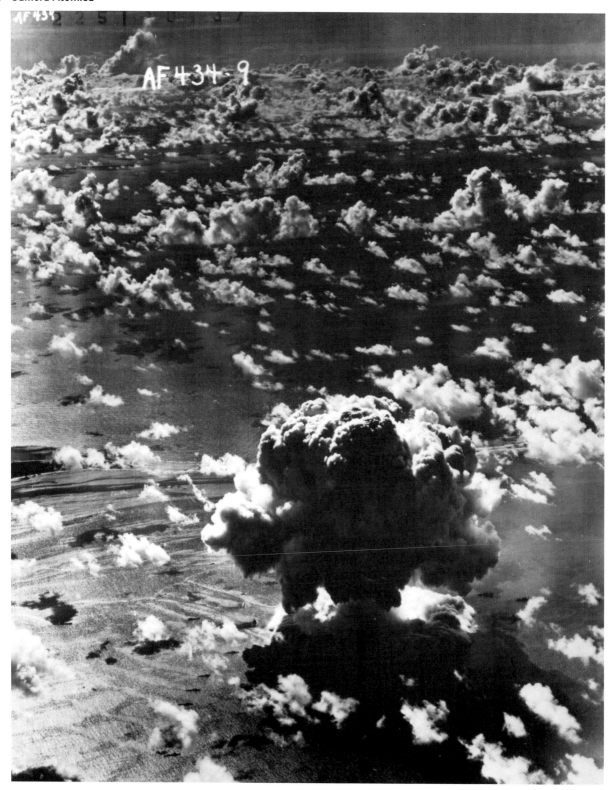

Los Alamos National Laboratory
Baker Test, Operation Crossroads, 1 July 1946

Los Alamos National Laboratory
Trinity Test, New Mexico, 16 July 1945

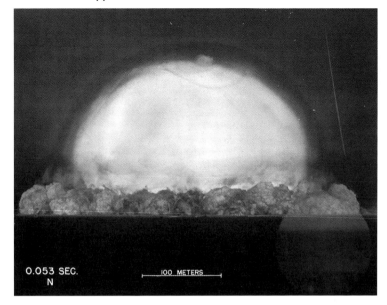

pursued scientifically, and its internal logics diagnostically unlocked as an emergent image-event that could produce knowledge about the world. The radioactive puffer fish of the Bikini Atoll revealed by Bradley's radio-autographs had become the unwitting agent *par excellence* enlisted in service to this new techno-scientific order.

We can make radio-autographs of the distribution of radioactivity in the bodies of little fish, and by means of fish population surveys attempt to discover whether or not the Bomb had any effect on the life-cycles of the lagoon inhabitants.... Such studies may influence the lives of people living in the Tibetan plateau. We don't know to what distances from Bikini the radiation disease may be carried. We can't predict to what degree the balance of nature will be thrown off by atomic bombs.... Bikini is not some faraway little atoll pinpointed on an out-of-the-way chart. Bikini is San Francisco Bay, Puget Sound, East River, it is the Thames, the Adriatic, Hellespont, and misty Baikal.[5]

However before the airborne particle became the delivery system *par excellence* by which lethal toxins were to be carried into the terrifying narratives of modernity, the nuclear capacities of the twentieth century were preceded by two key developments in photo-imaging technology: the discovery of the X-ray in 1895 followed by that of spontaneous radioactivity in 1896. Both of these experimental technologies transformed solid matter into a spectral image trace without the arbitration of the sun, a necessary precondition of all early photographic practices. On 22 November 1895 German physicist Wilhelm Conrad Röntgen exposed his wife's hand to a series of unusual rays as it rested immobile on a photographic plate. These emissions, which we now call Röntgen rays, could pass through the atmosphere and pierce the body to generate shadowy photographic renderings from a distance. A radiant energy that comes from elsewhere is a form of divine light that suggestively links the radiological science of the X-ray to the transcendental metaphysics of spirit. "Like a dream, this form of light moved

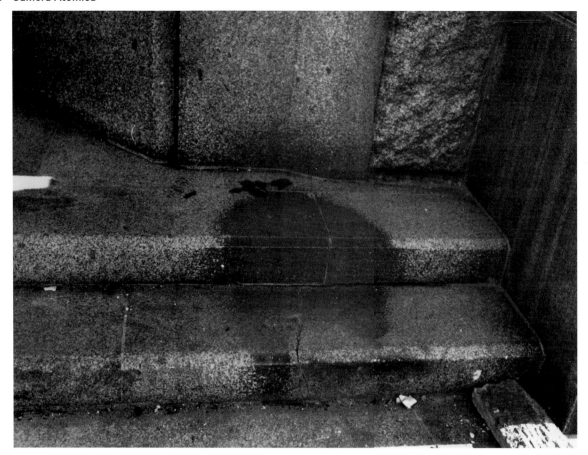

United States Strategic Bombing Survey
*Atomic shadow of a figure scorched into the steps
of Sumitomo Hiroshima Bank, 260 metres from the
hypocentre of the blast*, 20 November 1945

through objects, erased boundaries between solid objects, crossing
their internal and external borders."[6] Referred to as "ghost pictures"
because of the mysterious agency that could transform solid forms
into ethereal image-matter, the resulting ghostly view of Anna
Bertha's elongated skeletal digits conjured the coming of a "brave
new world" in which the potential for dematerialising the corporeal
substance of the body by technological means was first realised.

The photographic potential of radioactivity quickly followed on
the heels of Röntgen's work and was pioneered by French physicist
Henri Becquerel who was experimenting with uranium salts and
phosphorescence. He described his research methodology as follows:

One wraps a Lumière photographic plate with a bromide emulsion in two sheets
of very thick black paper, such that the plate does not become clouded upon being
exposed to the sun for a day. One places on the sheet of paper, on the outside, a
slab of the phosphorescent substance, and one exposes the whole to the sun for
several hours. When one then develops the photographic plate, one recognizes
that the silhouette of the phosphorescent substance appears in black on the
negative. If one places between the phosphorescent substance and the paper
a piece of money or a metal screen pierced with a cut-out design, one sees the
image of these objects appear on the negative... One must conclude from these

experiments that the phosphorescent substance in question emits rays which pass through the opaque paper and reduce silver salts.[7]

Becquerel didn't immediately recognise the role that spontaneous radioactivity had played in producing his mysterious images and believed instead that they were generated by exposing objects placed onto uranium-salt coated papers to sunlight. When a series of cloud-covered days disrupted his experiments in May of 1896, Becquerel put his materials away in a drawer. Upon resumption of his work, Becquerel decided for some inexplicable reason to develop these sequestered plates and found to his surprise that an incredibly bright and detailed image had etched itself into the uranium-salted paper while hidden away from sunlight. Uranium salts, it turned out, emitted radiation even when sheltered from an external source of energetic stimulation. Although film theorist André Bazin would make a similar claim for photography some years later when he declared that "For the first time, between the originating object and its reproduction there intervenes only the instrumentality of a nonliving agent",[8] it is Becquerel's breakthrough photographic plate fogged by its exposure to radiation, which also bears an uncanny resemblance to Bradley's irradiated puffer fish, that first achieves this remarkable feat.

40 years after Hiroshima and Operation Crossroads another radiological witness appeared, but this time not one spawned by the weapons testing conducted at the Los Alamos National Laboratory in the United States, but created by the civilian nuclear energy programme in the former Soviet Union during the 1970s. A period that saw 15 reactors built across the Ukraine, making it the second-largest custodian of nuclear materials outside of Russia, with the Chernobyl reactor complex supplying the Ukraine with the majority of its energy requirements.[9] Three days after the explosion and meltdown of Chernobyl's Nuclear Reactor Unit 4 on 26 April 1986, Ukrainian filmmaker Vladimir Shevchenko was granted permission to fly over the site in order to document decontamination

Henri Becquerel
Ghostly image of a metal object (Maltese Cross) generated by spontaneous radioactivity,
May 1896

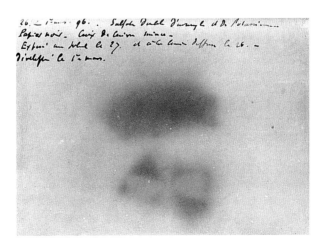

efforts being carried out by liquidators or bio-bots [biological robots] as they were sometimes called. The 30-square-kilometre radius of the Exclusion Zone marks the limits of a radioactive territory that is still considered too dangerous to support prolonged exposure.

When Shevchenko's 35 mm film footage was later developed, he noticed that a portion of the film was heavily pockmarked and carried extraneous static interference and noise. Thinking initially that the film stock used had been defective, Shevchenko finally realised that what he had captured on film was the image and sound of radioactivity itself.

Radiation is a fatal invisible foe. One that even penetrates steel plating. It has no odor, nor color. But is has a voice. Here it is. We thought this film was defective. But we were mistaken. This is how radiation looks. This shot was taken when we were allowed a 30-second glimpse from the armoured troop-carrier. On that April night the first men passed here—without protection or stop-watches, aware of the danger, as soldiers performing a great feat. Our camera was loaded with black and white film. This is why the events of the first weeks will be black and white, the colors of disaster.[10]

As his footage wound its way around the rollers of his flatbed editor a rapid series of tiny flares seemed to ignite the surface of the documentary film. Sparking and crackling a pyrotechnics of syncopated spectrality slowly appeared—impure images sullied by radioactive ghosts that still haunt the audio-track of the film and continue to distort its visual field. Not only had the disaster inscribed itself directly into the emulsive layer of the film as decaying radioactive particles transgressed the exterior casing of the movie camera, sadly they also unleashed their mutating virulence upon Shevchenko's own body.[11] An act of radiological recording that had converted silver halide particles into carriers of a lethal disease; transmuting the film quite literally into the most dangerous reel of footage in the world.[12] Although Shevchenko's documentary—*Chronicle of Difficult Weeks*—provides us with an intimate view into the space of disaster, its pictorial mediation allows us to remain at a safe and objective distance to it. However the sudden distortion of the film's sound and image flows by the Geiger-like interference of radiation displaces our initial confidence in its representational status as a fixed historical index and installs in its place a sense of dread that what we are witnessing on film is in fact the unholy representation of the real: an amorphous contagion that continues to discharge its lethal contaminates into the present. Shevchenko's damaged film is perhaps the most radical of all contact prints in that it is still 'dangerously alive'.

Conceptualising this unexpected filmic rupture as a capture of the real rather than an act of cinematic inscription forces a rethinking of the ontological nature of mediatic matter itself. Contrary to André

Bazin's well-known theorisations of film as "time-embalmed" or "change mummified", this particular sequence of irradiated film cannot be fixed at 24-fps.[13] There is no ontological ground that we can return to in perpetuity, no film-substance to rewind and playback without loss or change, but only the topology of vibrating difference. The nature of being—filmic matter's ontological status as a record and index of past events—is thus transformed into a dynamic ontology of becoming as radiation exerts its modulating influences over time so that the "paralysed, frozen, petrified instance" of the 35 mm film-frame becomes "embryonic" teeming with the hallucinogenic elixir of alchemical life.[14] Arguably Shevchenko's documentary sets up a variant of the discussion around "the ontology of the image" if read entirely within the instrumental register of film's technical capacities for recording the images and sounds that stream 'naturally' into the camera's receptors without the "creative intervention of man".[15] However to read his film radiologically, I argue, is to collapse the gap between representation and the real, form and content, signification and affect, so that the ontological dimensions of the film extend beyond their accepted role as indexical trace stripped of all mediation and preconception to enter into a feedback loop with the *actual* material residue of the world, which is

itself a creative mediator, albeit without the intentionality so decried by Bazin. It is its agency as image-event produced independently of the event it aims to document that both confers upon it the status contact print and returns it to the ontological realm that Bazin advanced. The radical recoding of the film by way of the nuclear accident insists that an analytic pursuit of Shevchenko's film as merely a representation of the real must be set aside in favour of an engagement with the film as an actual event.

Bazin intuits a similar shift in representation from an ontology of depiction to an ontology of the event when he discusses Thor Heyerdal's documentary chronicling the Kon Tiki expedition (1947) in which six Norwegians drifted from Peru to Polynesia on a crude wooden raft guided only by the ocean's currents. *Kon Tiki*, writes Bazin, "manages to be the most beautiful of films while not being a film at all" in that the cinematic project was adjunct to the scientific purposes of the journey, but what the film managed to capture were momentary glimpses of the real.[16] While most of the footage was shot as the sailors were floating in calm waters, when something of significance did occur the camera was quickly abandoned. Bazin focuses his discussion upon a short sequence of frames in which the camera unwittingly captured the reflection of a shark-whale in the water as it lunged towards the raft—an almost imperceptible rupture in an otherwise extended tedium of benign footage. This disturbance in the image-flow can be conceptualised as a kind of cut that transforms representation into sensation, but without the repatriating operations that have theorised the cut as a form of filmic suture. What came before is ontologically incommensurable with the pro-filmic presence of danger that follows. Throughout this essay, the sea is figured as a carrier of threat in as much as the air is a carrier of risk. The sudden appearance of radioactive fallout in Shevchenko's film performs a similar ontological feat in converting a rather predictable documentary into energetic image-matter bringing about a cinematic conversion that signals immanent peril akin to that of the shark-whale's menace.

Does the killer whale, that we can barely see refracted in the water, interest us because of the rarity of the beast and the glimpse we get of it, slight as it is? Or rather because the shot was taken at the very moment when a capricious movement of the monster might well have annihilated the raft and sent camera and cameraman seven or eight thousand meters into the deep? The answer is clear. It is not so much the photograph of the whale that interests us as the photograph of *danger*.[17]

Not only does the unexpected intercession of the whale's emergence within the filmic regime activate its latent virtualities producing affects in the body of the viewer that short-circuit the conventional channels of spectatorship organised around signification and representation, but Bazin also foregrounds the role that the accidental will play in merging image with event. It is the chance capture of a few frames, whether the ominous appearance of the

shark-whale or the five seconds of lethal footage that alters the equilibrium of each documentary project. Sailors forget the camera in order to attend to the hazard of the whale; Shevchenko forgoes the screening of his rushes to interrogate the alien markings that mysteriously appear. These disruptions in the normative operations of the cinematic apparatus emphasise the distinction between the picture-making technology of the machine and the event-making capacities of the image.

Because of the energetic nature of nuclear materials their radioactive contaminants consistently break free of the technogenic housings that, in principle, are meant to contain them.[18] Escaping to migrate across sovereign borders, radiological dust clouds discharge their particles at varying rates of decay, irradiating environments and warping biological systems as they pass.[19] In distributing its effects, the nuclear expands the original contact zone of the event— its photographic registration marks if you will—making it difficult to apprehend the slow leaking of its violence across territories and over epochs, quite unlike the targeted immediacy of the atomic blast. The link between the source of the event and its trace effects are forever being pulled further apart where radiological ecologies are concerned. While most of the more than 100 radioactive elements that were in evidence in the vicinity of Chernobyl have long since decayed, Strontium-90 and Caesium-137 isotopes, for example, are still present in areas of the world today.[20] In this sense, the contained image of the nuclear archived by the radio-autograph of the puffer fish is somewhat misleading, as Bradley himself realised when he described the strange milky bleed of the coral reef as offering the first sign that radioactive contaminates were altering the physical ecosystems of the Atoll. It was this phenomenon that led Bradley's team to forensically examine and photograph the marine tissue of fish, whose toxicity would in short order begin to make its ways up through the food chain.[21] "With the discovery, by divers, that areas of coral were bleaching out into chalky white from some unexplainable and lethal agent has come an increasing concern over the fish."[22]

In this essay radioactivity has been the force that radicalises matter, transforming all that it comes into contact with, producing a kind of insurgent photographic medium that always operates in excess of vision. The radioactive particle is, after all, the sleeper cell *par excellence*. From atomic weapons testing to the nuclear accident, what better agent than a medium directed towards image-capture to arrest this elusive and unseen enemy. Yet the radioactive comes into visibility when representation is no longer the objective of image-making and the making of the image itself becomes the event. This is ultimately the provocation of such radical contact prints, to bear material witness to processes whose political registers might otherwise secret themselves behind the surface-effects of things.

NOTES

1 United States. Joint Task Force One. Office of the Historian, *Operation Crossroads: The Official Pictorial Record*, New York: WH Wise, 1946, p 216. See also Bradley, David, *No Place to Hide*, Boston: Brown Little, 1948, p 125.

2 Film theorist Akira Mizuta Lippit advances the concept of a-visuality when he reflects upon a comment made by the late Abstract Expressionist painter Willem de Kooning with respect to the "radical visuality" produced by the atomic bomb. "The advent of atomic light signalled, for de Kooning, the absolute transformation of visual representation" inaugurating a new kind of seeing freed by the nuclear foreclosure of figuration's traditional symbolic economy. In the apocalyptic forces unleashed by the bomb de Kooning located a 'transcendent' sublime as everyone was momentarily reduced to colourless transparency and dispersed into the radioactive dust of angels. Lippit argues that de Kooning's "sadistic metaphysics" confuses the radical a-visuality of atomic light with a kind of religious fervour that maps a "redemptive" narrative onto the conversion of the physical body into ghostly spirit-matter by the sheer visceral and spectral force of atomic energy. Akira Mizuta Lippit, *Atomic Light: Shadow Optics*, Minneapolis, Minnesota ; London: University of Minnesota Press, 2005, p 81.

3 Heidegger, Martin, *The Question Concerning Technology and Other Essays*, William Lovitt, trans, New York: Harper Torchbooks, 1977, p 134.

4 See Schuppli, Susan, *Material Witness: Forensic Media and the Production of Evidence*, Leonardo, London: MIT Press, Forthcoming 2015.

5 Bradley, *No Place to Hide*, p 149.

6 Lippit, *Atomic Light: Shadow Optics*, p 44.

7 Becquerel, Henri, " Sur les Radiations Emises par Phosphorescence", in *Comptes rendus hebdomadaires des séances de l'Académie des sciences*, Académie des sciences, Paris: Gauthier-Villars, 1896, pp 420–421.

8 Bazin, André, "The Ontology of the Photographic Image", *Film Quarterly* 13, no 4, 1960, p 7.

9 I wish to acknowledge the terrific research of Joseph Masco who also makes a connection between Operations Crossroads and Chernobyl in his chapter "Mutant Ecologies" in Joseph Masco, *The Nuclear Borderlands: The Manhattan Project in post-Cold War New Mexico*, Princeton: Princeton University Press, 2006, p 303–307. Russia successfully detonated a nuclear bomb test in 1949 and inherited a vast nuclear weapons production complex after the dissolution of the Soviet Union. It still maintains vast holdings of enriched uranium and its related weapons arsenal. www.nti.org/country-profiles/russia/ Accessed 29.9.13.

10 Transcription of film voice-over from Vladimir Shevchenko, "Chernobyl: Chronicle of Difficult Weeks", in *The Glasnost Film Festival*, USSR: The Video Project, 1986.

11 Vladimir Shevchenko died in 1999. Today there are still only 31 confirmed deaths officially linked to the accident at Chernobyl.

12 I'm indebted to Peter C van Wyck whose citation of this incident/accident provoked my search for the actual film footage. van Wyck, Peter C, *Signs of Danger: Waste, Trauma, and Nuclear Threat*, vol 26, *Theory Out of Bound*, Minneapolis: University of Minnesota Press, 2004, p 97.

13 "If the plastic arts were put under psychoanalysis, the practice of embalming the dead might turn out to be a fundamental factor in their creation. The process might reveal that at the origin of painting and sculpture there lies a mummy complex. The religion of ancient Egypt, aimed against death, saw survival as depending on the continued existence of the corporeal body. Thus, by providing a defense against the passage of time it satisfied a basic psychological need in man, for death is but the victory of time. To preserve, artificially, his bodily appearance is to snatch it from the flow of time, to stow it away neatly, so to speak, in the hold of life. It was natural, therefore, to keep up appearances in the face of the reality of death by preserving flesh and bone." See Bazin, "The Ontology of the Photographic Image", pp 4–5.

14 Deleuze, Gilles, *Cinema 2: The Time Image*, Hugh Tomlinson and Barbara Habberjam, trans, London: Continuum, 1989, p 166.

15 Bazin, "The Ontology of the Photographic Image", p 7.

16 Bazin, André, "Cinema and Exploration", in *What is Cinema?*, Hugh Gray, trans and ed, Berkeley and Los Angeles: University of California Press, 1967, p 160.

17 Bazin, "Cinema and Exploration", p 161.

18 "Nuclear materials" writes Peter C van Wyck "stand in relation to their containment only very

imperfectly—there is always leakage". Van Wyck, *Signs of Danger: Waste, Trauma, and Nuclear Threat*, p 19.

19 Caesium, one of the most enduring radioactive isotopes, is easily absorbed by natural materials because of high degree of solubility of its salts, which are some of the most common chemical compounds found within it.

20 Large amounts of Strontium-90 (Sr-90) were also dispersed worldwide during atmospheric nuclear weapons tests conducted during the 1950s and 1960s, so Chernobyl is not the only source of Sr-90. See International Atomic Energy Agency. www.iaea.org/newscenter/features/chernobyl-15/cherno-faq.shtml. See also US Environmental Protection Agency briefings. www.epa.gov/radiation. Accessed 22.9.13 and 29.9.13 respectively.

21 "Almost all seagoing fish recently caught around the atoll of Bikini have been radioactive. Thus the disease is passed on from species to species like an epizootic. The only factors which tend to limit the disease, as distinguished from infectious diseases are the half-lives of the material involved, and the degree of dilution and dissemination of the fission products." Bradley, *No Place to Hide*, p 126.

22 Bradley, *No Place to Hide*, pp 124–125.

Atomic
Timeline

1942
United States, Canada and
Britain begin collaborating on
the Manhattan Project to build
nuclear weapons.

1945
First atomic bomb tested at
Alamagordo, New Mexico (16 July);
Nuclear weapons used against
Hiroshima and Nagasaki (6 and
9 August); Soviet atomic spy ring
revealed in Canada by Igor Gouzenko
(5 September).

1949
Soviet Union conducts first
nuclear tests.

1952
Hydrogen bomb tested by the United
States in the Pacific.

1954
United States launches first
nuclear-powered submarine; *The
Lucky Dragon*, a Japanese fishing
boat, contaminated by fallout from
hydrogen bomb test.

1956
World's first nuclear power plant
opens at Calder Hall, Britain.

1957
Soviet Union launches first artificial
satellite; United Nations establishes
the International Atomic Energy
Agency, a nuclear watchdog.

1958
Campaign for Nuclear Disarmament
founded in Britain.

1960
France conducts first nuclear test.

1962
Cuban Missile Crisis brings world to
brink of nuclear war.

1963
United States and the Soviet Union
sign Partial Test Ban Treaty.

1964
China explodes first atomic bomb.

1968
Treaty for the Non-Proliferation of
Nuclear Weapons signed.

1972
Richard Nixon and Leonid Brezhnev
sign Strategic Arms Limitation
Treaty Accord and Anti-Ballistic
Missile Treaty.

1974
India conducts first nuclear test.

1979
Meltdown of Three Mile Island
nuclear reactor.

1981
Largest-ever anti-nuclear protests
occur in North America, Europe
and Japan.

1983
Ronald Reagan outlines plans
for new "Star Wars" anti-missile
defense technology.

1986
Explosion at Chernobyl Nuclear
Power Plant; Ronald Reagan
and Mikhail Gorbachev discuss
elimination of nuclear weapons
at Reykjavík.

1989
Berlin Wall falls, symbolising the
end of Cold War.

1993
George Bush and Boris Yeltsin sign
Strategic Arms Reduction Treaty.

1994
South Africa completes
disarmament of nuclear weapons.

1998
India and Pakistan conduct
nuclear tests within three
weeks of each other.

2007
North Korea conducts a nuclear test.

2009
Barack Obama calls for the abolition
of nuclear weapons in Prague.

2011
Earthquake causes triple meltdown
at Fukushima Daiichi.

2013
Iran reaches a deal on its nuclear
programme with six world powers.

List of Illustrations

Bourke-White, Margaret
*Crewmen of B-36 Bomber Posing in Arctic
Equipment [Greenland]*
1951
Gelatin silver print
33.66 x 26.04 cm
San Francisco Museum of Modern Art, gift of Michal Venera
2001.425
© Estate of Margaret Bourke-White
Image courtesy San Francisco Museum of Modern Art
and Getty Images
Page 37

Brack, Dennis
*Sitting on the Patio of the Officer's Beach Club,
Illuminated by an Atomic Explosion at Enewetak Atoll*
8 April 1951
Gelatin silver print
20.3 x 25.4 cm
Black Star Collection, Ryerson University
BS.2005.236819; BS# 144-76
Page 97

Brixner, Berlyn
Trinity Test Explosion, 0.006 Seconds
16 July 1945
Gelatin silver print
21.6 x 27.94 cm
Private collection
Page 83 (top)

Brixner, Berlyn
Trinity Test Explosion, 0.016 Seconds
16 July 1945
Gelatin silver print
21.6 x 27.94 cm
Private collection
Page 83 (bottom)

Brixner, Berlyn
Trinity Test Explosion, 30 Seconds
16 July 1945
Gelatin silver print
21.6 x 27.94 cm
Private collection
Page 23

Brixner, Berlyn
Trinity Test Explosion, 90 Seconds
16 July 1945
Gelatin silver print
21.6 x 27.94 cm
Private collection
Page 22

Burke, Bill
Industry Shipping
c 1970
Gelatin silver print
27.94 x 35.56 cm
Ryerson Image Centre, Black Star Collection
BS.2005.280122; BS# 177-256
© Bill Burke
Page 257 (top)

Burtynsky, Edward
AMARC #5, Tuscon, Arizona, USA
2006
Chromogenic print
© Edward Burtynsky
Image courtesy Nicholas Metivier Gallery, Toronto
Page 256 (bottom)

Burtynsky, Edward
Uranium Tailings #12, Elliot Lake, Ontario
1995
Chromogenic print
© Edward Burtynsky
Image courtesy Nicholas Metivier Gallery, Toronto
Page 14 (left)

Busse, Henry
Commemorative Plaque, Port Radium
c 1950s
Digital image from original negative
Northwest Territory Archives
N1979-052:4877
Page 182 (top)

Busse, Henry
Miners Underground, Eldorado Mine, Port Radium
c 1950s
Digital image from original negative
Northwest Territory Archives
N1979-052:3348
Page 182 (bottom)

Busse, Henry
Miner with Headlamp, Port Radium
c 1950s
Digital image from original negative
Northwest Territory Archives
N1979-052:3409
Page 183 (top)

Busse, Henry
Port Radium Minesite on a Winter Night
c 1950s
Digital image from original negative
Northwest Territory Archives
N1979-052:3305
Page 183 (bottom)

Canadian Conservation Institute
Connelly Containers Fallout Shelter Medical Kit C
2011
X-ray photograph of the contents
© Government of Canada, Canadian Conservation
Institute
CCI 122242-0001
Page 199 (top)

Chancel, Philippe
*Arirang Series, DPRK (Democratic People's Republic
of Korea)*
2006
Lambda print face-mounted to diasec (edition of 5)
125 x 100 cm
© Philippe Chancel
Pages 60–61

Condé, Carol and Karl Beveridge
No Immediate Threat
1985–1986
Dye destruction print (Cibachrome)
Collection of the Art Gallery of Ontario
86-279 A-J
Pages 208–209

Connelly Containers, Pennsylvania
Fallout Shelter Medical Kit C
February 1963
Sealed cardboard box with bottles and medications
60 x 45 x 30 cm; weight: 35 kg
Canada Science and Technology Museum, Ottawa
Page 199 (bottom)

Conner, Bruce
BOMBHEAD
2002/1989
Pigment on RC photo and Somerset paper, acrylic
81.3 x 63.5 cm
Conner Family Trust, San Francisco/ARS
Image courtesy Magnolia Editions, Oakland, CA
Page 101

Coupland, Douglas
Nagasaki Blanket
2011
Woven cotton with silk trim
152.4 x 101.6 cm
Private collection
Photo: Trevor Mills, Vancouver Art Gallery
Page 90

Dean, Loomis
*Burned up except for face, this mannequin was 7,000
feet from atomic bomb blast, Yucca Flat, Nevada*
1 May 1955
Gelatin silver print
26.7 x 26.7 cm
International Center of Photography, The LIFE
Magazine Collection, 2005
1996.2005
Image courtesy Getty Images
Page 59

Dean, Loomis
*Fallen mannequin in house 5,500 feet from bomb is
presumed dead, Yucca Flat, Nevada*
1 May 1955
Gelatin silver print
22.5 x 33.5 cm
International Center of Photography, The LIFE
Magazine Collection, 2005
1993.2005
Image courtesy Getty Images
Page 57

Dean, Loomis
*Scorched male mannequin wearing dark suit
indicates a human would be burned by atomic bomb
blast but alive, Yucca Flat, Nevada*
1 May 1955
Gelatin silver print
26.5 x 26.8 cm
International Center of Photography, The LIFE
Magazine Collection, 2005
1995.2005
Image courtesy Getty Images
Page 58

Dean, Loomis
*Unburned female mannequin with wig askew is
wearing light-colored dress that absorbs less heat
from atomic bomb blast, Yucca Flat, Nevada*
1 May 1955
Gelatin silver print
26.5 x 26.8 cm
International Center of Photography, The LIFE
Magazine Collection, 2005
1994.2005
Image courtesy Getty Images
Page 56

Del Tredici, Robert
*The Becquerel Reindeer, Harads Same-produktor,
Harads, Lapland, Sweden*
3 December 1986
Gelatin silver print
30.5 x 45.1 cm
National Gallery of Canada
PSC87:070
© Robert Del Tredici
Page 16

Del Tredici, Robert
Cooling the Derby and Sampling the Derby
From the book *At Work in the Fields of the Bomb*
(Vancouver: Douglas & McIntyre, 1987)
Plates 17 and 18
© Robert Del Tredici
Page 79

Del Tredici, Robert
*First Foreign Journalists on Novaya Zemlya, South
Island*
15 October 1991
Gelatin silver print
30.3 x 45.2 cm
National Gallery of Canada
EX-93-21
© Robert Del Tredici
Page 38 (top)

Gordon, Peter G
Displaying a Geiger Counter at Atomic Survival Exhibit
19 March 1952
Gelatin silver print
York University Libraries, Toronto Telegram Fonds
ASC08141
Page 193 (top)

Gowin, Emmet
Minuteman III ICBM Silo Near Conrad, Montana
1989/91
Gelatin silver print
27.9 x 35.6 cm
Yale University Art Gallery
1999.27.3
© Emmet Gowin
Image courtesy Pace MacGill Gallery
Page 24

Gowin, Emmet
*Subsidence Craters, Northern End of Yucca Flat,
Nevada Test Site*
1996
Gelatin silver print
71.1 x 35.1 cm
Yale University Art Gallery
2005.51.27
© Emmet Gowin
Image courtesy Pace MacGill Gallery
Page 25

Grant, Frank
Ban the Bomb Protest, Toronto
4 November 1961
Gelatin silver print
York University Libraries, Toronto Telegram Fonds
ASC08191
Page 44 (top left)

Grant, Ted
Untitled [The Medical Team: The Children of Chernobyl]
1992
Gelatin silver print
45 x 30.8 cm
National Gallery of Canada/CMCP
EX-92-184
Page 203

Hai, Jin
*Shi jie zhi shi chu ban she [The Making of the Atomic
Bomb]*
2005
Book
Private collection
Page 49

Ham, Kyungah
Nagasaki and Hiroshima Mushrooms Clouds 02
2010
North Korean hand embroidery on silk,
graphite on frame
160 x 320 cm
Seoul Museum of Art
Page 91

Hamaya, Hiroshi
*The United States-Japan Security Treaty Protest,
Tokyo [Protestors being attacked with water hoses.]*
Alternate Title: *Chronicle of Grief and Anger*
15 June 1960
Gelatin silver print
20 x 30.5 cm
J. Paul Getty Museum
2012.29.7
© Keisuke Katano
Page 32

Hamaya, Hiroshi
*The United States-Japan Security Treaty Protest,
Tokyo [Aerial view of Japanese people marching in a
semi-circle in front of a row of observers.]* Alternate
Title: *Chronicle of Grief and Anger*
15 June 1960
Gelatin silver print
25.2 x 31 cm
J. Paul Getty Museum
2012.29.5
© Keisuke Katano
Page 33

Hamaya, Hiroshi
*The United States-Japan Security Treaty Protest,
Tokyo [A crowd of protestors being sprayed by a water
hose.]* Alternate Title: *Chronicle of Grief and Anger*
15 June 1960
Gelatin silver print
19.6 x 30.5 cm
J. Paul Getty Museum
2012.29.2
© Keisuke Katano
Page 34 (top)

Hamaya, Hiroshi
*The United States-Japan Security Treaty Protest, Tokyo
[Police in rain gear facing off with crowds of protestors,
some of whom are drenched while others have
umbrellas.]* Alternate Title: *Chronicle of Grief and Anger*
20 May 1960
Gelatin silver print
21.1 x 30.8 cm
J. Paul Getty Museum
2012.29.8
© Keisuke Katano
Page 34 (bottom)

Hamaya, Hiroshi
*The United States-Japan Security Treaty Protest, Tokyo
[Night time view of flags being waved in front of spot
lights.]* Alternate Title: *Chronicle of Grief and Anger*
19 June 1960
Gelatin silver print
25.3 x 30.8 cm
J. Paul Getty Museum
2012.29.4
© Keisuke Katano
Page 35

Harrington, Richard
Beijing, China (Children Reading Anti-American Sign)
1966
Gelatin silver print
19.4 x 24.1 cm
Private collection
Page 64

Harrington, Richard
*Beijing, China (Movie Billboard with Mushroom Cloud
and Soldier Wearing Anti-Radiation Gear)*
1966
Gelatin silver print
19.7 x 14 cm
Private collection
Page 65

Higuchi, Kenji
A Beautiful Day at Crystal Beach, Mihama Bay
August 2004
Colour photograph
© Kenji Higuchi
Pages 76–77

Higuchi, Kenji
*Nuclear Criticality Accident of JCO in Tokaimura,
Ibaraki Prefecture*
1 October 1999
Film (black and white)
© 1999 Kenji Higuchi
Page 206

Higuchi, Kenji
*Subcontract workers, Tsuruga nuclear power plant,
Fukui Prefecture, July 1977*
From the book *Photo Document: Japan's Nuclear
Power Plants* (Tokyo: Orijin Shuppan Senta, 1979)
© Kenji Higuchi
Page 80

Horton, Kristan
dr0275-s016-10
2003–2006
Giclee print on archival photo paper mounted on
DiBond (edition of 3 + 2AP)
27.9 x 76.2 cm
Image courtesy Kristan Horton and
Jessica Bradley Gallery
Page 201 (top)

Horton, Kristan
dr0276-s016-11
2003–2006
Giclee print on archival photo paper mounted on
DiBond (edition of 3 + 2AP)
27.9 x 76.2 cm
Image courtesy Kristan Horton and
Jessica Bradley Gallery
Page 201 (bottom)

INP Soundphoto by Phil Glickman
*Posse Maintaining Order During Uranium Boom,
Miracle Hot Springs, California*
3 June 1955
Gelatin silver print
20.4 x 25.3 cm
Private collection
Page 186

International News Photo
Soviet Defector Igor Gouzenko Wearing a Hood
29 January 1954
Gelatin silver print
22.9 x 17.7 cm
Private collection
Page 242 (right)

International Nickel Company (Inco)
Even this cloud has a silver lining
Advertisement in *Time* magazine
March 22, 1954
p 109
Private collection
Page 96

Isozaki, Arata
*Re-ruined Hiroshima Project, Hiroshima,
Japan, Perspective*
1968
Ink and gouache with cut-and-pasted Gelatin silver
print on Gelatin silver print
35.2 x 93.7 cm
Museum of Modern Art, gift of
The Howard Gilman Foundation
1205.2000
© Arata Isozaki
Pages 136–137

Joint Task Force One
*Mass Grouping of Cameras Used to Photograph First
Bikini Tests*
From the book *Operation Crossroads: The Official
Pictorial Record* (New York: Wm. H. Wise, 1946)
Private collection
Page 93

Joint Task Force One
That Men May Live
From the book *Operation Crossroads: The Official
Pictorial Record* (New York: Wm. H. Wise, 1946)
Private collection
Page 94

United States Information Service
Nuclear Worker in Suit with Geiger Counter
c 1950s
Gelatin silver print
20 x 25.5 cm
Collection of the Art Gallery of Ontario
2005-5216
Page 190

United States Information Service
Reactor Container 36 meters high being constructed for the Niagara Mohawk Power Corporation, Lake Ontario near Oswego, New York
c 1950s
Gelatin silver print
20 x 25.5 cm
Collection of the Art Gallery of Ontario
2005-5180
Page 98

United States Strategic Bombing Survey
Atomic shadow of a figure scorched into the steps of Sumitomo Hiroshima Bank, 260 metres from the hypocentre of the blast (double-page illustration in The Nuclear Century: Voices of the Hibakusha of the World, Hiroshima: Japan Peace Museum, 1997)
20 November 1945
Page 284

Unknown
Atomic Bomb Victim No. 1, Kiyoshi Kikkawa
30 April 1947
Gelatin silver print
11 x 7.5 cm
Private collection
Page 138

Unknown
Bank of Oscillograph Record Cameras, Operation Castle Bravo
11 February 1954
Gelatin silver print
Image courtesy National Nuclear Security Administration/Nevada Site Office and VCE, Inc.
Page 115 (top left)

Unknown
Hiroshima, Japan
1946
Gelatin silver print
20.32 x 25.4 cm
Ryerson Image Centre, Black Star Collection
Page 28

Unknown
President Kennedy and Glenn Seaborg, Chair of the Atomic Energy Commission, Presenting the Enrico Fermi Award at the White House
1961
Photograph tinted by uranium toner
20.3 x 25.4 cm
Private collection
Page 255

Unknown
Publicity still from *Dr. Strangelove or: How I Learned to Stop Worrying and Love the Bomb*
1964
Gelatin silver print
private collection
Page 200

Unknown
Tom & Big Boy & Baby Bomb
1956
Gelatin silver print
11.6 x 7 cm
Private collection
Page 242 (left)

U.S. Army Air Force
Leaflet Dropped on Japanese Cities Prior to the Bombing of Hiroshima and Nagasaki
27 July 1945
Printed leaflet
Private collection
Page 145

U.S. Army Air Force
Presentation Album of Original Photographs of the Bombing Missions on Hiroshima and Nagasaki [Nagasaki Mushroom Cloud]
9 August 1945
Gelatin silver print
Private collection
Page 86, 87

U.S. Army Air Force
Presentation Album of Original Photographs of the Bombing Missions on Hiroshima and Nagasaki [Paul Tibbets Waving from the Cockpit of the Enola Gay]
6 August 1945
Gelatin silver print
Private collection
Page 88

U.S. Army Air Force
Presentation Album of Original Photographs of the Bombing Missions on Hiroshima and Nagasaki [Survivors Making Their Way through the Ruins of Hiroshima or Nagasaki]
August 1945
Gelatin silver print
Private collection
Page 88

U.S. Army Photographic Signal Corps
Test Baker, Operation Crossroads, Bikini Atoll
1946
Gelatin silver print
11.5 x 23.2 cm
Private collection
Pages 40–41

U.S. Atomic Energy Industry
Meet Citizen Atom - Your Partner in Progress
1960
Newspaper insert
Private collection
Page 264

U.S. Department of Defense
Nuclear Device Detonated at the Trinity Test Site, Alamorgordo, New Mexico
16 July 1945
Gelatin silver print
Page 12

U.S.M. Corporation Atomic Power Department
Label for a Defective Part
c 1960
Private collection
Page 78

U.S. Military
Five Air Force officers are observers at Ground Zero during the explosion of the first air-to-live atomic rocket ever fixed from a manned aircraft
18 July 1957
Gelatin silver print
Image courtesy National Nuclear Security Administration/Nevada Site Office
Page 120

U.S. Military
Lookout Mountain Cameraman Staff Sergeant John Kelly, Nevada Test Site
1958
Image courtesy National Nuclear Security Administration/Nevada Site Office
Page 112

U.S. Military
Lookout Mountain cameraman, telephoto lens and Mitchell camera: Operation Teapot
1955
Image courtesy National Nuclear Security Administration/Nevada Site Office and VCE, Inc.
Page 111

U.S. Military
Operation Dog, taken from News Nob
1951
Gelatin silver print
Image courtesy National Nuclear Security Administration/Nevada Site Office and VCE, Inc.
Page 113

U.S. Military
Operation Grable
25 May 1953
Gelatin silver print
Page 115 (top right)

U.S. Military
Operation Plumbbob/Hood
5 July 1957
Gelatin silver print
Image courtesy National Nuclear Security Administration/Nevada Site Office
Page 116 (bottom)

U.S. Military
Operation Priscilla, taken at the moment of the shockwave, 1957 / Camera Crew at Exact Moment of Shockwave Arrival, Nevada Test Site
1957
Gelatin silver print
Image courtesy VCE, Inc.
Page 110 (bottom)

U.S. Military
Operation Priscilla [Cameramen Silhouetted at Moment of Detonation, Nevada Test Site]
1957
Gelatin silver print
Image courtesy National Nuclear Security Administration/Nevada Site Office
Page 116 (top left)

U.S. Military
Operation Teapot
1955
Gelatin silver print
Image courtesy National Nuclear Security Administration/Nevada Site Office
Page 115 (bottom)

U.S. Military
Operation Teapot, Nevada Test Site
29 March 1955
Gelatin silver print
Image courtesy National Nuclear Security Administration/Nevada Site Office
Page 110 (top)

U.S. Military
Operation Tumbler-Snapper
1952
Gelatin silver print
Image courtesy National Nuclear Security Administration/Nevada Site Office.
Page 120 (right)

U.S. Military
Photographic Engineering Section of Operations Crossroads
1946
Gelatin silver print
The Perry M. Thomas Collection, Michigan State University Archives and Historical Collections
Page 280

Colophon

© 2015 Art Gallery of Ontario, Black Dog Publishing Limited, the artists and authors. All rights reserved.

Art Gallery of Ontario
317 Dundas Street West
Toronto, Ontario
M5T 1G4
Canada
www.ago.net

Black Dog Publishing Limited
10A Acton Street, London
WC1X 9NG UK
t. +44 (0)207 713 5097
f. +44 (0)207 713 8682
e. info@blackdogonline.com

The Art Gallery of Ontario is partially funded by the Ontario Ministry of Culture. Additional operating support is received from the Volunteers of the Art Gallery of Ontario, the City of Toronto, the Department of Canadian Heritage and the Canada Council for the Arts.

All opinions expressed within this publication are those of the author and not necessarily of the publisher.

Published in conjunction with the exhibition
Camera Atomica
Art Gallery of Ontario
8 July 2014–25 January 2016

Contemporary programming at the Art Gallery of Ontario is supported by

Canada Council Conseil des Arts
for the Arts du Canada

Design by João Mota at Black Dog Publishing

British Library Cataloguing-in-Publication Data.
A CIP record for this book is available from the British Library.
Cataloguing data available from Library and Archives Canada.

ISBN 978 1 908966 48 3

Black Dog Publishing is an environmentally responsible company. *Camera Atomica* is printed on sustainably sourced paper.

Camera Atomica is published in association with the Art Gallery of Ontario.

AGO
Art Gallery of Ontario

art design fashion
history photography
theory and things

black dog
publishing

www.blackdogonline.com london uk